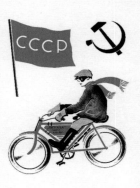

INSIDE THE RAINBOW

— Вот и **МАСТЕР**,—молвит он:

— Надо
 нам
 достать **КАРТОН**.
Лошадей подобных тело
из картона надо делать.

Lidia Popova, illustration for *The Fire Horse* by Vladimir Mayakovsky, 1928

INSIDE THE RAINBOW

RUSSIAN CHILDREN'S LITERATURE 1920–1935: BEAUTIFUL BOOKS, TERRIBLE TIMES

EDITED BY JULIAN ROTHENSTEIN AND OLGA BUDASHEVSKAYA

First published in 2013
Redstone Press, 7a St Lawrence Terrace, London W10 5SU
www.redstonepress.co.uk
www.theredstoneshop.com

ISBN 978 1870003 95 7

Design: Julian Rothenstein
Artwork: Otis Marchbank
Scanning: Ilya Kalnitsky Production: Tim Chester
Manufacture: C and C Offset Printing, China

ACKNOWLEDGEMENTS

Many thanks to Sasha Lurye whose marvellous collection of Russian children's literature made this book possible.

Extracts from the following publications are reproduced by permission of the copyright holders:

Before Igor: My Memories of A Soviet Youth by Svetlana Gouzenko, by permission of W. W. Norton
Tale of the Military Secret by Arkady Gaidar, translated by Eric Konkol, courtesy SovLit.net / *Six Weeks in Russia* by Arthur Ransome courtesy Faber and Faber Ltd / I Dreamt Revolution by William Reswick courtesy H. Regnery Company / *Moscow Diary* by Walter Benjamin, MIT press in conjunction with October magazine, Ltd. *Babies of the Zoo* and *The Trumpet and the Drum* by Samuil Marshak, © The Estate of Samuil Marshak 2013 / Poem by Osip Mandelstam, translated by James Greene, courtesy Penguin Books © James Greene / *The Foundation Pit,* translated by Robert Chandler and Geoffrey Smith, courtesy Robert Chandler / *The Muddle, The Stolen Sun, The Telephone* by Kornei Chukovsky © The Estate of Kornei Chukovsky, 2013 Daniil Kharms, *A Fairy Tale,* from *The Man With the Black Coat* by Daniil Kharms and Alexander Vvedensky / Daniil Kharms, *The Four-Legged Crow,* from *Oberiu: An Anthology of Russian Absurdism,* edited by Eugene Ostashevsky *Russia in 1919* by Arthur Ransome, courtesy Faber and Faber Ltd / *Hope Against Hope* by Nadezhda Mandelstam by permission of Random House / Daniil Kharms, *A Man Once Walked Out of His House,* courtesy Eugene Ostashevsky and Matvei Yankelevich.

Every effort has been made to contact copyright holders, but in some cases this has not been possible.
In the event of a claim please write to the publishers so that a correction can be made in future editions.

Many thanks to:
James Attlee, Lutz Becker, Jamie Byng of Canongate Books, Robert Chandler, Elaine Feinstein, Jill Hollis, Olga Kabanova, Mikhail Karasik, Gerben van der Meulen of the International Institute of Social History (Amsterdam), Hiang Kee, Albert Lemmens, Bill McAlister, Andrew Nurnberg, www.marxists.org., Ella Rothenstein, Lucien Rothenstein, Kevin Sim, Elena Spitsyna and Serge Stommels.

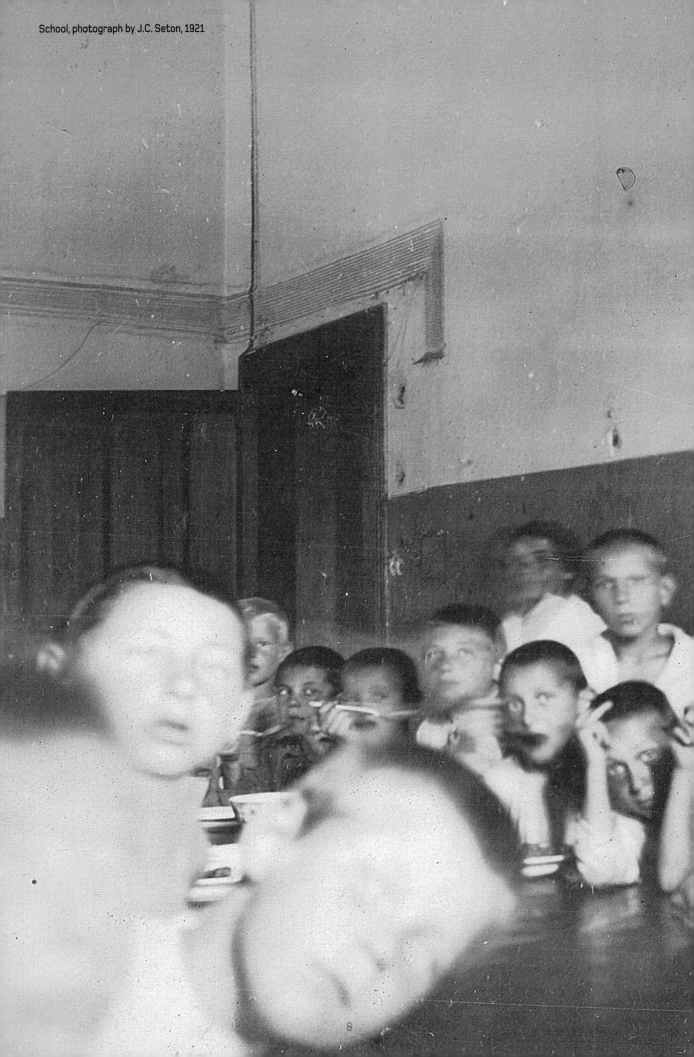

School, photograph by J.C. Seton, 1921

8

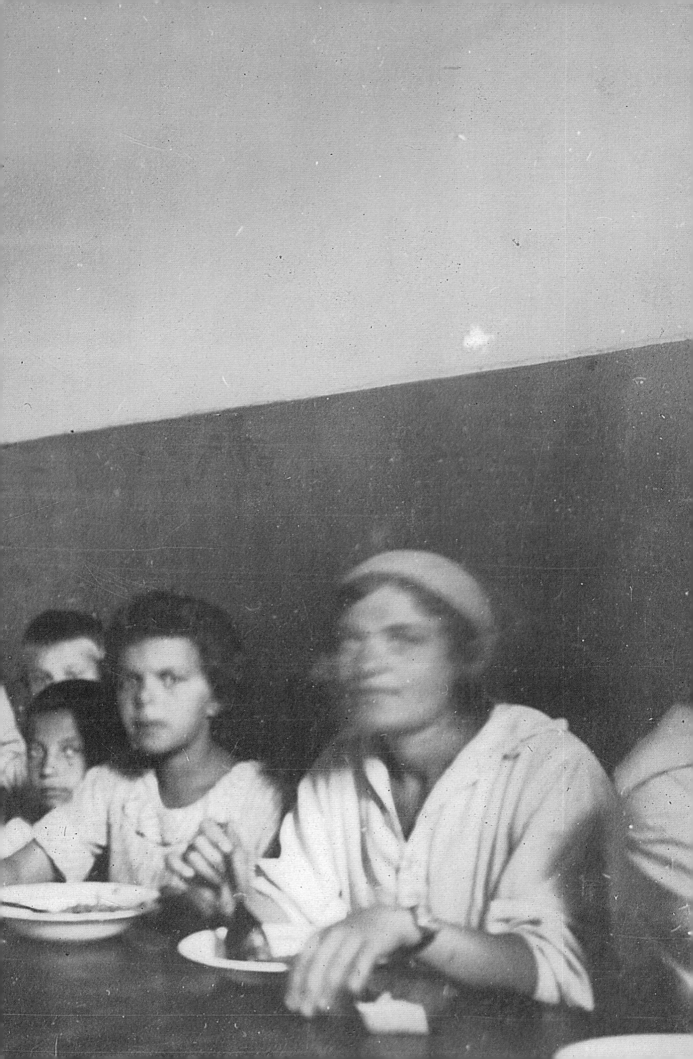

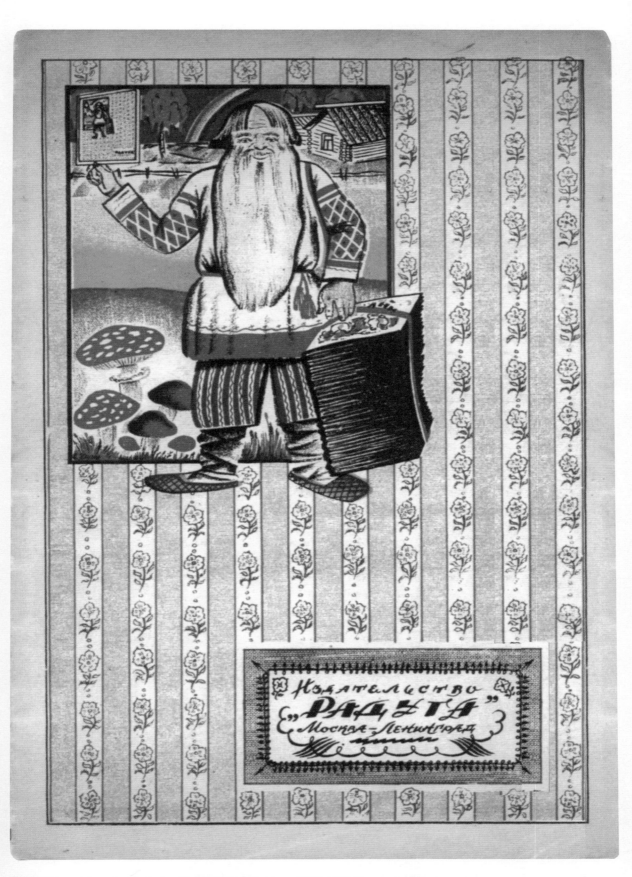

Cover of the catalogue for the Raduga (Rainbow) publishing house (1922–1930), Moscow–Leningrad

WHAT A TREASURY! The world of Russian children's illustrated books in the first twenty years or so of Soviet rule is almost incomparably rich. What were they doing, these commissars and party secretaries, to allow this wonderland of modern art to grow under their very noses? I expect the rule that applies to children's books was just as deeply interiorised in the Soviet Union as it has been in the rest of the world: they don't matter. They can be ignored. They're not serious.

But if we didn't know it already, we can see from the evidence so splendidly spread out in these pages that children's books are capable of astonishing beauty and an almost unparalleled range of expressive design.

With so much to look at, one's eye tries to find patterns or correspondences, to get hold of shapes that rhyme. And one that leaps out to me is that of the Jumping Jack, the old wooden toy: you pull a string and his arms and legs shoot out at either side. That shape, a sort of schematized, simplified human figure, turns up again and again. Its pure form occurs in the child's figure on page 232, in *Pashka and Papashka*, but there are many variants: in Lidia Popova's illustration from Mayakovsky's *The Fire Horse* on page 10, in the children from China and (presumably) Scotland and the Russian Young Pioneer leading the way to a brave communist future on page 34, in miniature on page 127 (and in profile on the preceding page), and interestingly from behind, doing something very modern and heroic to an electricity pylon, on page 92. Even the diver on page 106, in a book illustrating clothes worn by workers, takes up the same pose. (The textures and colours of the plates from that book illustrated here remind me of Eric Ravilious's marvellous lithographs in his *High Street* of 1938, but what a world of difference in the social context!) With small variations, this Jumping Jack, facing us directly with his straight legs firmly planted in an A shape, is everywhere.

The kind of modern art that lives so vigorously and joyously in these pages is, of course, one with a Russian ancestry. There is no Cubism here (though has there ever been a children's book with Cubist illustrations?), no Post-Impressionism (though one of Cézanne's fruit-bowls turns up most unexpectedly on page 254), no Dada. What there is is Constructivism, and plenty of it, and of its metaphysical parent, Suprematism. Basic geometrical shapes, the square, the circle, the rectangle, are everywhere; flat primary colours dominate. The cover for Mayakovsky's *What Will You Be When You Grow Up?* of 1929 (pages 280-281) is a perfect example–very striking, bold, simple and dramatic. El Lissitzky's Suprematist tale about two squares from 1922 (page 98) puts the principle to work, and Malevich's famous black circle turns up in the position of a giant full stop in Lidia Popova's cover design for Sergei Neldikhen's *9 Words* of 1929 (page 108)

The playfulness is terrific, in fact. And in designing this book, Julian Rothenstein has brought off a brilliant coup on pages 246-247, by placing Lidia Popova's blue-overlapping-red rectangles on the right to match exactly the blue-overlapping red shorts of the near-Jumping Jack figure from a quite different book on the left.

But it's not all geometrical and primary colours. Some of the textures are beautifully rendered, and almost palpable: was there ever a pricklier hedgehog than the one peering around suspiciously on page 182? And the leopard on page 165 looks as if it comes fresh from the brush of Brian Wildsmith.

It's tempting to go through this book page by page simply pointing out the delights: the brilliant rhythm of the flatly-printed locomotives on page 256, the utterly bizarre dragon on page 250, the

exquisitely rendered birds on pages 186-187, the sheep escaping across their deep red background on page 181 - the pleasures go on and on.

But nothing comes without a context, not even a black circle or a red square. The context here is simply and brilliantly presented in a series of photographs of Russian children; adults too, but mainly children, little shaven-headed boys and wide-eyed girls gazing at the camera over their bowls of soup in a shabby school room, or crowded into the back of a charabanc for an excursion into the woods, perhaps, or marching brightly forwards into the future to the beat of a drum, with a red star (added later) on each breast, or looking profoundly uncertain in their paper hats and tucked-up shorts as they play at being soldiers or medical orderlies.

Perhaps the most haunting of these photographs is the one of Osip Mandelstam after his arrest in 1934. Darkness was gathering; all the hope and excitement of the early revolutionary years was being snuffed out. Mandelstam's powerful face, grim, exhausted, defiant, stands for a generation whose creativity was peerless, and by that very fact a threat that had to be crushed.

And we have some of the thinking behind the destruction here too: the Hints on Upbringing to be placed in the reception rooms of crèches, a real mixture of generous good sense ("Be careful of any trifle which a child considers a toy, even though it may only be a piece of wood or a stone") with this miserable diktat: "Never tell a child about things he cannot see. (This means that fairy stories should not be told to children)". This, from the land of the Firebird, of Baba Yaga, of the hut on chicken legs!

Or this, from Nikolay Bukharin's *The ABC of Communism* in 1920: 'The salvation of the young mind and the freeing of it from the noxious reactionary beliefs of parents is one of the highest aims of the proletarian government.'

Or the criticism by the psychologist Lev Vygotsky (1896-1934) of the immensely popular writer of verse for children, Kornei Chukovsky: "Chukovsky seems to proceed from the assumption that the sillier something is, the more understandable and the more entertaining it is for the child, and the more likely that it will be within the child's grasp. It is not hard to instil the taste for such dull literature in children, though there can be little doubt that it has a negative impact on the educational process ... In his babbling verse Chukovsky piles up nonsense on top of gibberish. Such literature only fosters silliness and foolishness in children."

There is always a voice ready to say things like that, and sometimes a fist, a rifle, or a prison cell ready to back it up.

But for a few years Russian children's books were free of the darkness that descended over the Soviet Union, and the light they shed, a lovely primary-coloured geometrical wonderland-light sparkling with every conceivable kind of wit and brilliance and fantasy and fun, is here in this book still. As I began by saying, what a treasury. And it ends with the most appropriate sign of all: a gigantic

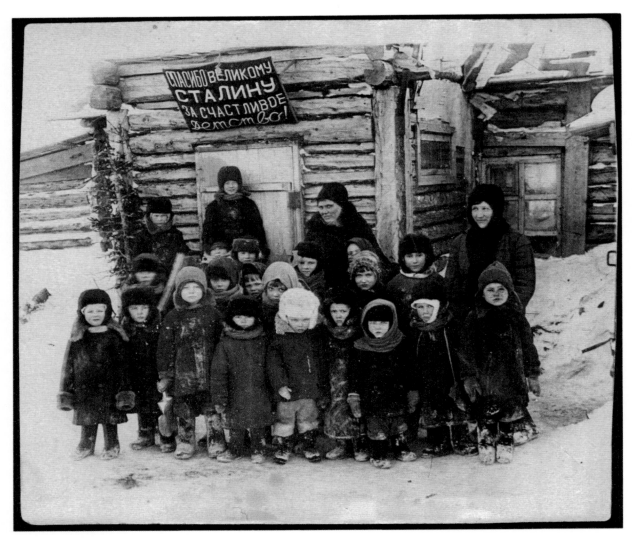

Kindergarten in Norilsk, c.1935. From the family archive of Olga Kabanova, whose father Igor Kabanov is in the upper row, under the poster 'Thank you great Stalin for the happy childhood!'.

INSIDE THE RAINBOW really is a gorgeous album, perfectly composed and impeccably accessible; each page strikes the eye faultlessly and precisely. Small wonder, given its splendid subject matter: Soviet children's book design of the 1920s and 1930s is the acme of all design before and after. For if we see design as a "strategic approach for someone to achieve a unique expectation" (and that is how it is commonly viewed), then Soviet children's books are exemplars of perfect design, books in which an absolute balance between message and image has been found. The covers of *Wallpaper* magazine simply pale into nothingness when compared to any run-of-the-mill page from *Five-Year Plan* or *The Children's International*. Every irregularity and error, each defect of the cheap printing and paper become virtues. They reach right into the viewer's soul, bringing bliss to the discerning eye, akin to the enjoyment derived by a gourmet from lunch at a tavern serving dishes made from local produce and served in a simple clay pot on a wooden table unadorned with any sort of tablecloth, and thus positively breathing authenticity.

What a terrific exhibition these books would make! I can just imagine the opening in London. The crème de la crème of the design, lifestyle, travel, entertainment, fashion and media worlds have gathered for the event. Their faces reflect the ethnic diversity of the contempoaray intellectual scene, but they are all Londoners, and so black dominates their attire, as at a Sicilian mafioso's funeral, albeit with judicious infusions of colour, and two or three corduroy jackets worn over red sweaters: "Charming", "excellent" and even "unbelievable" are among the remarks we overhear: everyone is delighted. The backdrop rising above this gathering of aesthetes is a page from the booklet *How the Capitalists Are Armed*, featuring two elegant figures of monsters sporting gas masks. All of it is fascinating and marvellous – but what does it have to do with children?

Is this what the cultured and not-so-cultured commissars in leather jackets (someone in the crowd at the imaginary exhibition opening is wearing such a jacket) had in mind when, revolvers raised to the sky, they led the crowds of the dispossessed and downtrodden to storm the Winter Palace in Petersburg, where the Provisional Government, a pack of helpless bourgeois wiseacres, sat paralysed with fear? Is this what they had in mind when later, after seizing the Winter Palace and experiencing the hunger, cold and fear of the Civil War, they herded the same crowds into building a new world in the name of happiness on earth, to the words of the Russian Socialist Republic's (and, later, the Soviet Union's) first anthem, a slightly reworked version of The Internationale, to wit:

> We will destroy this world of violence
> Down to the foundations, and then
> We will build our new world

> … ?

Children's books were, after all, a vital part of the new world that was to have been erected on the ruins of the old world, the world of violence. The new world was so close, so attainable. It was still in the future, certainly, but not in the distant future. The third millennium was to have been marked by the completion of the building of the new world, whose first stone had been laid in Petrograd in October 1917, when the cultured and not-so-cultured commissars

with the revolvers had taken power on behalf of all the dispossessed and downtrodden on earth, in the name of their happiness. Having seized power and destroyed everything, down to the foundations, they had to build.

Build what? The future.

The present, on the contrary – terrible, dark, hungry, dirty and literally lousy, as Petrograd was in 1917 – was seen as raw material for the construction of a beautiful, radiant, sated, clean future, overflowing with butterflies. The first step, the destruction of the old world, had been taken, and all that remained was to make the dream a reality. It seemed back then that around about 2013 communism would triumph and the whole earth would be filled with happiness and abundance. For the sake of the joyous rainbow glow surrounding the dream of the new world, in order to make the dream a reality, people could and must struggle, suffer and endure hardship. And what is the result? A hip art show in a world still filled with violence.

Already in the twentieth century it was apparent that nothing would come of this dream of a new world: everything was mutating into grey and mediocre socialism. The dispossessed and downtrodden masses were as destitute and oppressed as ever, while the commissars, shedding their romantic leather jackets and revolvers, had morphed into Party bureaucrats in properly grey suits whose main aspiration was to skedaddle abroad on a business trip and kick up their heels to their heart's content in the old world, the world of violence. And then it all came crashing down, and now we view this broken and mangled dream as a cultural phenomenon. We fish out bits and pieces from it and savour their aesthetic qualities without giving a damn about the ideas behind them, for time is as ruthless as our crowd of hardcore aesthetes at that imaginary gallery.

…and in any case, do we think much about the death of the idea that gave rise to the Kingdom of Egypt when visiting an exhibition of ancient Egyptian art? …

No, to be honest, we couldn't care less that millions of Egyptians died constructing the pyramids, died in order to exalt the idea of the kingdom, embodied in the figure of pharaoh, when the eventual outcome is that there are no longer any Egyptian pharaohs or a KIngdom of Egypt, only the Arab Republic of Egypt.

That is how history works.

It is the same way with Soviet children's books. They were a great occurrence in the history of the art, of course, and like every occurrence in art, they are phenomenal, just like – well, the murals in Akhenaton's palace in Akhetaten, his new capital. Isolating the phenomenon's purely aesthetic significance and consigning everything associated with ideas to historians and other specialists (let them muck about and defend their dissertations, turning ideas into ideology and climbing the career ladder in the process), the public savours aesthetic value much as it does a freshly caught cuttlefish (to return to my tavern metaphor). But here I want to draw attention to the fact that the ultimate significance of every phenomenon, whether Akhenaton's murals, Soviet children's books or fresh cuttlefish, is not determined by the way it is served or even cooked – in this case, meaning the way the material is skilfully presented – but by the natural and innate qualities of the product itself. In Akhenaton's case, this was the idea of a single solar deity. In our particular case, that of Soviet children's books, it is the ideological fervour for the radiant future that led to their creation.

What is the incarnation of the future? Childhood. Children embody the future in the present. Adults, incarnations of the present, have no future; all they have to look forward to is death, eternity and the afterlife. Now, however, the new world had abolished the afterlife, replacing the soul's immortality with the immortality of the dream of a new

world. Adults can only build the future, build it for their children, and their children's children, and their children's children's children. In order that children would mesh with the radiant future being built for them, they themselves had to be rebuilt; they could not be the same children who were born before the great moment when the old world was destroyed. This destruction was the cornerstone on which the new world would be based, the new world for whose sake one would have no regrets about sacrificing one's present – one's own life, and other people's lives in the bargain. Children had to be not merely new – children are, generally speaking, always new – but radically new. They had to be quite different from the children in the old world of violence, and thus the education of children was the most vital affair in the new Land of the Soviets. Books play a quite important role in children's education.

But what did we find in the old world of violence? Nothing to write home about. Folk tales, with their celebration of princesses and princes, and Ivan the Fool, who aspired to be a prince. Worst of all was the contemporary children's literature that had come to replace folk tales. This was a product of the universal bourgeois humanism in which Dickens had made his mark, but in its mass-produced version this humanism had devolved into a torrent of sweetly sentimental entertaining trash. In Russia, writer Lidia Charskaya was the embodiment of such dreck for kids. In the early decades of the last century she held real sway over the minds of schoolgirls and schoolboys, and a huge number of novels about good little sensitive princesses and ordinary girls – ugly ducklings who dream of becoming princesses – flooded the literary market. The illustrations in these books were par for the course: girls in lace pantaloons, long-tressed lads in jabots – Little Lord Fauntleroy and all that nonsense. They defined the Imaginationland of Russian children prior to the Revolution, and this old Imaginationland thus had to be destroyed along with the world of violence.

All the princesses and lords were to be swept out of the minds of Soviet children with a red broom. The "dreamer in the Kremlin" (as the more innocuous English fantasy writer H.G. Wells had dubbed Russia's main fantasy writer and ideologue of the new world, Vladimir Lenin) was keenly aware of the importance of this task, so much so that he entrusted his own wife, Nadezhda Krupskaya, a dull-witted but diligent woman, with its implementation.

While he was at it, he committed a crime that illustrated what was to be done with all of Charskaya's princesses: in the wee hours of 17 July 1918, he had all the Grand Duchesses, the Tsar's daughters, shot in Yekaterinburg along with Russia's own Little Lord Fauntleroy, Tsarevich Alexei.

In the light of the new government's concern with childhood (i.e. the future), the crime was remarkable: the old world's version of childhood had been finished off, and the pre-Revolutionary Imaginationland's main characters physically exterminated. It also put an end to the universal and suprasocial bourgeois humanism so decried by Soviet ideologues in the work of Dickens, for the new world required a humanism that was class-based and thus selective.

Shooting the children of the ruling class is a cruel deed, but one in line with biblical and even evangelical tradition: if you don't massacre the innocents, eternal bliss will never come (was the Kremlin dreamer aware of this?) Hence, after massacring the innocents and putting paid to the old Imaginationland, the Kremlin set to work building a new Imaginationland under the direction of Krupskaya, a flabby, sick and worthless woman with no claim to fame other than her status as the Kremlin dreamer's wife, but who, thanks to a college education, did have a cultural background. Besides Krupskaya and other wives of the new leadership, the country's best creative forces – artists, writers and poets – were recruited to the cause. This group included both those who sincerely believed in the advent of the new world and those who had been formed by the old pre-Revolutionary world, but had so far found no way to apply their talents and powers within the new project of building socialism.

It was their efforts that created the Soviet children's books of the 1920s, a phenomenon that combined both ideological and artistic renewal. The population of the new Imaginationland was updated: Young Pioneers populated territory once inhabited by the executed princesses and lords. The artistic idiom, both verbal and visual, was also updated: the revolutionary avant-garde swept away all the lace pantaloons and jabots, and the language became simpler, brighter, sharper, cleaner. There has never been anything like Soviet children's books anywhere in the world nor could there have been.

Created by talented artists and writers, the Soviet Imaginationland of the 'twenties was actually as speculative and abstract as the idea of communism. This decade, which began in America as the Roaring Twenties and was given various nicknames in Europe (e.g., the Golden Twenties, Die Goldene Zwanziger, les années folles), commenced in Russia with NEP, the New Economic Policy, which meant an easing of the dictatorship of the proletariat's power and a certain recognition of the value of the present, without, however, rescinding the value of the future, of the new world. The 1920s in Russia, the NEP period, were also, to some extent, a golden decade, a last gasp of freedom. This was stylistically expressed in a very peculiar Soviet version of art deco that absorbed all the avant-garde's revolutionary achievements and tried to adapt the avant-garde for widespread use. The Soviet Imaginationland was likewise fashioned in keeping with these requirements to accommodate the avant-garde to everyday life. The result was brilliant: the radiance of the Golden Twenties, so palpable in post-Revolutionary Russian constructivism, imparted its golden glow to Soviet children's books as well.

But even as I sincerely admire Soviet children's books, their aesthetic qualities, one fact comes to mind. During Russia's Golden Twenties, revolution and civil war left the country with between 4.5 million and 7 million *bezprizorniki*, that is, children who were not only bereft of parents, but who had never known either family or home. In English, *bezprizorniki* is rendered as "street children," but this translation fails to convey the specifically Russian problem of "neglected children"—the result of the mass executions, artificially induced hunger, arrests and forced relocations carried out in the name of the future. Given that Russia's dwindling population in those years numbered somewhere around 120 million people, this means that almost every third child in the country was homeless. The problem was obvious, so by way of complementing the Children's Friend Society, chaired by Krupskaya, a Central Committee Children's Commission was established. It was headed by Felix Dzerzhinsky, who was already busy carrying out the Red Terror declared by the Soviet government after a failed assassination attempt on Lenin.

"Street children," remarks one expert on the subject, "have an incredibly strong survival instinct, the ability to survive in extreme conditions. They are hyperexcitable and show a penchant for artificial stimulants (drugs and alcohol). Street children exhibit a heightened sense of justice and compassion, but they are prone to violence and begin having sex at a premature age. They are practically illiterate, but express their emotions vividly and sincerely. They display endurance, energy and solidarity during group activities. Hallmarks of homelessness include the absence of a family and its replacement with an informal community; living in places not intended for human habitation; subordination to the laws adopted by the informal community; and earning a living by criminal means." Seven million street children are a mighty force and an enormous disaster. Those seven million children remained outside the new world and the new Imaginationland.

Do we have the right to blame its creators for this? When we gaze at the pyramids, after all, we do not necessarily ponder the millions who perished from inhumane working conditions. There is, however, something in the majesty of the pyramids that makes you think about the mightiness of power's dictates, something manifested in the scale of other architectural marvels—gladiatorial circuses, castles and prisons, as well as Palaces of Congresses and concentration camps. The clean, sharp, quite precise language and design of Soviet children's books also exhibit features testifying to the presence of a dictatorship. It is in just this way, defining precisely what is good and what is bad, that a dictatorship must talk with children.

The Soviet Imaginationland was purged of all sentimentality and, along with it, the notorious universal humanism we have already mentioned, for a new hero had emerged, the Ordinary Worker (variously dubbed the Chemist, the Janitor, the Chimneysweep, etc.), and he replaced all the Ivanushkas and Alyonushkas. Grown-up intellectuals - the audience at our imaginary show of Soviet children's book art, for example - like this sort of thing, but I must honestly confess that no fully-fledged humanist heroes, the equivalents of Hansel and Gretel, Kai and Gerda, Ivanushka and Alyonushka or at least, in a pinch, Peter Pan, emerged in the Soviet Imaginationland.

Most of those millions of Soviet homeless children died from disease, hunger and violence, or they ended up in camps and prisons. The decree issued on 31 May 1935, by the Council of People's Commissars and the Communist Party Central Committee ("On the elimination of homelessness and neglect amongst children") was thus able to declare that "mass homelessness has been eradicated in the country." If we consider that around 500,000 children were raised in orphanages in the 1920s and 1930s, the way homelessness was eradicated becomes clear. The campaign coincided with an overall tendency set in motion by the 16th Party Congress, held in 1930, which had formulated a program for the full-scale implementation of socialism. 1935 was also the year when the latest book in this album was published: Samuil Marshak's wonderful *Babies of the Zoo,* illustrated by Yevgeny Charushin. In Charushin's little animals we sense a rejection of the avant-garde's supreme simplicity and a return to the sweet bourgeois sentimentality that, in fact, suffused the new "socialist realism" the Party prescribed in art. In accordance with this requirement, all the arts, including children's books, were purged of formalism. For many artists and writers, this meant a publishing ban and, in some cases, physical elimination. So when I come across these charming little animals from the 'thirties, I feel the way Kurt Russell must have done in *South Park* ("Imaginationland Episode II"). After being dispatched to Imaginationland with a group of soldiers, he encounters the talking "woodland Christmas critters" conceived by Eric Cartman in a previous season:

Why, it's a whole bunch of woodland critters! There's a talking bear and a beaver. […] *Oh, the cute little bear's eyes are starting to glow red now.* […] *They're raping me!! They're raping me!! Oh, it hurts!! They're raping all of us and it hurts!!*

Translated by Thomas Campbell

Цѣна 2 фр. 50 с.

Цена 35 коп.

Главлит А-5637. Д. 20. Гиз № 23907. Зак. 3317. Тир. 10.000 экз.
1-я Образцовая тип.-лит. Госиздата. Москва, Пятницкая, 71.

Цена 35 коп.

ИЗДАТЕЛЬСТВО

ЛЕНИНГРАД
71 внутри 72
ГОСТИННОГО ДВОРА
ТЕЛ. 58-32. 483-18

МОСКВА
ПЕТРОВКА 20
ТЕЛЕФ. 4-90-76

РАБОТА НА КАМНЯХ
П. СОКОЛОВА

Л. ПОПОВА

15 коп.

Главлит № А-20044. Гиз 25267. Зак. 843. Тир. 20.000

1-я Образцовая типо-лит. Госиздата. Москва, Пятницкая, 71.

1928

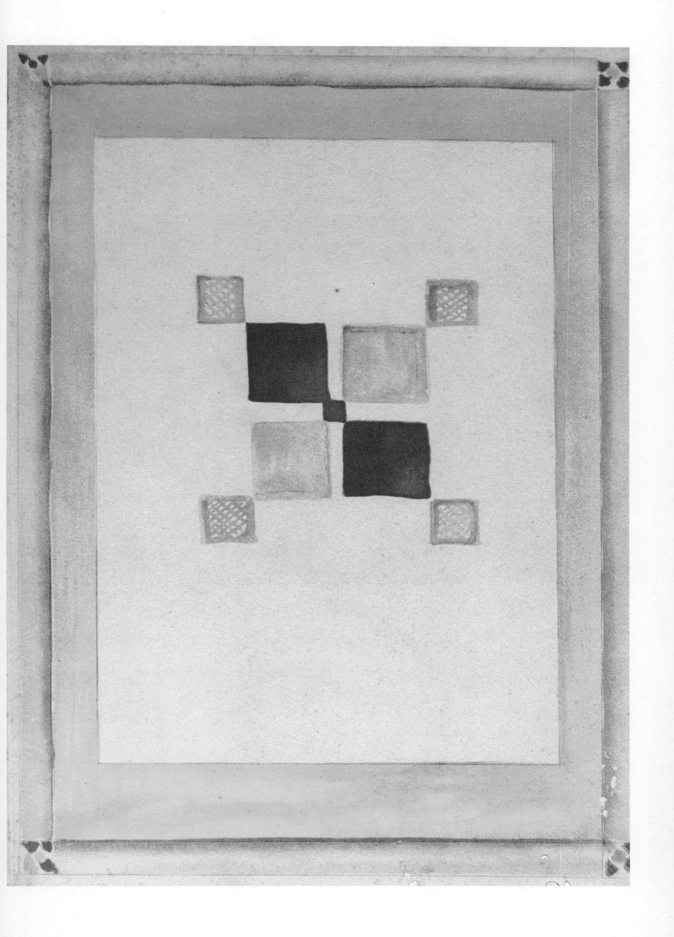

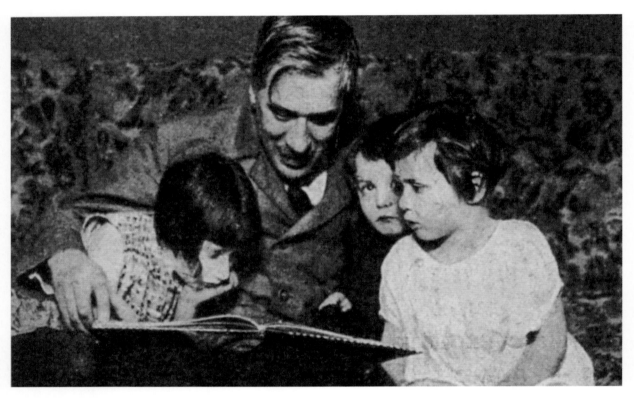

Kornei Chukovsky reading to children, c. 1932

All children's literature has one thing in common: it is written by grown-ups. And all grown-ups have ulterior motives: they have long grasped that shaping the minds of future generations is too important to be left to chance. Children's literature has always been a tug-of-war between entertainment and instruction, character formation and fun. The attitude of the Bolsheviks was no exception: they believed a Marxist-shaped world required children moulded by a Marxist world-view. Out with the old and in with the new – but what was the new to be? Where was it going to come from? The answer was unexpected. In fact, the new children's literature had already arrived.

About a year before Lenin stepped off the train at the Finland Station in Petrograd with his call for revolution, another traveller with a softer voice and more compromising disposition had also travelled to Petrograd by rail. The journalist and literary critic Kornei Chukovsky was thirty-four. He had a philologist's interest in the language of children and his two years as a journalist in London had left him with a lifelong admiration for England, and especially for English nonsense verse. For Chukovsky, the great Victorian English writers had added a new dimension to children's literature – the absurd. This was another revolutionary idea heading in Russia's direction.

Alongside Chukovsky in his railway compartment was his small son Kolya who was feeling unwell. To cheer the boy up his father spun a rhyme to the click-click-click sound of the train wheels. For Russian children's literature this was an *Alice in Wonderland* moment. The tale about a cigar-smoking, German-speaking crocodile became a Russian classic. Verse after verse described how this horrible creature exhaling smoke, walking and talking just like a human being, strolled down Nevsky Prospect swallowing up the inhabitants before being finally halted by the courageous efforts of a brave young boy. On the train from Switzerland Lenin wrote his famous *April Theses* – the manifesto of the Bolshevik Revolution. On *his* train, Chukovsky had drawn up the manifesto of the Golden Age of Russian children's literature.

'Let me teach a child for four years and the seed I'd have sown could never be destroyed,' said Lenin soon after the revolution. In February 1918, a *Pravda* article *The Forgotten Weapon* fired the first shot in the battle for little hearts and minds:

'In the great arsenal used by the bourgeoisie to fight against Socialism, children's books occupied a prominent role. In choosing our cannons and weapons, we have overlooked those that spread poison. We must seize this ammunition from the enemy hands.'

The response to this command exceeded all expectations.

There were a hundred publishers of children's books in Russia in the 1920s. One of them, called *Raduga* (Rainbow), with Chukovsky as one of its founding fathers, published exclusively for children. It was from here that the first children's books of the Golden Age emerged in 1922. By coincidence, there was another poet at *Raduga*, also touched by the spirit of England. Samuil Marshak, a young poet from a provincial Jewish background had risen by his own effort and with generous help from Russia's literary colossus, Maxim Gorky. Like Chukovsky, Marshak had been in England before the First World War where he'd translated the poetry of Blake, Wordsworth and Burns and discovered the classics of English children's writing. Like Chukovsky, he too had a professional interest in children since his work in an eccentric 'Simple Life' school in Surrey.

It is a fairy-tale miracle that the Bolsheviks' programme of re-ordering the world of childhood should have fallen into the hands of these two caring Anglophiles. Chukovsky and Marshak were to become the guiding spirits of the Golden Age and would continue to produce Russia's best-loved poems for children for the next half a century.

But they were not alone. In the 1920s Russia's finest writers from the pre-revolutionary era were out in the cold. Unable to find publishers, without means of support, and in fear of arrest, they were happy to find shelter in *Raduga*.

This was a unique pool of talent and not only established writers took part in the enterprise. Other professionals such as the actor Evgeny Shwarts, the zoologist and hunter Vitaly Bianki, the engineer Michail Ilyin and traveller Boris Zhitkov were also taught by Marshak how to write for children and soon became stars in their own right. They would be joined later by the absurdist writers of the OBERIU group inspired by Alexander Vvedensky and Daniil Kharms – wild men of literature with a reputation for literary hooliganism. Marshak's approach - as proclaimed at *Raduga* and later at the children's department of GIZ, the state publishing house - was that great children's literature is born only at the meeting of high literary tradition and the new reality.

It could only have happened in the extraordinary conditions of the time. 'Marshak's Academy' was a one off; a group of talented individuals turned into an artists' collective, all dedicated to the creation of a 'new big literature for little ones'. They'd said goodbye to pretty Art Nouveau; farewell to the princes and princesses, to cosy vistas of enchanted forests and cool streams. In place of gossamer: geometry. In place of magic: locomotion. In place of sorcery: engineering. Instead of nostagia for the past: the five-year plans for the future. Of course, they had to stay within the boundaries of ideological correctness.

It was different with the illustrators. The revolution in Russian art preceded the Russian Revolution by several years. Indeed, there were some amongst the Suprematists and Futurists who dared say that it was they and not the Bolsheviks who were the true guardians of the revolutionary flame. The Russian avant-garde artists had decorated the Bolshevik road to power with posters and artwork whose genius

is still cherished by collectors and curators. Who better then, in the early 1920s, when the common purpose of the revolution was still largely unquestioned, than these artists to refurbish the minds of Little Comrades with the required iconography of a Marxist millennium?

At that time 'The King of Children's Books' was artist Vladimir Lebedev, who came from the heart of the avant-garde. He was a cubist once and during the revolution he designed Agitprop posters with Mayakovsky that were considered so radical that in 1919 the British government refused him a visa on the grounds that he was 'a dangerous satirist'. From his earliest days at *Raduga*, Lebedev was the collaborator of Samuil Marshak - they created almost 40 children's books together. In 1925 when he became the art editor at GIZ, there soon was a 'Lebedev school' of illustrators running parallel to 'Marshak's Academy' of writers.

Lebedev's style, a synthesis of suprematism and constructivism, combined flat abstraction with brilliant drawing of characters with 'vivid funniness'. But although Lebedev was the boss, his was far from being the house style. Yes, he brought in the modernists – Vladimir Tatlin, Alexander Samokhvalov, Nikolay Radlov, Eduard Krimmer, Alisa Poret, Tatiana Glebova, Pavel Kondratiev, Vladimir Tambi and many others. But hand in hand with them worked the artists of the pre-revolutionary 'World of Art' circle - Vladimir Konashevich, Dmitry Mitrokhin, Mstislav Dobujinsky, Sergey Chekhonin, Juri Annenkov and Boris Kustodiev.

All this seemed fine – until the day the Party began to understand that perhaps it didn't have all that much in common with these intellectuals and artists after all. And then it wasn't fine.

'Only in Russia poetry is respected' - Osip Mandelstam used to say, foreseeing his own fate – 'it gets people killed. Is there anywhere else where poetry is so common a motive for murder?'

In 1930, when a state monopoly on publishing was finally established, *Raduga* was shut down. In 1931 Daniil Kharms and Alexander Vvedensky were arrested 'for connection with the terrorist group of Marshak'. In later years they would be followed by Vera Yermolaeva, Nikolai Zabolotsky, Nikolai Oleinikov, Gustav Klucis, Boris Zhitkov, Osip Mandelstam and many others, most of whom did not survive. Marshak was lucky: it is said that Stalin himself took him off a blacklist of those slated for arrest. 'He's a good children's poet,' Stalin said as he crossed out his name.

In a different age, many years later, Marshak wrote to Chukovsky: 'We both could have perished. The children saved us.'

The wonderful work in this book celebrates the Golden Age of Russian children's literature: it was a moment - just a moment - when we could all still believe that if we wished and worked hard enough the real world could become like the illustrated world of our storybooks.

1

LITTLE COMRADES

NO-ONE KNOWS what huge suns will illuminate the life of the future. It may be that artists will transform the grey dust of the cities into hundred-coloured rainbows; that the never-ending thunderous music of volcanoes will be turned into the sound of flutes resounding from mountain ranges; that ocean waves will be forced to play on nets of chords stretching from Europe to America.

Vladimir Mayakovsky, *Open Letter to the Workers*, 1918

THE SALVATION OF THE YOUNG MIND and the freeing of it from the noxious reactionary beliefs of their parents is one of the highest aims of the proletarian government.

Nikolay Bukharin, *The ABC of Communism*, 1920

FOR THE OCTOBER REVOLUTION our class produced a small play in which a group of young Pioneers expelled the heroes of Russian fairy tales as "non-Soviet elements". The curtain opened on this drab little group of Pioneers. Their appearance brought no response from the audience. Then the group leader, a girl called Zoya Mechova, got up and made an introductory speech. She explained that the old fairy tales, about princes and princesses, exploiters of simple folk, were unfit for Soviet children. As for fairies and Father Frost, they were simply myths created to fool children.

After her speech the colourful crowd of "non-Soviet elements" appeared on stage. A sigh of delight passed through the hall and grew into a wave of applause...

The Trial began. Cinderella was dragged before the judges and accused of betraying the working class. . . Next came Father Frost, who was accused of climbing down chimneys to spy on people. One by one we were condemned to exile. The only exception was Ivan the Fool, because he belonged to the common people and so was no traitor of his class. He was renamed Ivan the Cunning.

To the great disappointment of the audience, we were led away... Zoya Mechova made her summing up speech, but nobody heard it. The children in the audience began to cry. "Bring them back! Bring them back! Don't shoot them!" The uproar was deafening.

Svetlana Gouzenko, *Before Igor: My Memories of a Soviet Youth*, 1961

El Lissitzky, illustrations from *The Four Arithmetic Operations*, 1928

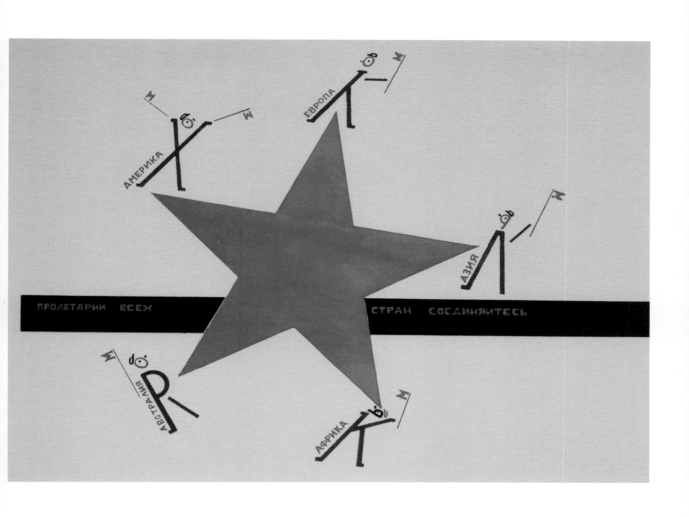

Georgy Echeistov, cover for *The Children's International* by Yuri Gralitsa, 1926

A. Laptev, cover for *May* by Agnia Barto, 1932

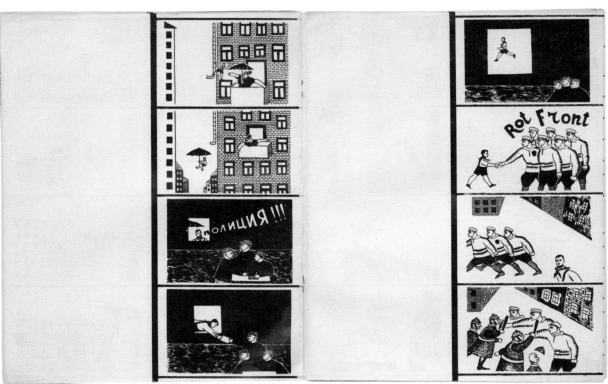

Isaak Eberil, illustrations for *A Cinema Book about Hans Who Saved the Strike Committee* by F. Kobrinets, 1931

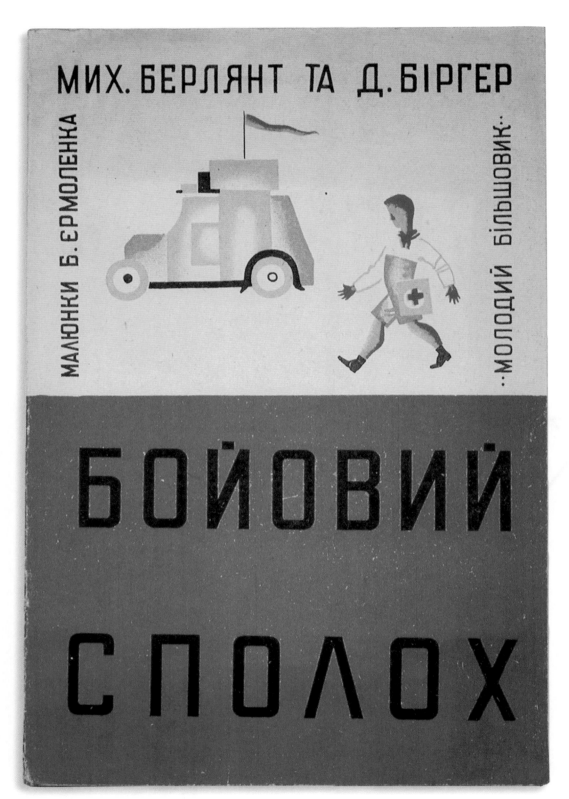

МИХ. БЕРЛЯНТ ТА Д. БІРГЕР

МАЛЮНКИ Б. ЕРМОЛЕНКА

..МОЛОДИЙ БІЛЬШОВИК..

БОЙОВИЙ СПОЛОХ

Georgy Echeistov, cover and illustrations for *The Children's International* by Yuri Gralitsa, 1926

А в місті атака,
гудуть панцирники,
кулемети такають.
ідуть полки.
Місто боронять
червоні войки.

Міцно озброєні
вдягнені в хакі,
кожний у протигазній
масці
і з зіркою червоною
на касці.

Дзвінко лунають
гудючі дзвони,
дим розливається
в садках по газонах.
Це зветься
отруєна зона.
Ватажок біжить
і свистить, свистить:
— Гей, несіть того
вапна білого.

Швидко йдуть,
нап'явши протигази,
піонери-дегазаторн
боротися з газом.
Вапно розсипають,
гасять фугас.
Вітер розвіває,
роздмухує газ.
Оточили площу,
зайняли шляхи.
Димом полоще
чорний небосхил.

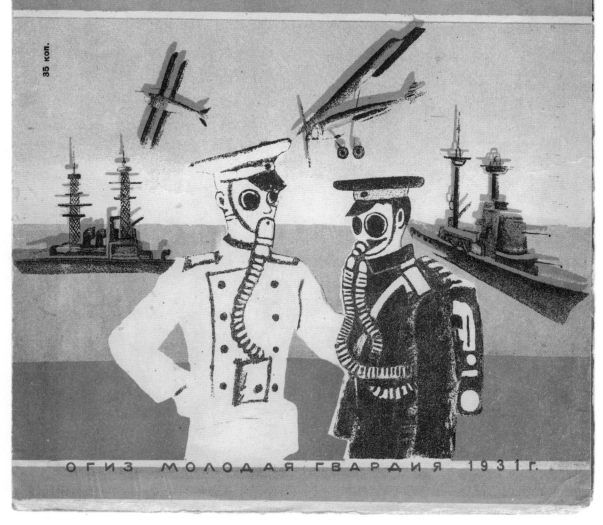

Unknown illustrator, cover and map for *How the Capitalists are Armed* by B. Zhukov, 1931

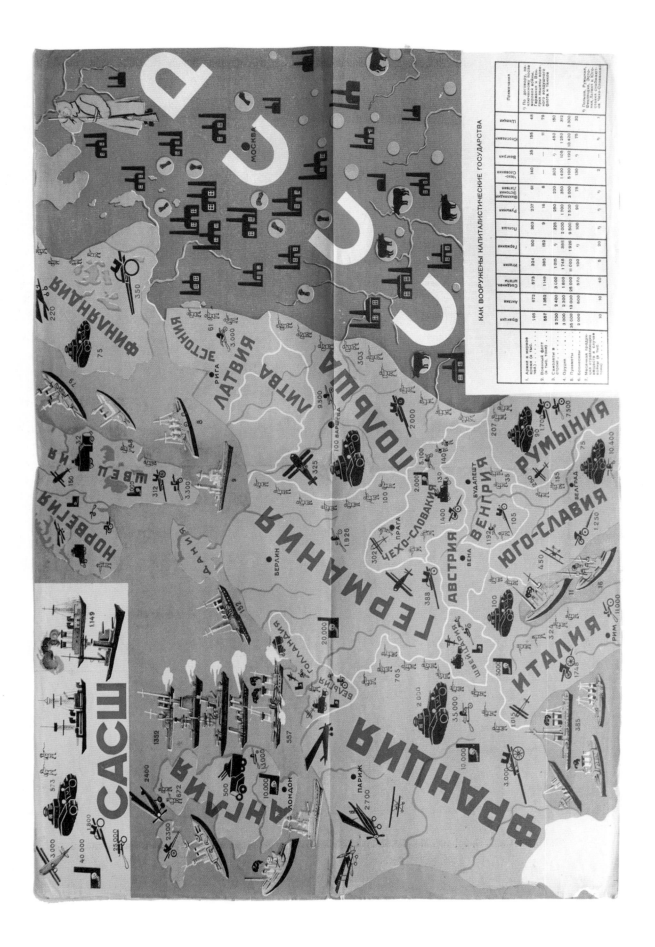

Vladimir Konashevich, illustrations for *Tale of the Military Secret* by Arkady Gaidar, 1933

ARKADY GAIDAR

TALE OF THE MILITARY SECRET

IN WHICH A LITTLE BOY KEEPS A BIG SECRET AND SAVES THE COMMUNIST MOTHERLAND

TRANSLATED BY ERIC KONKOL

"Tell us a story, Natka," a little blue-eyed girl asked and smiled guiltily. "A story?" Natka thought. "I don't know any stories. But . . . I could tell you Alka's story. May I?" she asked Alka, who suddenly pricked up his ears. "OK," he agreed, looking proudly at the little Octobrists, who had all fallen silent. "I'll tell Alka's story in my own words." said Natka. "If I forget something or make a mistake, he'll correct me. So now, listen:

"In those long-ago years, just after the thunder of war had fallen silent throughout the country, there lived a little boy. At that time, the White forces of the accursed bourgeoisie had been driven far away by the Red Army. It was quiet in the broad fields and green meadows where the rye was growing and the buckwheat ripening. There, amid lush cherry bushes, stood a little house in which lived a little boy – nicknamed Kibalchish – with his father and older brother. They didn't have a mother.

"The father worked mowing hay. The brother drove the hay wagon. And even the little boy worked sometimes, helping his father or his brother. Or he simply jumped up and played with other little boys. It was a good time. There were no bullets whizzing by, no shells exploding, no villages burning. You didn't have to lie on the floor to avoid bullets, or hide in the cellar to escape the exploding shells, or run into the forest away from the fires. There were no bourgeois to fear, there was no-one to bow down to. Just living and working – it was a good life.

"One day, as evening approached, the little boy Kibalchish stepped out onto the porch. He saw the clear sky, the breeze was warm, and the sun was setting behind the Black Mountains. All would have been well . . . except for one thing. The little boy could hear a sound like distant thunder or knocking. And he could smell on the wind not the scent of garden flowers or honey from the meadows, but smoke from fires or exploding gunpowder. He called to his father, who came outside, looking tired.

" 'What's the matter with you?' he asked the boy. 'That's just thunder the other side of the Black Mountains. And beyond the Blue River, shepherds are lighting their fires, watching their flocks and cooking their dinners. Go, boy, and sleep in peace.'

"The boy left. He lay down, but couldn't get to sleep. Suddenly he heard a clatter in the street and a knock at the window. The boy looked out and saw by the window a horseman. His horse was raven-black, his sword shone; he had a grey cap and a red star.

" 'Arise!' shouted the rider. 'Disaster has arrived from an unexpected quarter. The accursed bourgeoisie has attacked us from beyond the Black Mountains. Once again bullets are whistling and shells are exploding. Our forces are fighting the bourgeois, and messengers are racing to summon help from the distant Red Army.'

"The red-starred rider spoke these frightening words and then galloped off. The boy's father went to the wall, took down his rifle, shouldered his pack, and put on the ammunition belt.

" 'Well,' the father said to the older brother, 'I've planted a thick field of rye. There should be a good harvest for you.' And to Kibalchish he said, 'I've lived a full life, and my life has been good. I think, my boy, that you'll be fine.'

"And so saying, he kissed the boy and left. He didn't have time for long goodbyes: they could all hear explosions ringing out from beyond the meadows, and see the lights of smoking fires burning beyond the mountains, glowing like a breaking dawn.

"Am I telling it right?" asked Natka, looking out over the quiet children. "You are, Natka . . . you are," Alka answered quietly and laid his hand on her sunburnt shoulder.

"Well, one day passed. A second day passed. The boy came out onto the porch. No . . . still no sign of the Red Army. He climbed onto the roof. He stayed up there all day. Still no sign. At night he lay down to sleep. Suddenly he heard a clatter in the street and a knock at the window. The boy looked out. Standing by the window was the same rider as before. Only now the horse was thin and tired, the sabre bent and darkened, the cap shot through, the star torn, and the rider's head bandaged.

" 'Arise!' shouted the rider. 'At first we suffered only minor setbacks, but now disaster is all around. There are many bourgeois, but our numbers are small. The bullets fly in clouds, and shells explode in our ranks by the thousand. Come to our aid!'

"The older brother arose and said to the boy: 'Goodbye, little brother. You'll stay here alone. You have shchi in the pot, a cottage loaf on the table, water in the springs, and a head on our shoulders. Live as best you can, but don't wait for me.'

"One day passed, two days passed. The boy sat by the chimney on the roof and saw an unfamiliar rider approaching from the distance. The rider galloped up to the boy, leapt from his horse, and said: 'I beg you, dear boy, for some water. I've had nothing to drink for three days, no sleep for three nights, and I've worn out three horses. The Red Army has now been told of our misfortune. The buglers have sounded the alarm, the drummers have pounded loud on their drums. The standard bearers have unfurled all their battle flags. The entire Red Army is flying and galloping to our aid. If only, boy, we can hold out until tomorrow night!'

"The boy climbed down off the roof and brought some water. The messenger drank his fill and galloped off. Evening came, and the boy lay down to sleep. But he couldn't get to sleep. Suddenly, he heard footsteps in the street and a rustling by the window. The boy looked out of the window and saw the soldier once again. He was the same, yet not the same. He had no horse – his horse had fallen. He had no sabre – his sabre had been smashed. He had no cap – it had flown off. And he swayed unsteadily on his feet.

" 'Arise!' he shouted for the last time. 'We have shells, but the cannon are broken. We have rifles, but too few fighters. Help is near, but we lack strength. Arise, all those who are left! We just need to last through the night and hold out until daybreak!'

"The boy Kibalchish looked out onto the street. It was empty. No shutters flew open, no gates squeaked. There

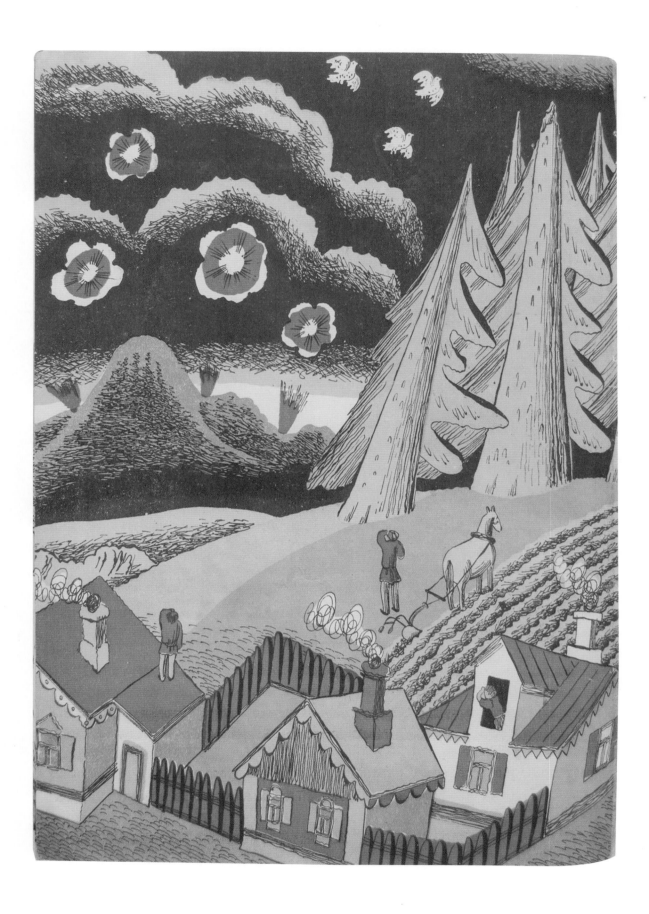

was no-one to arise. The fathers had all gone; the brothers had all gone. There was no-one left. All the boy saw emerging from a gate was a 100-year-old grandfather. The grandfather wanted to raise his rifle but he was so old he couldn't lift it. He wanted to strap on a sabre but he was so weak he couldn't buckle it on. The grandfather sat on a mound of earth, lowered his head and cried.

"Am I telling it right, Alka?" Natka asked as she took a breath and looked around. It was no longer just the Octobrists who were listening to the story. At some point (no-one knew quite when), the Pioneers from Ioskin's team had silently crept over. Even the Bashir girl, Eminey, who barely understood Russian, was sitting looking thoughtful and serious. And the mischievous Vladik, lying a little way off and giving the impression that he wasn't listening, was actually paying attention; you could tell because he was being quiet, not talking to anyone, not pestering anyone. "Yes, Natka, you are. Even better than right," Alka answered, moving still closer to her.

"Well . . . The old grandfather sat on the mound of earth, lowered his head, and cried. The boy felt very bad. Then the boy Kibalchish leapt out onto the street and shouted as loudly as he could: 'Hey, you kids! Are we children good only for playing and skipping? Our fathers have gone; our brothers have gone. Are we just going to sit and wait for the bourgeois to come and carry us off to their accursed bourgeois land?'

"As soon as the children heard these words, they began to shout at the tops of their voices! They came running into the street, climbing through windows and leaping over fences. They all wanted to help. Only the little boy Plokhish was keen to join the bourgeois. But this Plokhish was so sneaky that he didn't say anything to anyone. He pulled on his trousers and raced along with everyone else as if happy to help.

"The children fought on through the dark night and into the dawn. Only Plokhish did not fight. He was going around looking for a way to help the bourgeois. Behind a small hill, Plokhish found a pile of boxes, and hidden in these boxes were black bombs, white shells and yellow cartridges. 'Aha,' thought Plokhish, 'this is just what I need.'

"At that very moment, the Chief Bourgeois was asking his bourgeois forces: 'Well, bourgeois, have you claimed victory?' 'No, Chief Bourgeois,' the bourgeois forces answered. 'We crushed the fathers and brothers, and victory seemed to be ours. But then the boy Kibalchish rushed up to help, and we just couldn't defeat him.'

"The Chief Bourgeois was greatly surprised and grew very angry. He shouted in a terrible voice: 'How is it possible that you have failed to defeat a boy? You worthless, cowardly bourgeois! How is it possible that you are unable to destroy so insignificant a creature? Go quickly, and don't come back until you have won.'

"The bourgeois sat and wondered, 'What can we do?' Suddenly they saw the boy Plokhish as he clambered out of the bushes and made straight for them. 'Rejoice!' he shouted to them. 'I, Plokhish, did it all on my own! I cut wood, piled up hay and set fire to the boxes of black bombs, white shells and yellow cartridges. You'll hear them explode any moment now!'

"The bourgeois rejoiced and immediately enlisted the boy Plokhish in their bourgeois land. They gave him a whole barrel of jam and an entire basket of cookies. The boy Plokhish sat down, tucked in and was happy. Suddenly the burning boxes exploded! It was as if a thousand thunderclaps had sounded at the same time and a thousand bolts of lightning flashed from the same cloud.

" 'Treachery!' shouted the boy Kibalchish.

" 'Treachery!' shouted all the loyal children

"Out of the smoke and fire, the bourgeois forces swooped down. They surrounded and seized the boy Kibalchish.

They fettered him with strong chains. They locked him up in a stone tower. Then they hurried to ask the Chief Bourgeois what he wanted them to do with the captive boy. The Chief Bourgeois thought and thought for a long time, and then said: 'We shall kill this boy. But first let him tell us their Military Secret. Go bourgeois and ask him:

"How is it, boy, that forty tsars and forty kings fought and fought against the Red Army only to find themselves defeated?"

"Why, boy, with the jails and prison camps full, with police on the streets, with troops on the march, do we still have no peace either in the light of day or in the dark of the night?"

"Why, you damned boy, Kibalchish, do you think that in my Grand Bourgeois Land, in the Kingdom of the Plains, in the Snowy Tsardom, in the Hot Arid State, on the same day in early spring, on the same day in late autumn, the people sing, in different languages, the same songs, carry the same banners, give the same speeches, think the same and act the same?"

'Ask him, bourgeois:

"Boy, does the Red Army have some military secret?" And let him tell you that secret.

"Are our workers receiving foreign help?" And let him tell you from where that help is coming. "Boy, is there some secret way in which you are able to get into other countries from your own, a way which means that, when you call, some among us respond, when you begin singing, some of us take up the song, when you speak, some among us find they are having the same thoughts?"

"The bourgeois left but returned quickly, saying: 'No, Chief Bourgeois, the boy Kibalchish did not reveal the Military Secret to us. He laughed in our faces. He just said, "The Red Army has a great and powerful secret. And as you can never understand it, you will never achieve victory. There are untold numbers of reserves, and no matter how long you search for them, you will never have any peace, either in the light of day or in the dark of the night. There are deep-lying secret pathways. But no matter how long you search for them, you'll never find them. And even if you did find them, you could never fill them all in or block them or cover them over. I'll say nothing more to you, bourgeois. And accursed as you are, you will never guess the truth."

"The Chief Bourgeois frowned and said, 'Subject this secretive boy Kibalchish to the most horrible torment. Torture him until he reveals the Military Secret, because there will be no peace until we discover it."

The bourgeois left, and this time they did not return so quickly. When they did come back, they were shaking their heads. 'No, our leader Chief Bourgeois,' they said, 'The boy turned pale, but stood proud. He did not reveal the Military Secret to us, because he is so true to his resolve. And when we left, he lay down on the floor, pressed his ear to the hard, cold, stone floor and – whether you believe this or not, O, Chief Bourgeois – he smiled in such a way that we, the bourgeois, shivered and became frightened that perhaps he could hear evidence of our inescapable destruction moving along secret pathways.'

" 'It's not secret pathways. It's the galloping of the Red Army!' shouted the Octobrist Karasikov, unable to restrain himself. And he waved an imaginary sabre in the air so ferociously that even the girl who just recently – hopping on one leg – had fearlessly teased him as 'Krasik-rugasik', looked at him warily, and, just to be safe, moved a little further away."

Then Natka interrupted the story because, just at that moment, the lunch bell rang. "Finish the story!" ordered Alka in a commanding voice, looking at her with a hurt expression. "Finish the story!" pleaded the blushing Ioska winningly. "And then we'll get in line really quickly." Natka looked around. The children were not getting up. She saw their many

different heads – white-haired, dark-haired, chestnut, golden. Eyes were gazing at her from all sides – big brown ones like Alka's; clear, cornflower-blue ones like those of the girl who had asked her for the story; narrow, black ones like Eminey's. And many, many other eyes that were usually happy and mischievous, but were now thoughtful and serious. "All right, children, I'll finish the story."

" '. . . and we became frightened, Chief Bourgeois, that perhaps he could hear our inescapable destruction moving along secret pathways.' 'What kind of country is this?' exclaimed the surprised Chief Bourgeois. 'What kind of incomprehensible country is this where even little children know the Military Secret, and yet keep so firmly to their solemn word not to give it away. Make haste, bourgeois, and kill this proud boy. Load the cannons, ready your sabres, unfurl our bourgeois banners, because I hear our buglers sounding the alarm and our signallers waving their flags. It seems that this will not be an easy fight, but a fierce battle.'

"And the boy Kibalchish died," said Natka. Hearing these unexpected words, the Octobrist Karasinkov suddenly looked dismayed and sad, and stopped waving his arm in the air. The blue-eyed girl frowned, and the freckled face of Ioskin looked angry, as though he had just been deceived or insulted. The children stirred, exchanging whispers. Only Alka, who already knew how the story ended, sat quietly.

"Children – have you ever seen a storm?" asked Natka loudly, looking at the children who had all fallen silent. "It was just like a storm."

"The weapons crashed like thunder. Fiery explosions flashed like lightning. The cavalry detachments raced in like the wind. Have you ever seen the way rain pours down in a thunderstorm during a hot, dry summer? It was just like that – streams racing down a dusty mountainside, joining together to make one seething, bubbling flow. At the first sounds of war, uprisings boiled up in the bourgeois lands in the mountains, and were straight away taken up by thousand in the Kingdom of the Plains, the Snowy Tsardom and the Hot and Arid State.

"In great fear, the now-defeated Chief Bourgeois fled, loudly cursing this nation with its unpredictable people, its unconquerable army and its unguessable Military Secret.

"The boy Kibalchish was buried on a green hill by the Blue River. On his grave, a large red flag was planted.

Boats sail past – greetings to the Boy!
'Planes fly past – greetings to the Boy!
Trains race by – greetings to the Boy!
Pioneers march past – greetings to the Boy!

"And that, children, is the end of the story."

Цена 1 руб
Переплет 75 к.

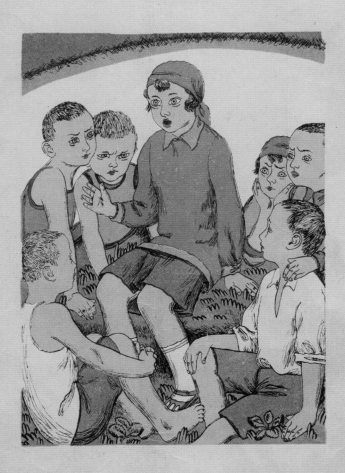

ДЛЯ ДЕТЕЙ МЛАДШЕГО ВОЗРАСТА

Редактор К. ПИСКУНОВ. Сдано в производство 20/II 1933 г.
Худ. редактор М. СЕРЕГИН. Подписано к печати 13/IV 1933 г.
Тех. редактор Н. ИСАЕВА. Ст. формат 94×120-¹/₁₆ д. 2¹/₂ п. л. 19500 п. зк. в 5 кр.

Уп. Главлита № Б-30007 М. Г. № 3590. Заказ № 1040 . Тираж 50000.
1-я Образцовая типография Огиза РСФСР треста „Полиграфкнига", Москва, Валовая, 28.

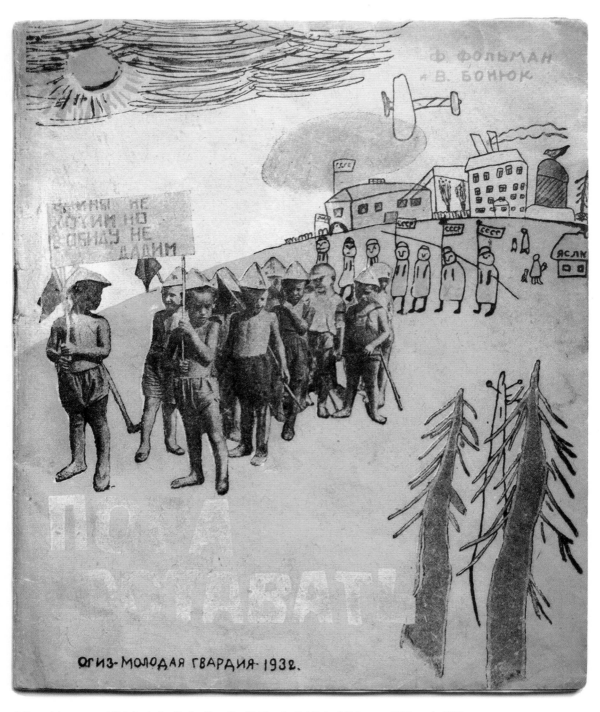

I. Tsarevich, cover and R. Apin photo-illustrations for *It's Time to Get Up* by F. Folman and V. Bonyuk, 1932

обложка И. Царевич
фото Р. Апин

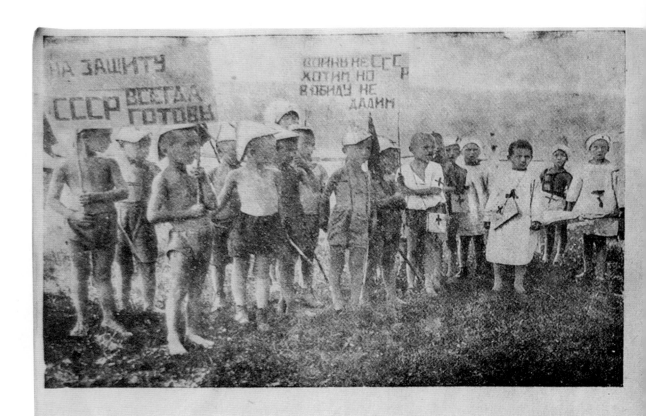

Тревога!

Мигом оставили работу, бросились в канцелярию, разобрали шлемы, ружья, барабан, и через две с половиной минуты **наш отряд стоит вполне готовый.**

На месте барабанщик, на месте санитары и знамя. А на знамени надпись: «Войны мы не хотим, но СССР в обиду не дадим».

Пионер сказал нам:

— **К защите СССР будь готов!**
— **Всегда готов!**

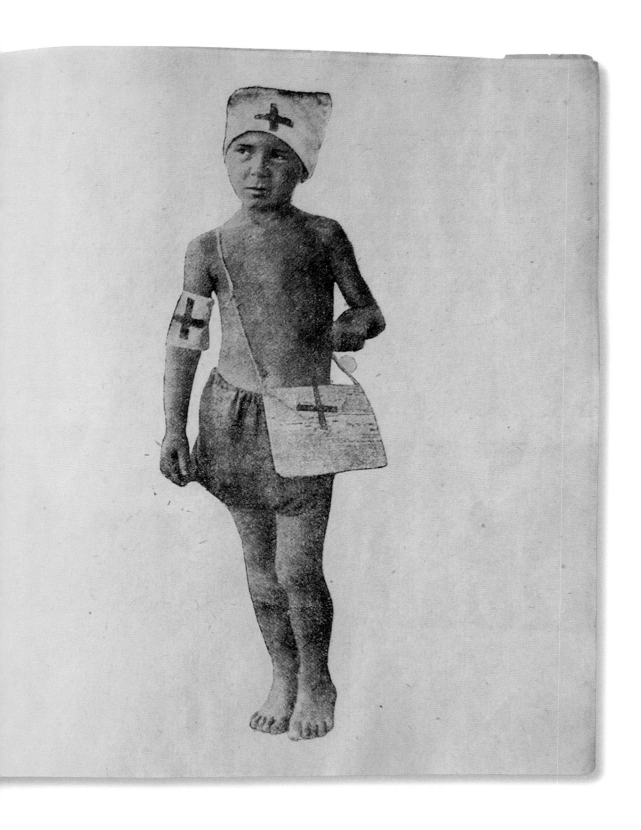

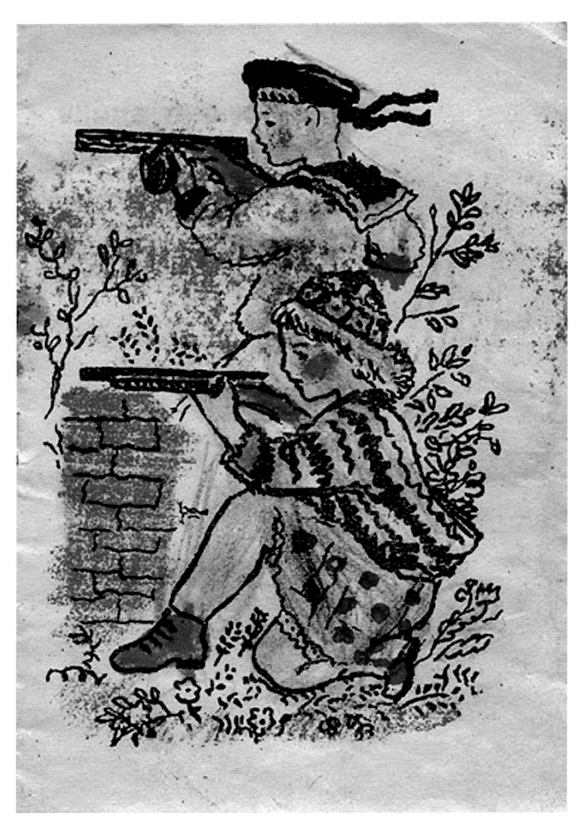

A. Yakobson, illustrations for *Let Us Take the New Rifles* by Vladimir Mayakovsky, 1927

И если двинет армии
страна моя,
мы будем
 санитарами
во всех боях.
 Ра-
 нят
 в ле-
 су,
 к сво-
 им
 сне-
 су.

4

Возьмем винтовки новые,
на штык флажки!
И с песнею
 в стрелковые
пойдем кружки.
 Раз,
 два!
 Все
 в ряд!
 Впе-
 ред,
 от-
 ряд!

1

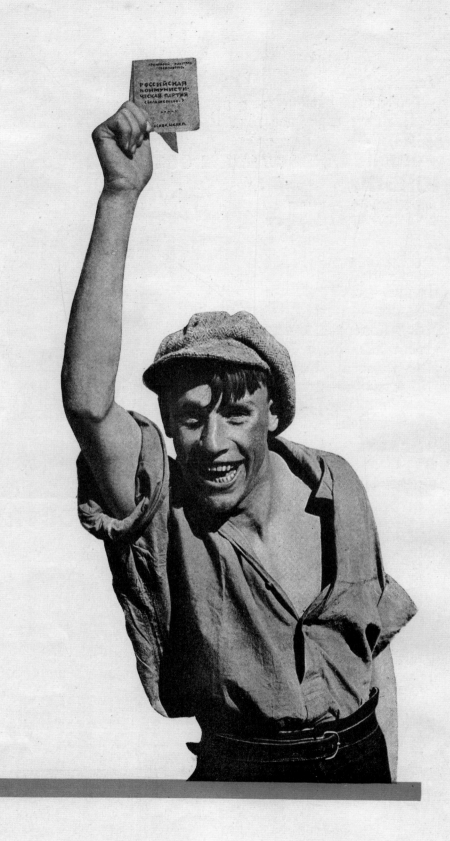

Alexei Pakhomov, illustration for *Camp* by Evgeny Shvarts, 1925

LEFT: Solomon Telingarter, photomontage for *Komsomolia* by Alexander Bezymensky, 1928

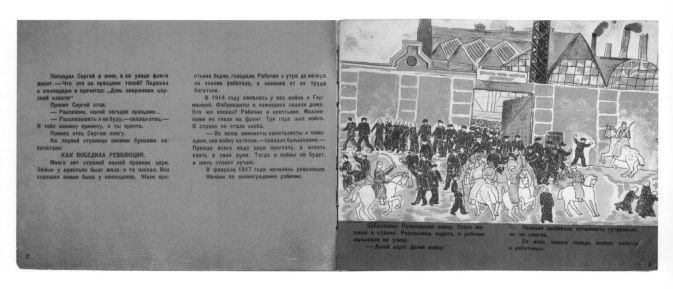

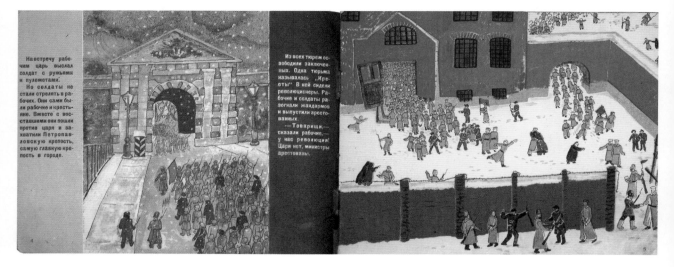

Alisa Poret, cover and illustrations for *How the Revolution Was Won* by Nikolai Zabolotsky, c. 1930

Ленин жил в это время за границей. В России ему жить было нельзя. Его искала полиция, чтоб засадить в тюрьму. Только через месяц ему удалось добраться до Ленинграда.

У вокзала Ильич взошел на броневик и сказал рабочим:

— Не бросайте оружие. Царя вы скинули, но остались капиталисты и помещики. Придется повоевать с ними.

Ильич был прав. Кто был в новом правительстве? Помещики и капиталисты. Они по-прежнему посылали рабочих и крестьян на войну, а землю и фабрики отдавать не хотели. По всей стране поднялись крестьяне. А в Ленинграде, у Таврического дворца, рабочие и солдаты устроили демонстрацию и потребовали:

— Власть — советам!

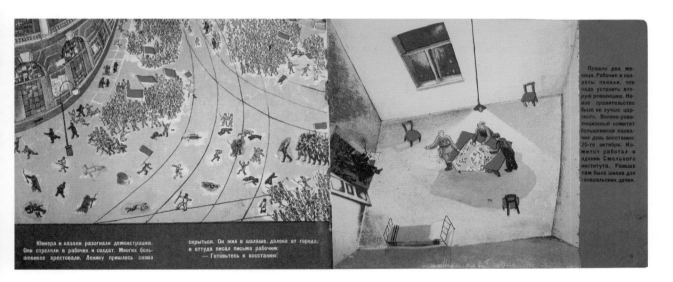

Юнкера и казаки разогнали демонстрацию. Они стреляли в рабочих и солдат. Многих большевиков арестовали. Ленину пришлось снова скрыться. Он жил в шалаше, далеко от города; и оттуда писал письма рабочим:

— Готовьтесь к восстанию!

Прошло два месяца. Рабочие и солдаты поняли, что надо устроить вторую революцию. Новое правительство было не лучше царского. Военно-революционный комитет большевиков назначил день восстания: 25-го октября. Комитет работал в здании Смольного института. Раньше там была школа для генеральских дочек.

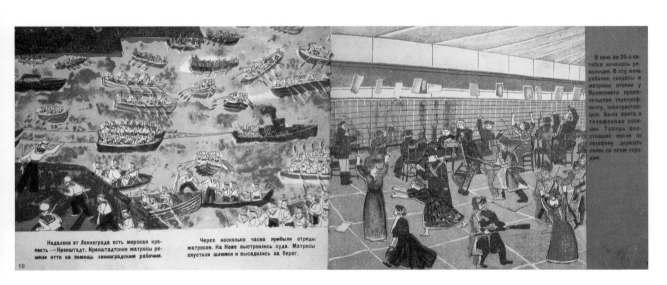

Недалеко от Ленинграда есть морская крепость — Кронштадт. Кронштадтские матросы решили идти на помощь ленинградским рабочим.

Через несколько часов прибыли отряды матросов. На Неве выстроились суда. Матросы спустили шлюпки и высадились на берег.

В ночь на 25-е октября началась революция. В эту ночь рабочие, солдаты и матросы отняли у Временного правительства телеграф, почту, электростанцию. Была взята и телефонная станция. Теперь восставшие могли по телефону держать связь со всем городом.

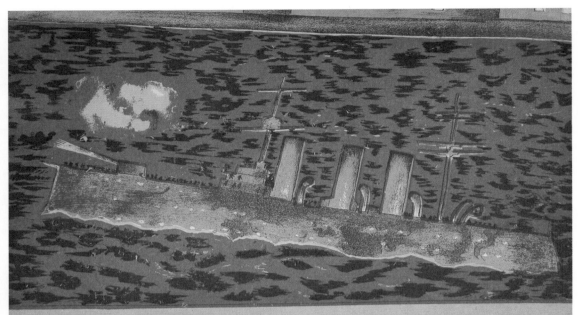

Это стреляли матросы с крейсера „Аврора". Выстрелы были холостые. Воздух дрожал от грохота, а снаряды не вылетали. Но юнкера испугались орудийной пальбы.

Отряды рабочих, матросов и солдат вошли во дворец. Военно-революционный комитет приказал:

— Министров в Петропавловскую крепость!

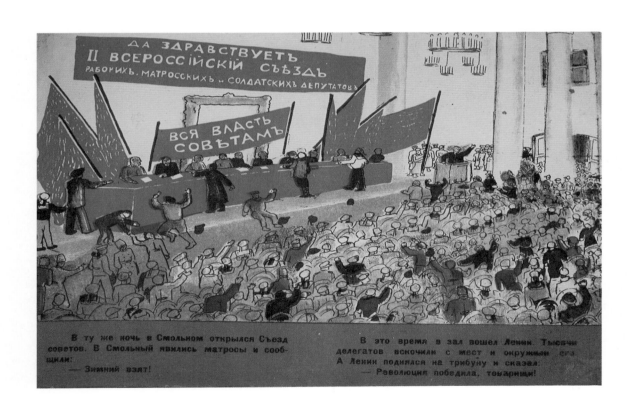

В ту же ночь в Смольном открылся Съезд советов. В Смольный явились матросы и сообщили:

— Зимний взят!

В это время в зал вошел Ленин. Тысячи делегатов вскочили с мест и окружили его. А Ленин поднялся на трибуну и сказал:

— Революция победила, товарищи!

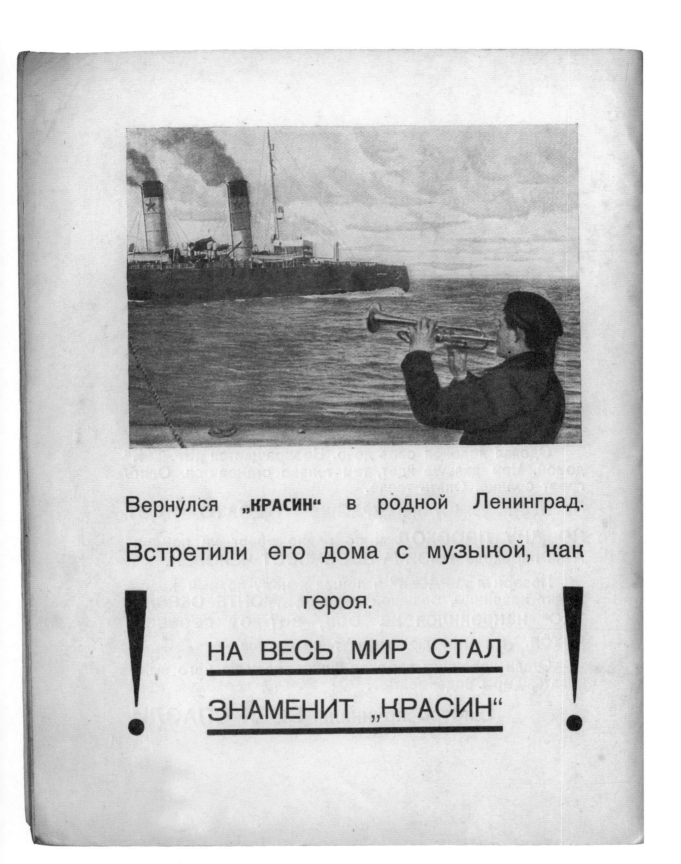

Вернулся **„КРАСИН"** в родной Ленинград.

Встретили его дома с музыкой, как

героя.

НА ВЕСЬ МИР СТАЛ

ЗНАМЕНИТ „КРАСИН"

P. Suvorov, montage for *"Krasin" in the Ice Fields* by Emmanuel Mindlin, 1929

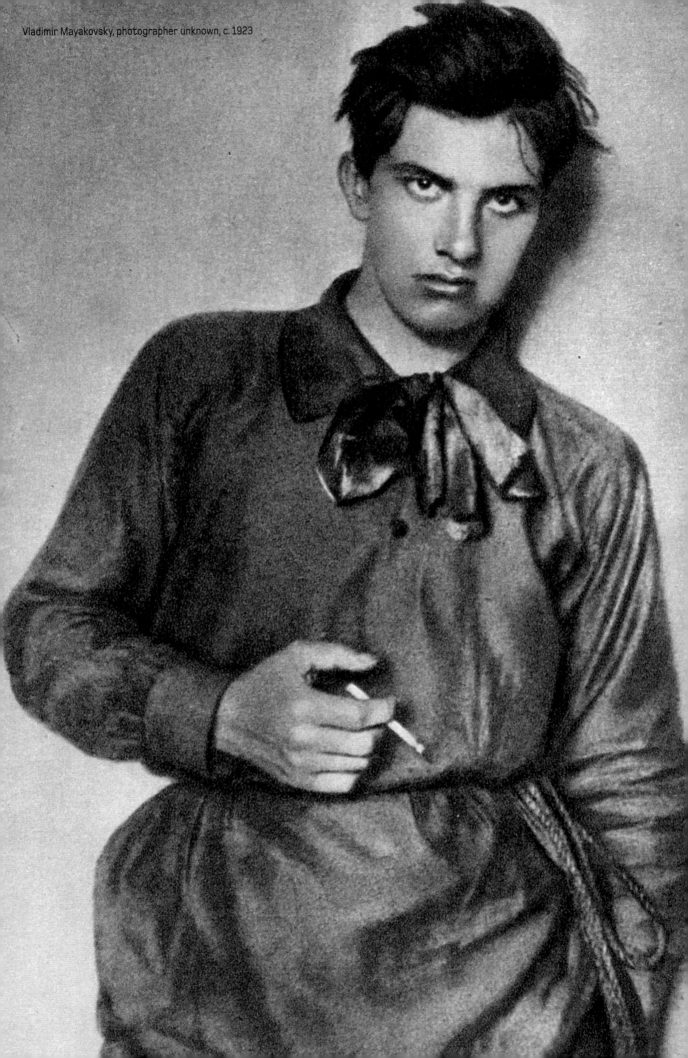

Vladimir Mayakovsky, photographer unknown, c. 1923

2

WHAT IS GOOD AND WHAT IS BAD

Notes and Posters on Child Care as Found in the Reception Rooms of Crèches and the Museums of Mother and Child.

HINTS ON UPBRINGING

It is very hard to give due education to a single child, for a child needs the company of others his own age.

Never take a child to motion pictures or the theatre.

Do not carry a child in your arms for any length of time; he must move.

Do not help a child who is in a difficult situation unless it be dangerous; he must learn to care for himself.

If you are ill, upset or unhappy, do not let the child feel it.

Never whip, kick, or spit on a child.

Parents and elders should agree on what is allowed to and forbidden to children. It is bad to have one parent allow what the other forbids.

A well-balanced routine makes a child grow healthy and accustoms him to organized social life.

Teach a child to work for others.

Understand and take part in a child's happiness and sorrow, and he will come to you when he needs you.

Do not disturb a child while he plays, or he will disturb you while you work.

If a child is annoyed with a toy, take it away and give it to him after he has forgotten his grievance.

Be careful of any trifle which a child considers a toy, even though it may only be a piece of wood or a stone.

Not everything you see in the toyshop is a good toy. Before buying a toy, see if you have anything in the house which will serve the same purpose.

Never forbid a child to play with other healthy children.

Do not tell stories to a child before he goes to sleep, for you will disturb him with new impressions.

Do not awaken a child without need when he should be sleeping.

Fresh air is as necessary in a child's room in winter as in summer.

A child should be given a chance to urinate before and after sleeping.

Do not allow a child to stay up later than eight o'clock in the evening.

Sleep for a child under three years of age is as necessary during - the day as during the night.

Each child must sleep in an individual bed; and each bed must consist of a hair mattress, an oilcloth, a pillow, blankets and sheets.

A child must spend between three and four hours outdoors each day, and, if he is old enough, he should walk during that time.

WHAT TO TELL A CHILD AND HOW TO TELL IT

From listening to grown-up persons, a child learns how to talk, so be careful of your language.

Never tell a child about things he cannot see. (This means that fairy stories should not be told to children.)

Children are interested in stories about domestic and wild animals and about men and children.

In speaking to a child you must use simple language, but not "baby talk".

Give truthful answers to all questions a child may ask, even though they may be embarrassing; a child discovers the truth sooner or later, and if you have lied to him he will not respect you.

Alice Withrow Field, *Protection of Women and Children in Soviet Russia*, 1932

ЕСЛИ
СЫН
ЧЕРНЕЕ НОЧИ,
ГРЯЗЬ ЛЕЖИТ
НА РОЖИЦЕ —

ЯСНО,
ЭТО
ПЛОХО ОЧЕНЬ
ДЛЯ РЕБЯЧЬЕЙ КОЖИЦЫ.

Alexei Laptev, illustrations for *What is Good and What is Bad?* by Vladimir Mayakovsky, 1930

ЕСЛИ
 МАЛЬЧИК
 ЛЮБИТ МЫЛО
И ЗУБНОЙ ПОРОШОК,

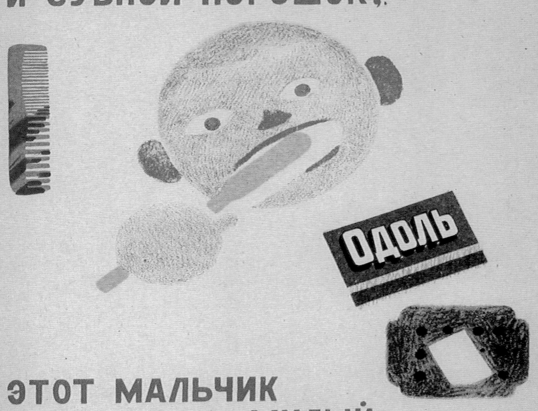

ЭТОТ МАЛЬЧИК
 ОЧЕНЬ МИЛЫЙ,
ПОСТУПАЕТ ХОРОШО.

ЕСЛИ ВЕТЕР
 КРЫШИ РВЕТ,
ЕСЛИ
 ГРАД ЗАГРОХАЛ—

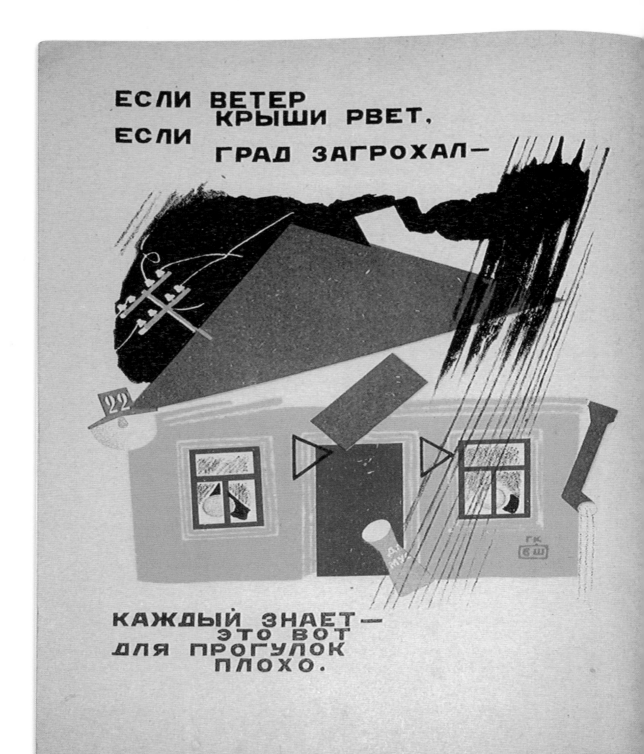

КАЖДЫЙ ЗНАЕТ—
 ЭТО ВОТ
ДЛЯ ПРОГУЛОК
 ПЛОХО.

ДОЖДЬ ПОКАПАЛ
И ПРОШОЛ.
СОЛНЦЕ В ЦЕЛОМ СВЕТЕ.

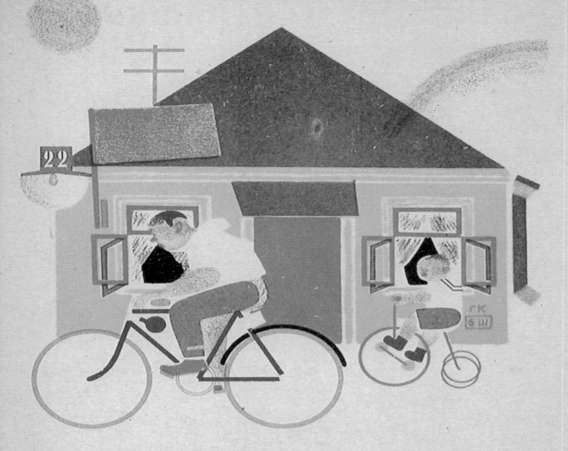

ЭТО
ОЧЕНЬ ХОРОШО
И БОЛЬШИМ
И ДЕТЯМ.

ЕСЛИ БЬЕТ
 ДРЯННОЙ ДРАЧУН
СЛАБОГО МАЛЬЧИШКУ,

Я

 ТАКОГО
 НЕ ХОЧУ
ДАЖЕ
 ВСТАВИТЬ В КНИЖКУ.

ЭТОТ ВОТ КРИЧИТ:
—НЕ ТРОЖЬ;
ТЕХ
КТО МЕНЬШЕ РОСТОМ!—

ЭТОТ МАЛЬЧИК
ТАК ХОРОШ!
ЗАГЛЯДЕНЬЕ ПРОСТО.

ЭТОТ
В ГРЯЗЬ ПОЛЕЗ
И РАД,
ЧТО ГРЯЗНА РУБАХА.

ПРО ТАКОГО
ГОВОРЯТ:
—ОН ПЛОХОЙ,!—
НЕРЯХА!—

ЭТОТ ЧИСТИТ ВАЛЕНКИ,
МОЕТ САМ
ГАЛОШИ.

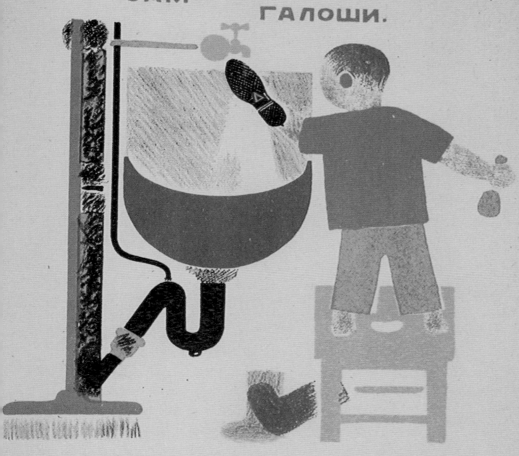

ОН
ХОТЯ И МАЛЕНЬКИЙ,
НО ВПОЛНЕ ХОРОШИЙ.

The Tasks of the Youth Leagues

VLADIMIR LENIN: FROM THE SPEECH DELIVERED AT THE THIRD ALL-RUSSIAN CONGRESS OF THE RUSSIAN YOUNG COMMUNIST LEAGUE, OCTOBER 2, 1920

...But is there such a thing as Communist ethics? Is there such a thing as Communist morality? Of course, there is. It is often made to appear that we have no ethics of our own; and very often the bourgeoisie accuse us Communists of repudiating all ethics. This is a method of shuffling concepts, of throwing dust in the eyes of the workers and peasants.

In what sense do we repudiate ethics and morality? In the sense in which it is preached by the bourgeoisie, who derived ethics from God's commandments. We, of course, say that we do not believe in God, and that we know perfectly well that the clergy, the landlords and the bourgeoisie spoke in the name of God in pursuit of their own interests as exploiters. Or instead of deriving ethics from the commandments of morality, from the commandments of God, they derived them from idealist or semi-idealist phrases, which always amounted to something very similar to God's commandments.

We repudiate all morality taken apart from human society and classes. We say that it is a deception, a fraud, a befogging of the minds of the workers and peasants in the interests of the landlords and capitalists.

We say that our morality is entirely subordinated to the interests of the class struggle of the proletariat. Our morality is derived from the interests of the class struggle of the proletariat

... The class struggle is continuing and it is our task to subordinate all interests to this struggle. And we subordinate our communist morality to this task. We say: morality is what serves to destroy the old exploiting society and to unite all the toilers around the proletariat, which is building up a new, communist society.

Communist morality is the morality which serves this struggle, which unites the toilers against all exploitation, against all small property; for small property puts into the hands of one person what has been created by the labour of the whole of society. In our country the land is common property.

But suppose I take a piece of this common property and grow on it twice as much grain as I need and profiteer in the surplus? Suppose I argue that the more starving people there are, the more they will pay? Would I then be behaving like a Communist? No, I would be behaving like an exploiter, like a proprietor.

This must be combated. If this is allowed to go on things will slide back to the rule of the capitalists, to the rule of the bourgeoisie, as has happened more than once in previous revolutions. And in order to prevent the restoration of the rule of the capitalists and the bourgeoisie we must not allow profiteering, we must not allow individuals to enrich themselves at the expense of the rest, and the toilers must unite with the proletariat and form a Communist society

. . . When people talk to us about morality, we say: for the Communist, morality lies entirely in this solid, united discipline and conscious mass struggle against the exploiters. We do not believe in an eternal morality, and we expose the deceit of all the fables about morality. Morality serves the purpose of helping human society to rise to a higher level and rid itself of the exploitation of labour. . . .

. . .The training of Communist youth must consist not in giving them sentimental speeches and moral precepts. This is not what training consists of. When people saw how their fathers and mothers lived under the yoke of the landlords and capitalists, when they themselves experienced the sufferings that befell those who started the struggle against the exploiters, when they saw what sacrifices the continuation of this struggle entailed in order to defend what had been won, and when they saw what frenzied foes the landlords and capitalists are – they were trained in this environment to become Communists. The basis of communist morality is the struggle for the consolidation and completion of communism. That too is the basis of communist training, education, and teaching. That is the reply to the question as to how communism should be learnt

. . . But our school must impart to the young the fundamentals of knowledge, the ability to work out communist views independently; it must make educated people of them. In the time during which people attend school, it must train them to be participants in the struggle for emancipation from the exploiters. The Young Communist League will justify its name as the league of the young communist generation only when it links up every step of its teaching, training and education with participation in the general struggle of all the toilers against the exploiters . . .

. . . Thus, to be a Communist means that you must organise and unite the whole rising generation and set an example of training and discipline in this struggle. Then you will be able to start building the edifice of communist society and bring it to completion . . .

. . . The generation which is now about fifty years old cannot expect to see a communist society. This generation will die out before then. But the generation which is now fifteen years old will see a communist society, and will itself build this society. And it must know that the whole purpose of its life is to build this society.

Vladimir Lebedev, cover and illustration for *Ice Cream* by Samuil Marshak, 1925

Отличное,
Земляничное,

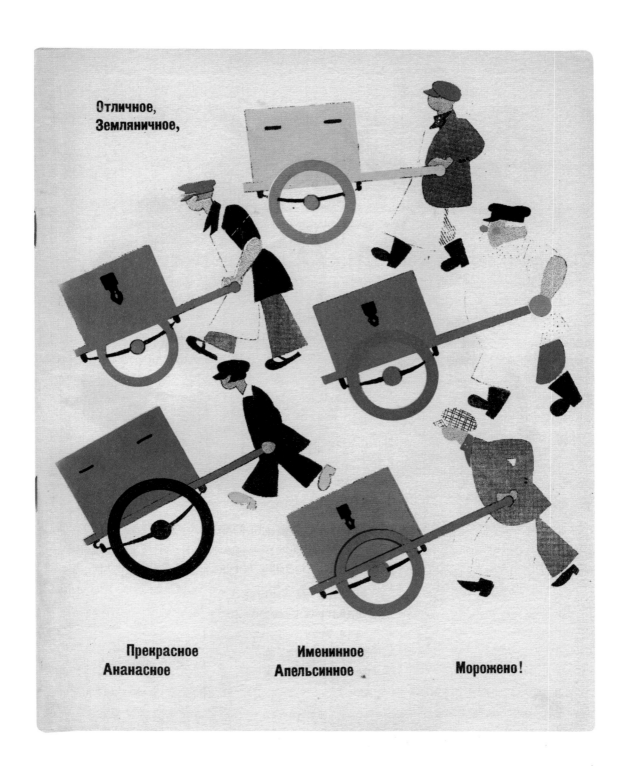

Прекрасное
Ананасное

Именинное
Апельсинное

Мороженo!

Boris Kronberg, illustration for *Gymnastics to Amuse* by I. Irak, 1930

— Папка, а папка!
Зачем у моссельпромщицы красная
 шапка?

А есть у собаков ум?
А что значит слово „Гум"?

4

S. Adlivankin, illustration for *Pashka and Papashka* by Sergei Tretyakov, 1926

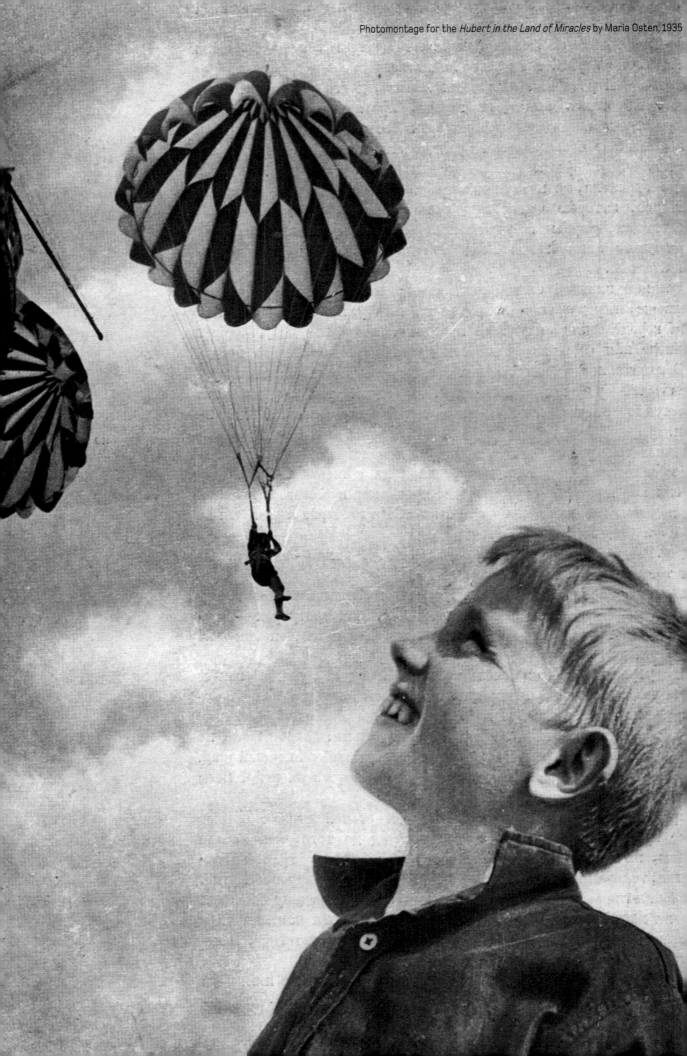

3

HOW THE WORLD WORKS

IN THE OLD SCHOOLS, THEORY WAS USUALLY DIVORCED FROM PRACTICE . . . The heads of children were stuffed with wide-ranging knowledge, but, divorced from life and practical work, that knowledge was quickly forgotten. This led many teachers to propose that greater emphasis be placed on the development of work skills and habits.

Polytechnical education must inspire the younger generation with the romantic character of socialist economic development and enable them to participate in building socialism . . . and to familiarize themselves with the various branches of the national economy through practical activities.

By correctly combining physical labour occupations with mental labour occupations and doing this on a large scale we shall undermine the very foundations of the social division of people into intellectuals and people engaged in physical labour.

The Young Communist League should immediately undertake the elimination of the division of the population into intellectuals and people engaged in physical labour. The situation produced by building socialism will itself increasingly contribute to this.

Lenin particularly noted Marx's statement in the first volume of *Das Kapital* concerning combining the instruction of children and adolescents with productive labour... labour should be made obligatory for all adolescents and should be closely associated with instruction.

Nadezhda Krupskaya [Lenin's wife] from: *On Labour-Oriented Education and Instruction*

SOME CHARMING LITTLE GIRLS who gathered round me in a children's playground (which I must say was entirely praiseworthy, like everything else that is done here for the young) harried me with questions. What they wanted to know was not whether we have children's playgrounds in France, but whether we know in France that they have such fine children's playgrounds in the USSR. The questions you are asked are often so staggering that I hesitate to report them . . . They smile sceptically when I say that Paris too has a subway. Have we even got street-cars? Buses? . . . For them, outside the USSR the reign of night begins. Apart from a few shameless capitalists, everybody else is groping in the dark.

André Gide, *Return from the USSR,* 1936

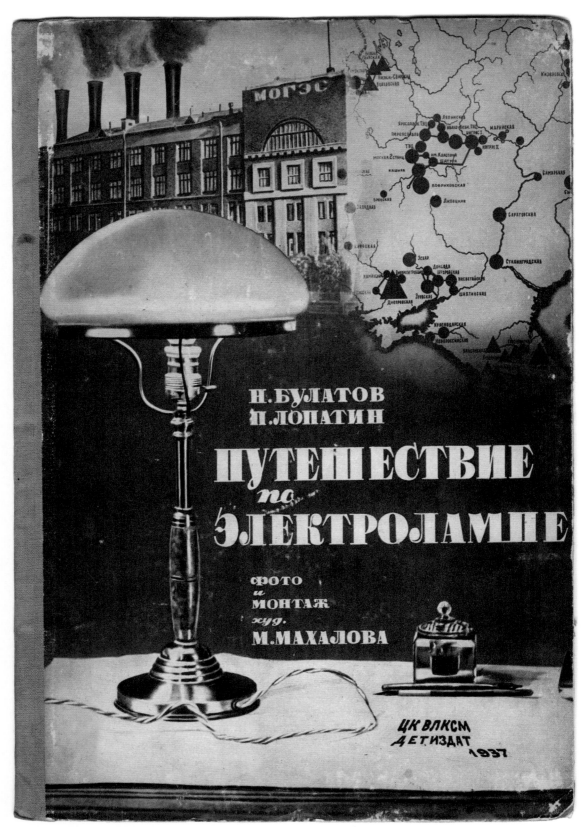

M. Makhalov, photography and photomontage for *The Journey inside the Electric Lamp* by N. Bulatov and P. Lopatin, 1937

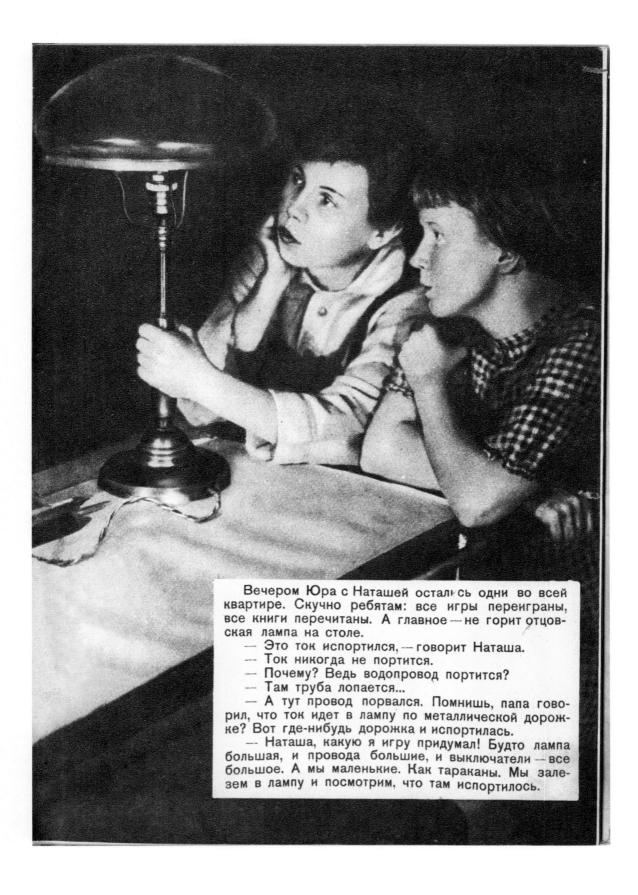

Вечером Юра с Наташей остались одни во всей квартире. Скучно ребятам: все игры переиграны, все книги перечитаны. А главное — не горит отцовская лампа на столе.

— Это ток испортился, — говорит Наташа.

— Ток никогда не портится.

— Почему? Ведь водопровод портится?

— Там труба лопается...

— А тут провод порвался. Помнишь, папа говорил, что ток идет в лампу по металлической дорожке? Вот где-нибудь дорожка и испортилась.

— Наташа, какую я игру придумал! Будто лампа большая, и провода большие, и выключатели — все большое. А мы маленькие. Как тараканы. Мы залезем в лампу и посмотрим, что там испортилось.

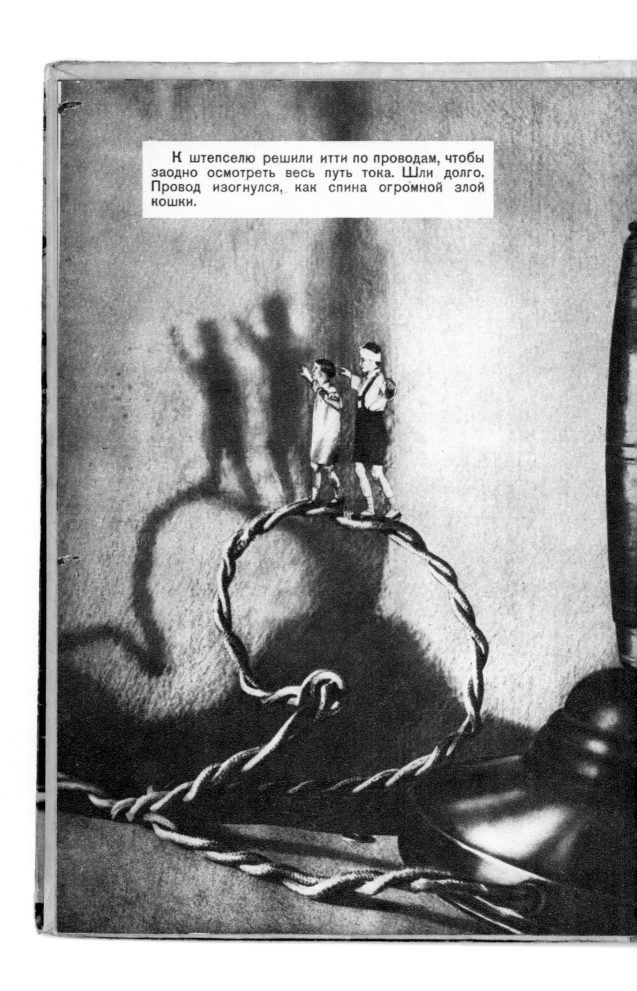

К штепселю решили итти по проводам, чтобы заодно осмотреть весь путь тока. Шли долго. Провод изогнулся, как спина огромной злой кошки.

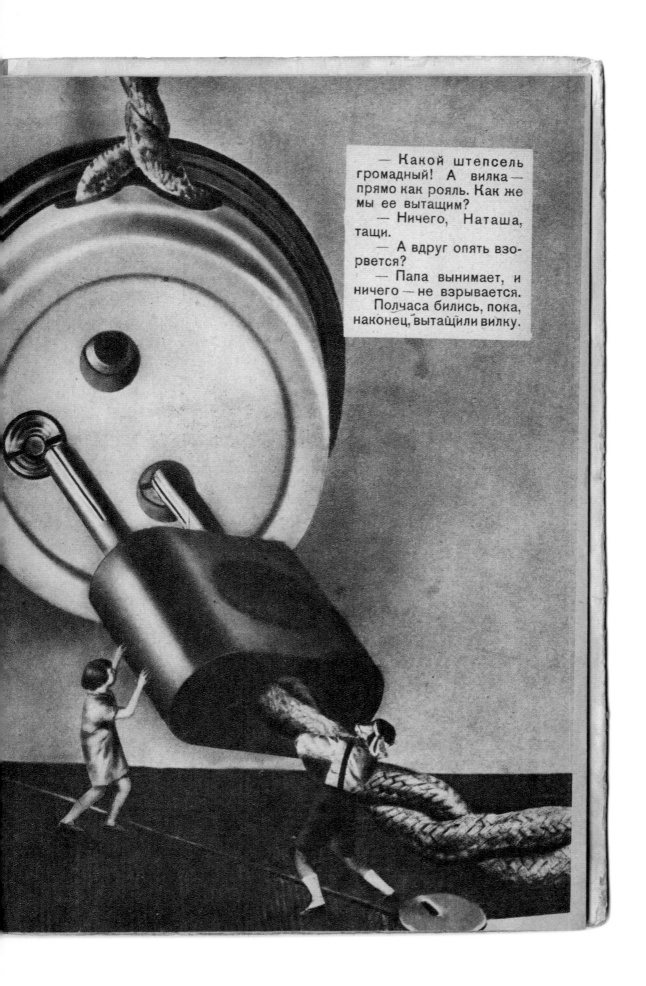

— Какой штепсель громадный! А вилка — прямо как рояль. Как же мы ее вытащим?

— Ничего, Наташа, тащи.

— А вдруг опять взорвется?

— Папа вынимает, и ничего — не взрывается.

Полчаса бились, пока, наконец, вытащили вилку.

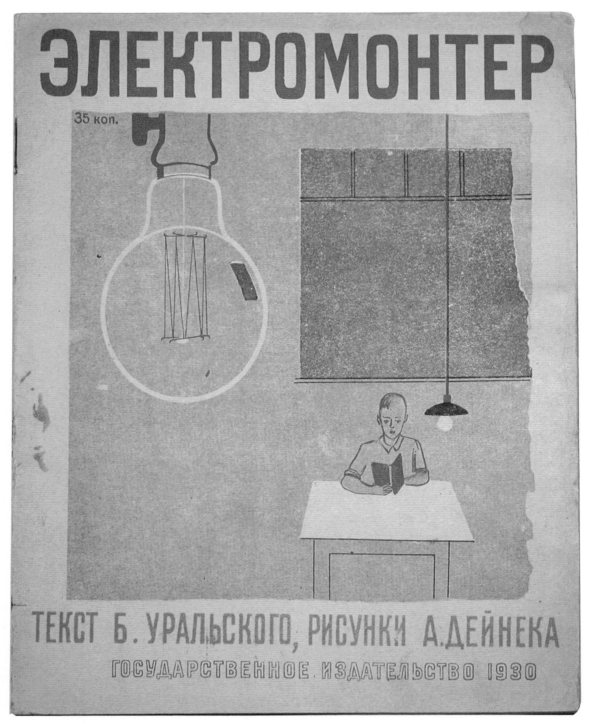

Alexander Deineka, cover and illustrations for *The Electrician* by B. Uralsky, 1930

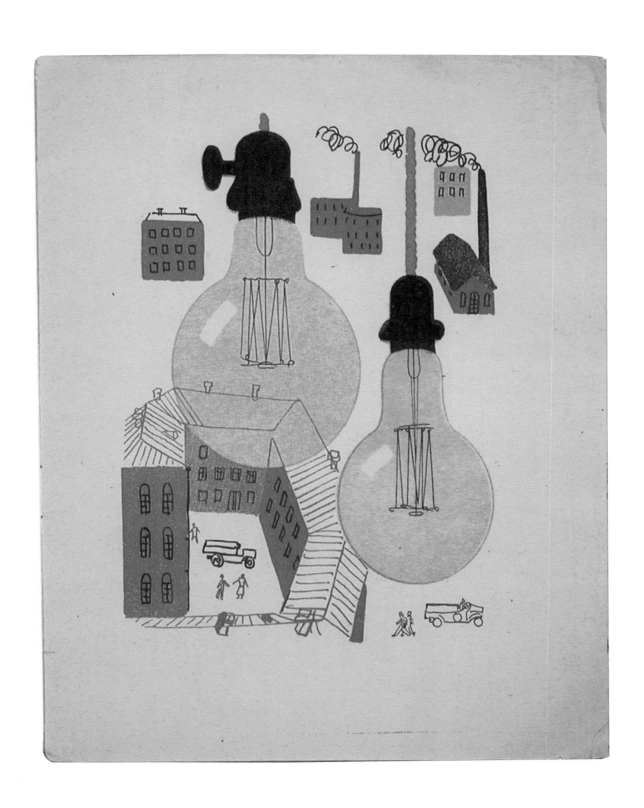

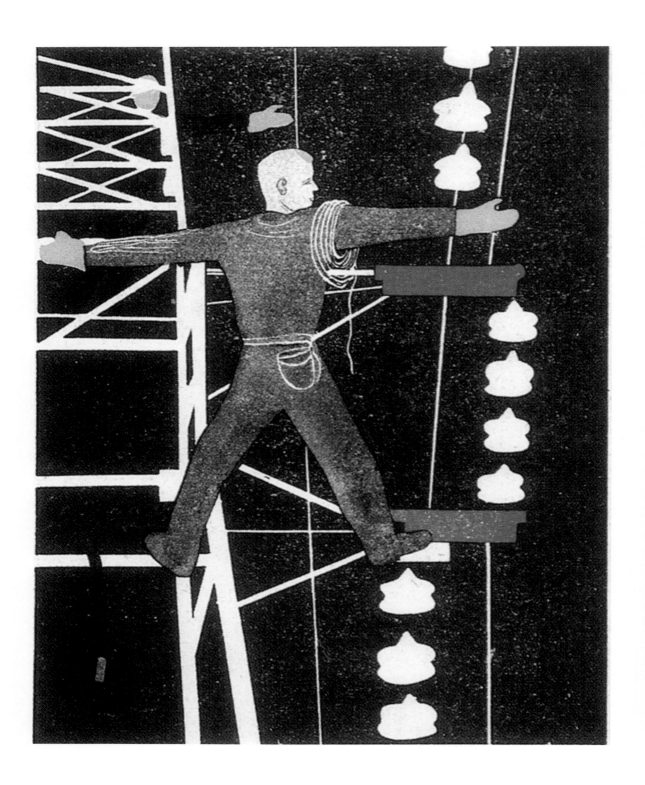

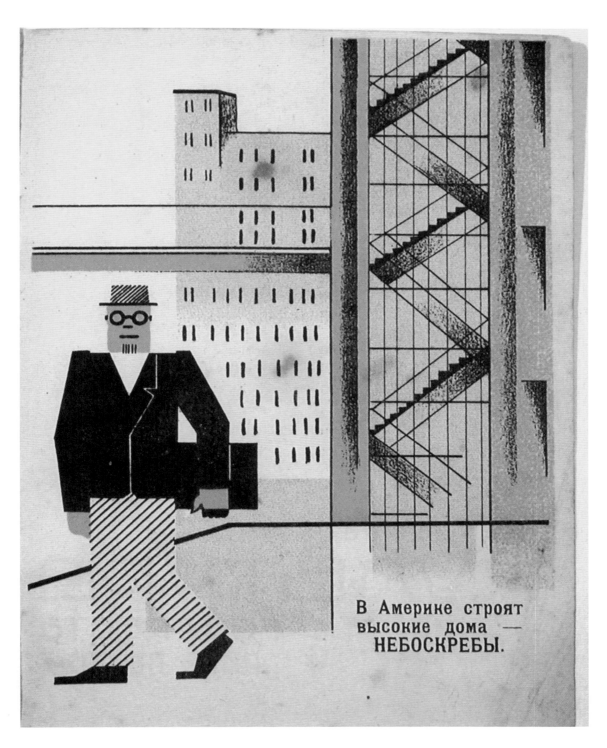

В Америке строят
высокие дома —
НЕБОСКРЕБЫ.

Dmitri Bulanov, illustration for *How They Build*, c. 1922

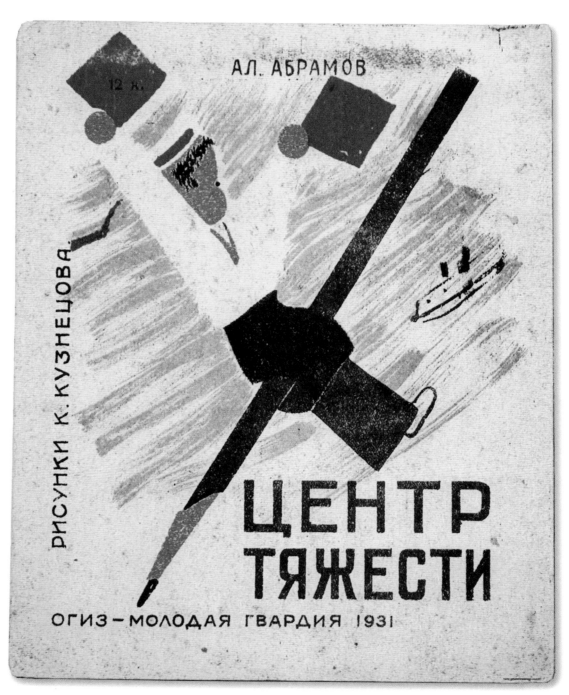

Konstantin Kuznetsov, cover and illustration for *Centre of Gravity* by A. Abramov, 1931

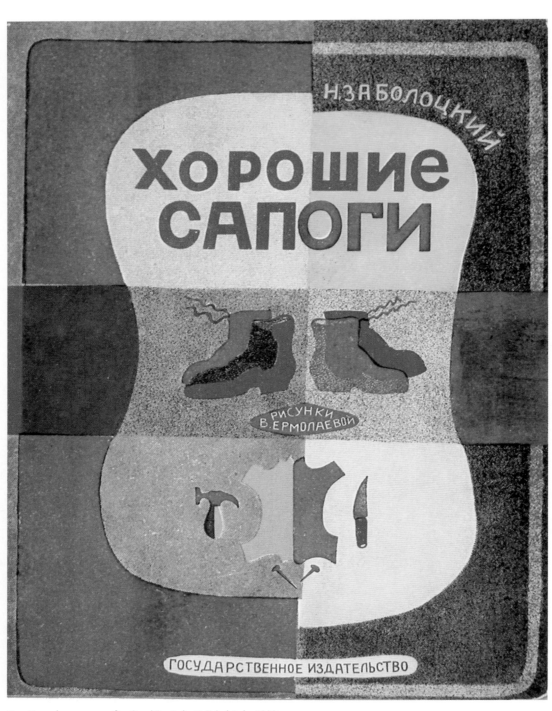

Vera Yermolayeva, cover for *Good Boots* by N. Zabolotsky, 1929

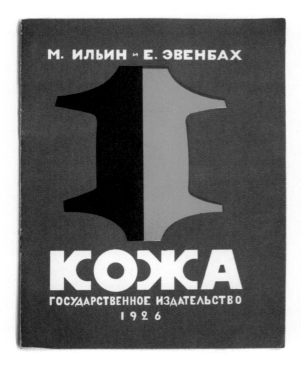

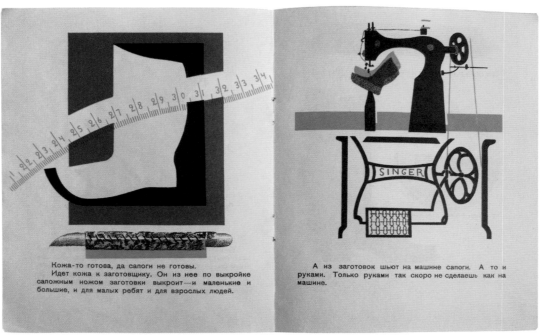

Evgeniya Evenbakh, illustrations for *Leather* by M. Ilyin, 1925

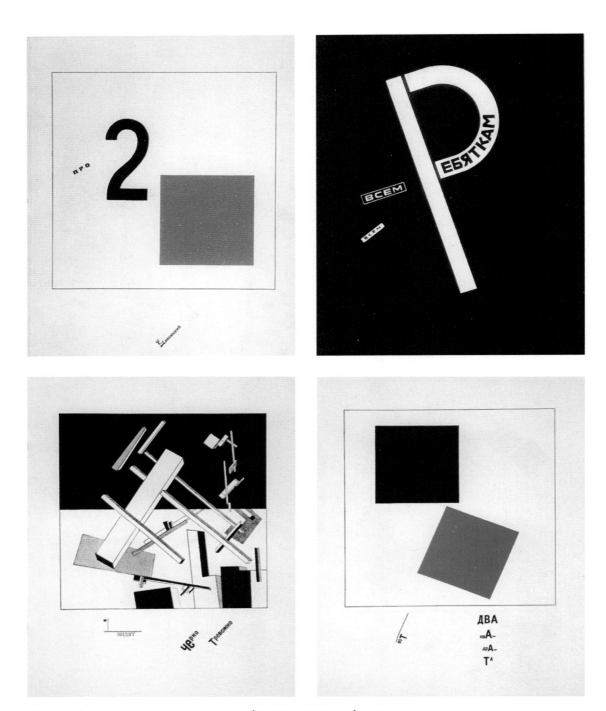

El Lissitzky, illustrations for his *About Two Squares* ("To All, For All Children"), 1922

Mariya Sinyakova, back cover for *Shop Windows* by N. Saksonskaya, 1930

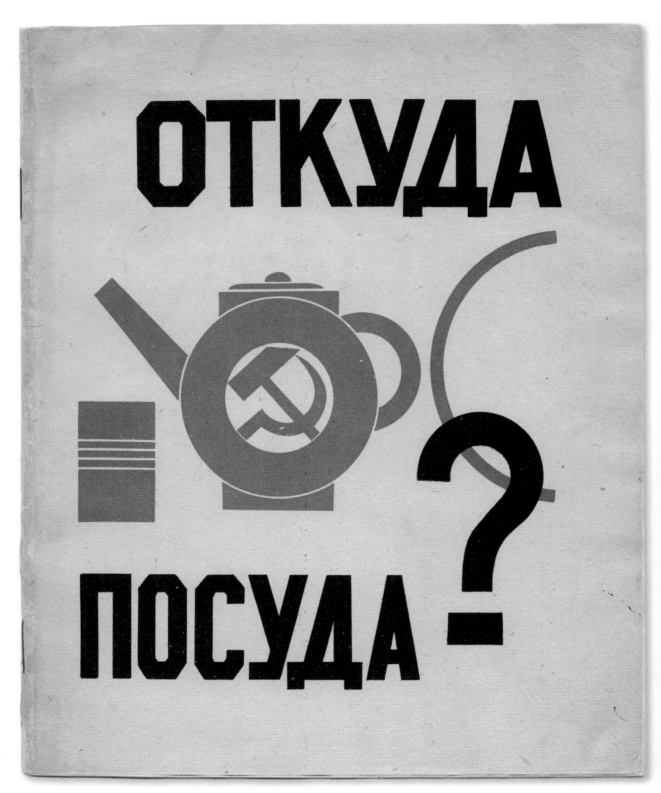

Galina and Olga Chichagova, cover and illustrations for *Where Does Crockery Come From?* by Nikolai Smirnov, 1924

Выстроилась посуда на окне в ряд.

Вещи, как жар,
На солнце горят.
Ухмыляется гончар,
Рад.—

— 12 —

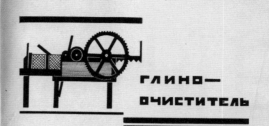

ГЛИНО—
ОЧИСТИТЕЛЬ

КАК ДЕЛАЮТ ПОСУДУ.

Пояснительный очерк.

Глину привозят на завод, выбирают из нее крупные камни, кладут в ящики, мочат, и затем, когда глина вымокнет, ее пропускают через очиститель. Это—такая машина, похожая на сито, через которую глину прожимают, при чем мелкие камни не проходят через сито, а остаются в машине, откуда их потом выбрасывают.

Очищенную глину мнут в глиномялке—машине, похожей по своему устройству на мясорубку (котлетную машинку). Глину кладут внутрь машины; поршень с ножами, двигающийся при помощи колес, режет и мнет глину до тех пор, пока она не станет как тесто. Теперь глина готова для производства.

Глиняная посуда изготовляется при помощи точильного или, так называемого, гончарного круга. Гончар приводит ногой в движение нижний круг; вместе с нижним кругом вертится и верхний, на котором лежит ком глины. Гончар формует глину руками, и так как глина вертится на круге между пальцами, то вещи выходят ровными.

— 13 —

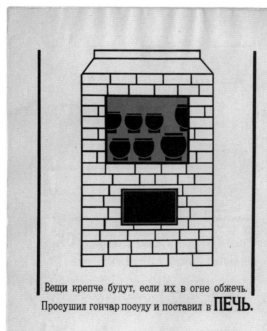

Вещи крепче будут, если их в огне обжечь.
Просушил гончар посуду и поставил в ПЕЧЬ.

— 8 —

В печке вещи эти
Стоят четверть дня.

ИЗМЕНИЛИСЬ

В ЦВЕТЕ

От огня,
Стали твердые, звенят.

— 9 —

Leonid Gamburger, cover for *Five-Year Plan* by B. Evgenyev, 1930

NEW PEOPLE: FACTORIES FOR THE REFINING OF PEOPLE

A great plan has been conceived; men have set themselves a great task: to change Nature and to change themselves. Are we, such as we are, fit for the new way of life? We know little; we have few engineers, few physicians, few scientists; half of us above eight years of age in the village cannot even read. In America only six per cent of the people are illiterate. We need factories not only to refine iron and steel but also to refine people; we need schools, universities, libraries, cottage reading rooms; we need many more books and newspapers many more than we have now. We must eradicate drunkenness; we must close shops purveying alcohol and replace saloons with theatres and cinemas, with clubs and rest homes.

We must root out uncouthness and ignorance, we must change ourselves, we must become worthy of a better life. And this better life will not arrive miraculously: we ourselves have to create it. But to create it we need knowledge: we need strong hands, yes, but we need strong minds too.

The Little Five-Year Plan and the Big Five-Year Plan
Do not imagine that the Five-Year Plan is just work for grown-ups.
Every one of you can be a builder of the Five-Year Plan.

HERE IT IS: YOUR FIVE-YEAR PLAN

1. To discover beds of lime and phosphorus.
2. To gather useful junk: rags, ropes, wool, bones, scraps of metal, and so on. All of these things will come in handy in our factories. Every Pioneer should collect no fewer than twenty kilograms a year.
3. To build radios and loud-speakers. Within the next few years 75,000 should be installed in villages. Not a single school should be without a loud-speaker.
4. To sort and treat with insecticide 100% of all grain used in kolkhozes and on farms.
5. To gather ashes for fertilizing fields. Each troop of Pioneers should gather two tons of ashes a year.
6. To destroy ten marmots a year in the regions infested by these animals; to clear one tenth of a hectare of land of parasites; to destroy all pests on one fruit tree and on ten different vegetables; to catch or destroy five rats and ten mice.
7. To build one starling house and two feeding houses a year; to raise the number of starling houses to a million and a half and of feeding houses to two million. Birds are our allies: they will help us destroy parasites.
8. To organize in five years, 5000 children's bird brotherhoods, to found 5000 collective poultry yards, and to build 5000 chicken houses.
9. To add two good laying hens to the possessions of every peasant household.
10. To plant ten trees each in five years; to create Pioneer forests of 75 million trees.
11. To destroy bedbugs, roaches, and flies in 500,000 houses. Each troop should clean up ten houses.
12. To teach the illiterate to read and write. Each troop should endeavour to wipe out illiteracy in its region.

These are only some of your chief tasks. If you wish to learn the details, read *The Report of the Pioneer Meet*. Herein lies your power.

Mikhail Ilin, *New Russia's Primer: The Story of the Five-Year Plan*, The Riverside Press, 1931, Translated by George S. Counts and Nucia P. Lodge

Unknown illustrator, cover for *Pioneer*, 1931

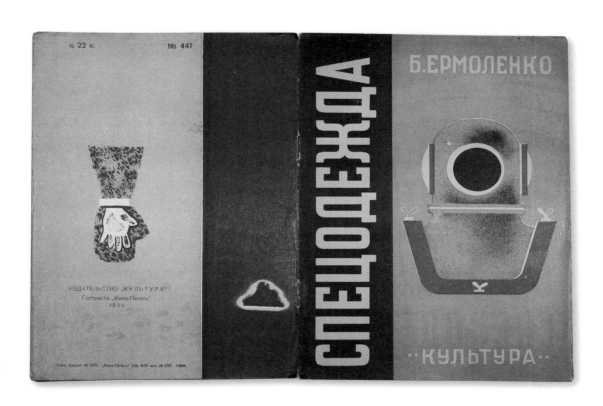

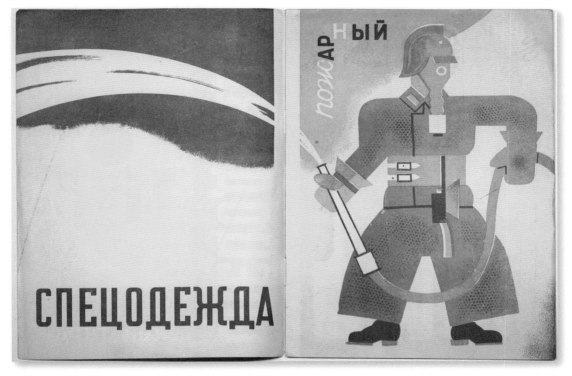

Boris Ermolenko, cover and Illustrations for *Special Clothing*, 1930

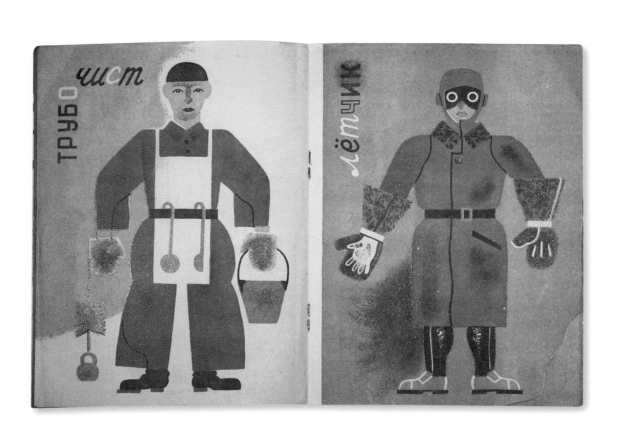

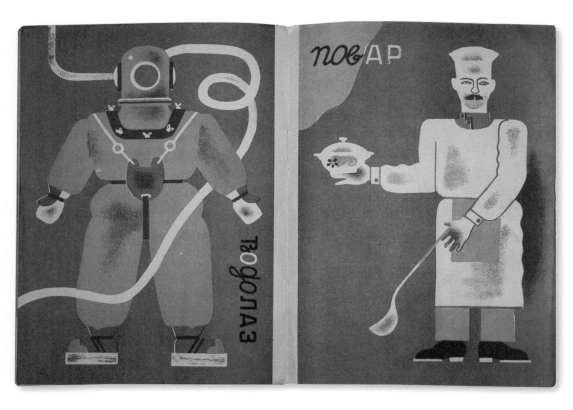

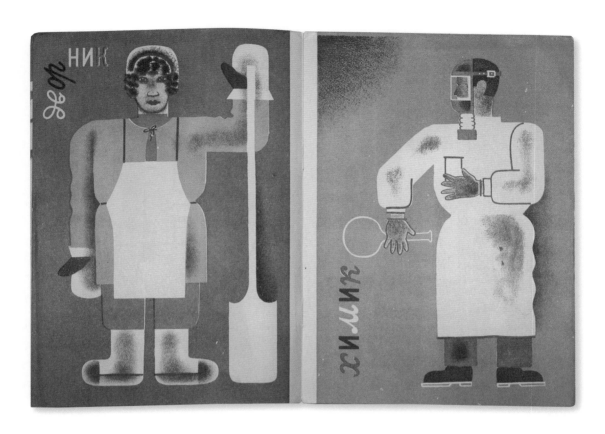

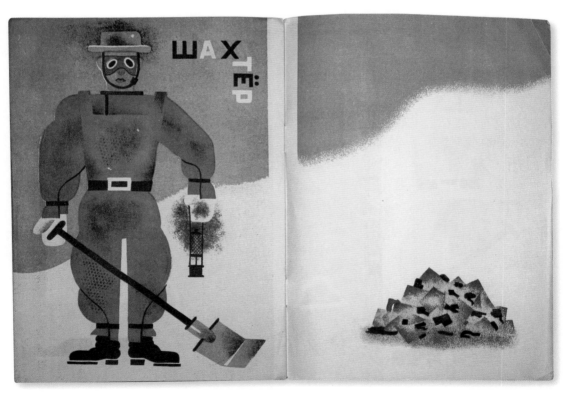

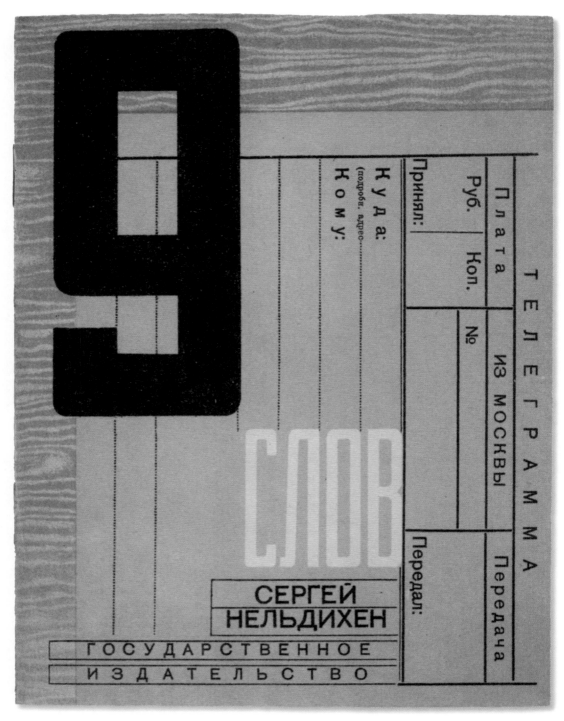

Lidia Popova, front and back cover for *9 Words* by Sergei Neldikhen, 1929

12 коп.

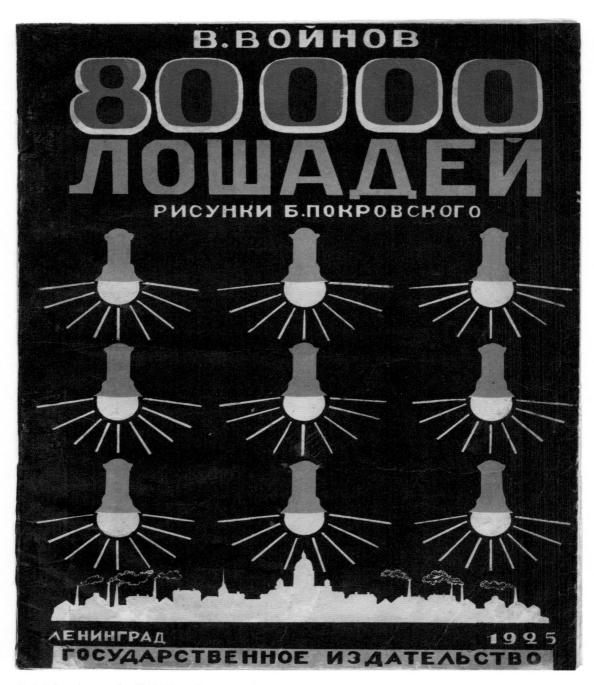

Boris Pokrovsky, cover for *80,000 Horses* by V. Voynov, 1925

Vladimir Tambi, illustrations for *What Are We Building?* by L. Savelyev, 1930

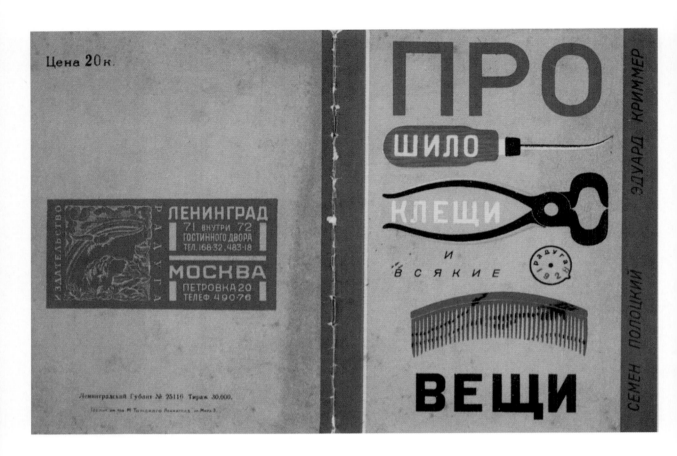

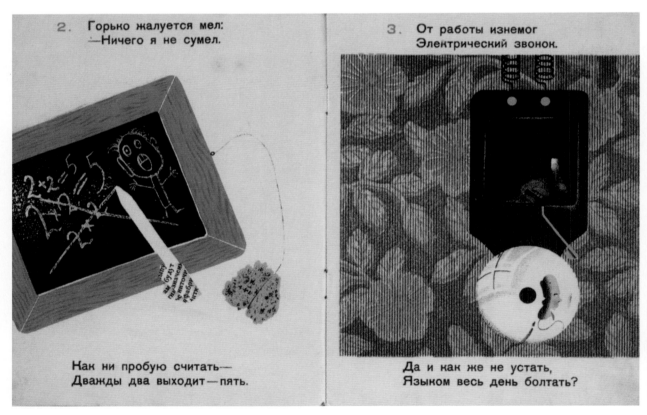

Eduard Krimmer, cover and illustrations for *About the Bradawl, Pliers and other things* by Semyon Polotsky, 1927

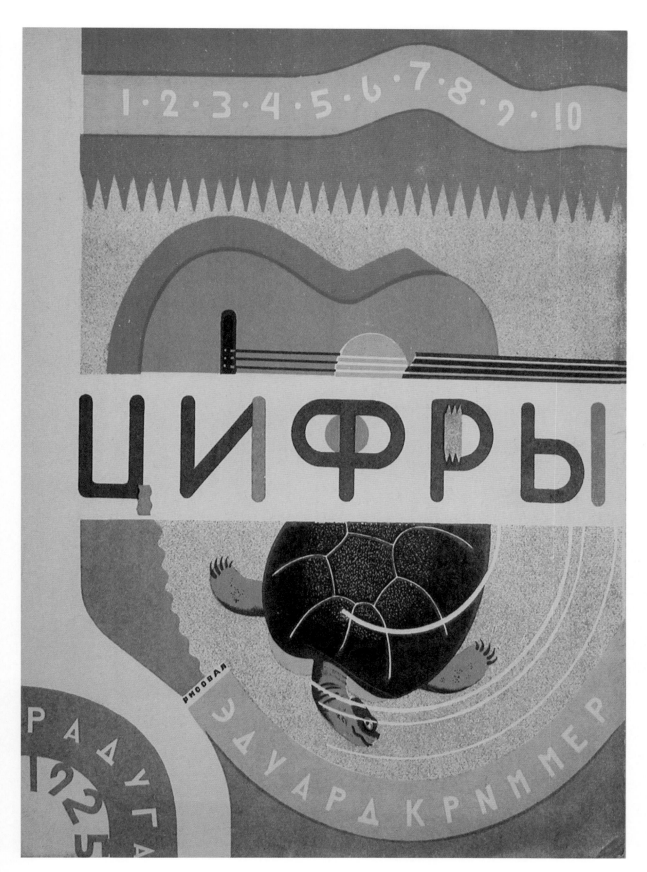

Eduard Krimmer, cover for *Numbers*, 1925

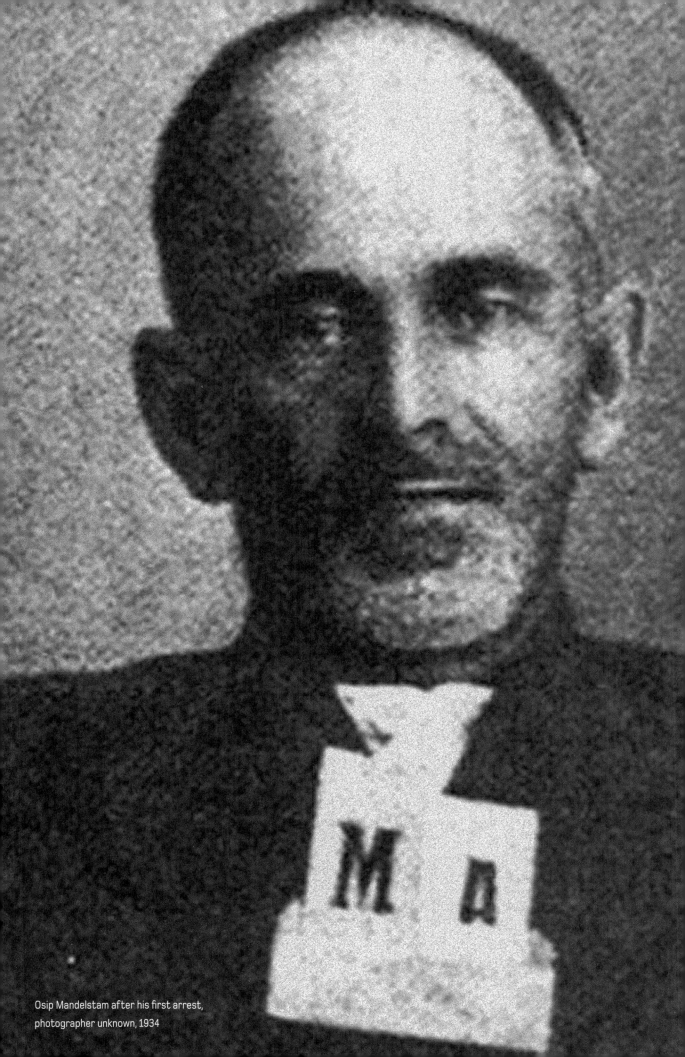

Osip Mandelstam after his first arrest,
photographer unknown, 1934

4

WHAT GROWN-UPS DO

DEAR ALEKSEI MAKSIMOVICH (GORKY)!

I saw Tankov, and even before his visit and your letter, we had decided in the Central Committee [Tseka] to appoint Kamenev and Bukharin to review and confirm the arrests of the bourgeois intellectuals of the quasi-Constitutional Democrat [Kadet] stripe and to free everyone possible. For it is clear to us that here indeed mistakes were made.

It is also clear that, in general, the arrest of the Kadets and quasi-Kadets was the necessary and correct measure to take. When I read your frank opinion on this subject, I recall a phrase you used during our conversations in London, Capri and elsewhere that made a deep impression on me: "We artists are irresponsible people." Just so! What gives you cause to utter these improbably angry words? This cause, that dozens or even hundreds of these Kadet and quasi-Kadet little gentlemen will spend several days in prison in order to prevent conspiracies similar to the surrendering of the Krasnaia Gorka Fort, conspiracies that threaten the lives of thousands of workers and peasants!

What a tragedy, you're thinking! What an injustice! Intellectuals in prison for several days or even weeks just to prevent the massacre of tens of thousands of workers and peasants!

"Artists are irresponsible people." . . . Recently I read his (Korolenko's) *War, Motherland, and Mankind,* a pamphlet written in August 1917. Korolenko, you know, is the best of the "quasi-Kadets", almost a Menshevik. But what a vile, despicable, rotten defence of the imperialist war, dressed up with sugar-coated phrases! A pitiful petty bourgeois captivated by bourgeois prejudices! For such gentlemen, 10,000,000 men killed during an imperialist war is a matter deserving support (by deeds, while mouthing sugar-coated phrases "against" the war), but the death of hundreds of thousands in a just civil war against landlords and capitalists evokes only aahs, oohs, sighs and hysteria.

No. It isn't a sin to jail such "men of talent" for short periods if that's what it takes to prevent plots (such as the one at Krasnaia Gorka) and the deaths of tens of thousands. We uncovered the conspiracies of the Kadets and quasi-Kadets. And we know that quasi-Kadet professors are giving assistance heart and soul to the conspirators. That is a fact.

The intellectual forces of the workers and peasants are growing and getting stronger in their fight to overthrow the bourgeoisie and their accomplices, the educated classes, the lackeys of capital, who consider themselves the brains of the nation. In fact they are not its brains but its shit.

We pay above-average salaries to those "intellectual forces" who want to bring learning to the people (rather than toadying to capital). That is a fact. We cherish them. That is a fact.

Tens of thousands of officers are serving in the Red Army and are winning in spite of hundreds of traitors. That is a fact.

Regarding your frame of mind, I know how to "understand" it (once you asked whether I would understand you). Several times, on Capri and elsewhere, I told you, "You let yourself be surrounded by the worst elements of the bourgeois intelligentsia , and you give in to their whining. You hear and listen to the wail of hundreds of intellectuals about their "terrible" incarceration lasting several weeks, but you do not hear or listen to the voices of the masses, of millions – workers and peasants – who are threatened by Denikin, Kolchak, Lianozov, Rodzianko, the Krasnaia Gorka (and other Kadet) conspirators. I quite, quite understand that this is how you can end your letter with the statement that these "Reds are just as much enemies of the people as the Whites" (fighters for the overthrow of capitalists and landlords are just as much enemies of the people as are the capitalists and the landlords), or even end up believing in a tin divinity or in "our father the tsar". I quite understand.

Really and truly you will die if you don't break away from this situation with the bourgeois intelligentsia. With all my heart I wish that you would break away as soon as possible.

Best regards

Yours, Lenin.

But you're not writing! To waste yourself on the whining of decaying intellectuals and not to write – is that not death for an artist, is that not a shame?

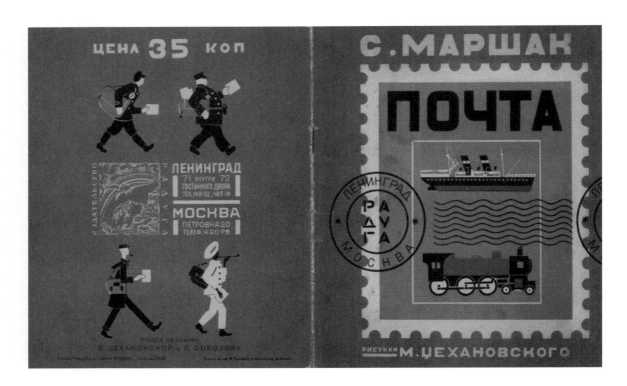

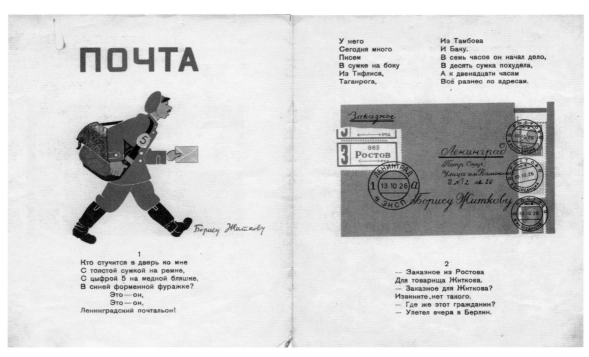

Mikhail Tsekhanovsky, cover and illustrations for *Post* by Samuil Marshak, 1927

3

Житков за границу
По воздуху мчится —
Земля зеленеет внизу.
А вслед за Житковым
В вагоне почтовом
Письмо заказное везут.

Пакеты по полкам
Разложены с толком,
В дороге разборка идет,
И два почтальона
На лавках вагона
Качаются ночь напролет.

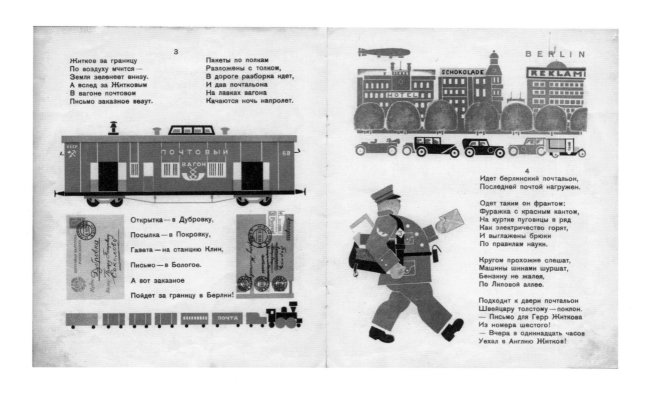

Открытка — в Дубровку,

Посылка — в Покровку,

Газета — на станцию Клин,

Письмо — в Бологое.

А вот заказное

Пойдет за границу в Берлин!

4

Идет берлинский почтальон,
Последней почтой нагружен.

Одет таким он франтом:
Фуражка с красным кантом,
На куртке пуговицы в ряд
Как электричество горят,
И выглажены брюки
По правилам науки.

Кругом прохожие спешат,
Машины шинами шуршат,
Бензину не жалея,
По Липовой аллее.

Подходит к двери почтальон
Швейцару толстому — поклон.
— Письмо для Герр Житкова
Из номера шестого!
— Вчера в одиннадцать часов
Уехал в Англию Житков!

5

Письмо
Само
Никуда не пойдет,
Но в ящик его опусти —
Оно пробежит,
Пролетит,
Проплывет
Тысячи верст пути.

Нетрудно письму
Увидеть свет.
Ему
Не нужен билет,
На медные деньги
Объедет мир
Заклеенный
Пассажир.

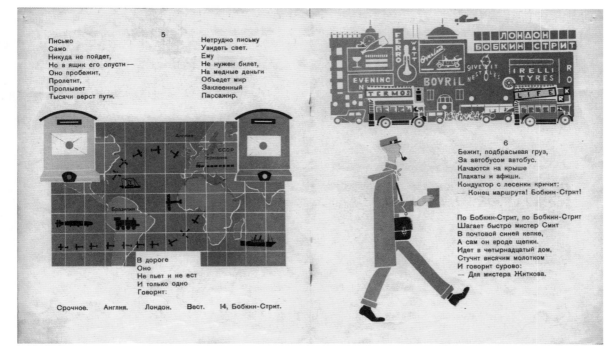

В дороге
Оно
Не пьет и не ест
И только одно
Говорит:

Срочное. Англия. Лондон. Вест. 14, Бобкин-Стрит.

6

Бежит, подбрасывая груз,
За автобусом автобус.
Качаются на крыше
Плакаты и афиши.
Кондуктор с лесенки кричит:
— Конец маршрута! Бобкин-Стрит!

По Бобкин-Стрит, по Бобкин-Стрит
Шагает быстро мистер Смит
В почтовой синей кепке,
А сам он вроде щепки.
Идет в четырнадцатый дом,
Стучит висячим молотком
И говорит сурово:
— Для мистера Житкова.

10

Мой сосед вскочил с постели:
— Вот так чудо, в самом деле!
Погляди, письмо за мной
Облетело шар земной.

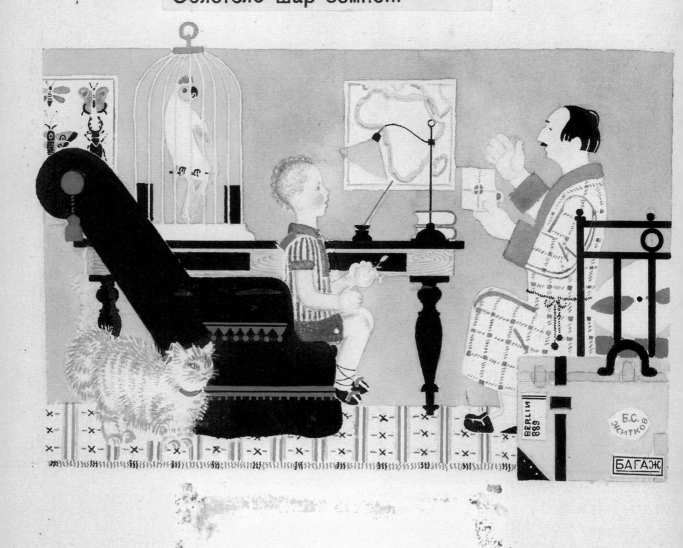

Mikhail Tsekhanovsky, original artwork for *Post* by Samuil Marshak, 1927

MORE THAN EVER, LENIN STRUCK ME AS A HAPPY MAN. Walking home from the Kremlin, I tried to think of any other man of his calibre who had had a similar joyous temperament. I could think of none. This little, bald-headed, wrinkled man, who tilts his chair this way and that, laughing over one thing or another, ready any minute to give serious advice to any who interrupt him to ask for it, advice so well reasoned that it is to his followers far more compelling than any command, every one of his wrinkles is a wrinkle of laughter, not of worry. . . . He is consequently free with a freedom no other great man has ever had. It is not so much what he says that inspires confidence in him. It is this sensible freedom, this obvious detachment. With his philosophy he cannot for a moment believe that one man's mistake might ruin all. He is, for himself at any rate, the exponent, not the cause, of the events that will be for ever linked with his name.

The sitting opened with a report by Dzerzhinsky that strange ascetic who, when in prison in Warsaw, insisted on doing the dirty work of emptying the slops and cleaning other people's cells besides his own, on a theory that one man should where possible take upon himself the evil which would otherwise have to be shared by all; and in the dangerous beginning of the revolution had taken upon himself the most unpopular of all posts, that of President of the Extraordinary Commission. The struggle with counter-revolution had passed to a new stage. They no longer had to do open battle with open enemies; they had merely to guard themselves against individuals. The laws of war by which, meeting him on the field of battle, the soldier had a right to kill his enemy without trial, no longer held good. The situation was now that of peace, where each offender must have his guilt proved before a court. Therefore the right of sentencing was removed from the Extraordinary Commission; but if, through unforeseen circumstances, the old conditions should return, they intended that the dictatorial powers of the Commission should be restored to it until those conditions had ceased. Thus if, in case of armed counter-revolution, a district were declared to be in a state of war, the Extraordinary Commission would resume its old powers. Otherwise its business would be to hand offenders, such as Soviet officials who were habitually late (here there was a laugh, the only sign throughout his speech that Dzerzhinsky was holding the attention of his audience), over to the Revolutionary Tribunal, which would try them and, should their guilt be proved, put them in concentration camps to learn to work. He read point by point the resolutions establishing these changes and providing for the formation of Revolutionary Tribunals. Trial to take place within forty-eight hours after the conclusion of the investigation, and the investigation to take not longer than a month. He ended as he ended his sentences, as if by accident, and people scarcely realized he had finished before Sverdlov announced the next speaker.

Arthur Ransome, *Six Weeks in Russia*, 1919

THEN KALININ, PRESIDENT OF THE REPUBLIC, stepped forward to make the announcement. In rasping tones devoid of any trace of emotion the goateed little Bolshevik told the audience that Lenin had died the night before… Nobody stirred. Only scattered coughing could be heard from the rear of the pit. At that moment an orchestra struck up the first strains of Chopin's funeral march. All at once the tension gave way to an outburst of grief. From every corner of the auditorium came wailing and groans. Gigantic, bearded Russians cried like children. The hysteria rose steadily, merging with the weeping trumpets, then surmounting them until they sounded faint and distant as if coming from a storm at sea…

I turned back to the stage. There before me stood Russia's rulers, crying like the people they ruled… Everybody wept, with one exception: Stalin. He alone stood dry-eyed, calm, steely, as composed in manner as he had always appeared at parades. I watched him closely. He was dressed in his familiar attire: a military tunic buttoned at the neck, a pair of black boots, an old soldier's overcoat.

The more the audience wept, the greater seemed Stalin's determination to retain his pose of strength, of a man unmovable by grief, pain, pity, or death itself. Then suddenly he looked down at the newsmen in front of him and, as if embarrassed by their concerted gaze, shifted from foot to foot, dug into his coat pocket, pulled out a handkerchief, and raised it to his eyes. As the weeping continued, Stalin seemed to become annoyed by this sudden impulse to conform, for he pocketed his handkerchief as quickly as he had pulled it out, raised his head, and again stared into space meditative, dry-eyed, completely calm.

Thus the Man of Steel appeared before the Soviet Congress on that fateful day when he was about to step into Lenin's shoes.

William Reswick, *I Dreamt Revolution*, 1952

F. Shternberg and N.Gippius, illustrations for *The Postman Knocks at the Door* by Agnia Barto, 1932

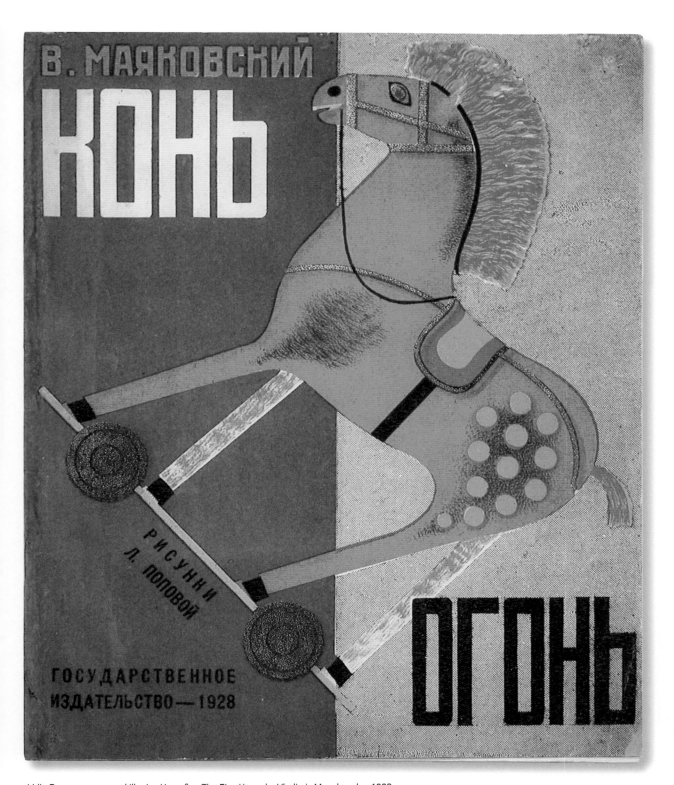

Lidia Popova, cover and illustrations for *The Fire Horse* by Vladimir Mayakovsky, 1928

КОНЬ-ОГОНЬ

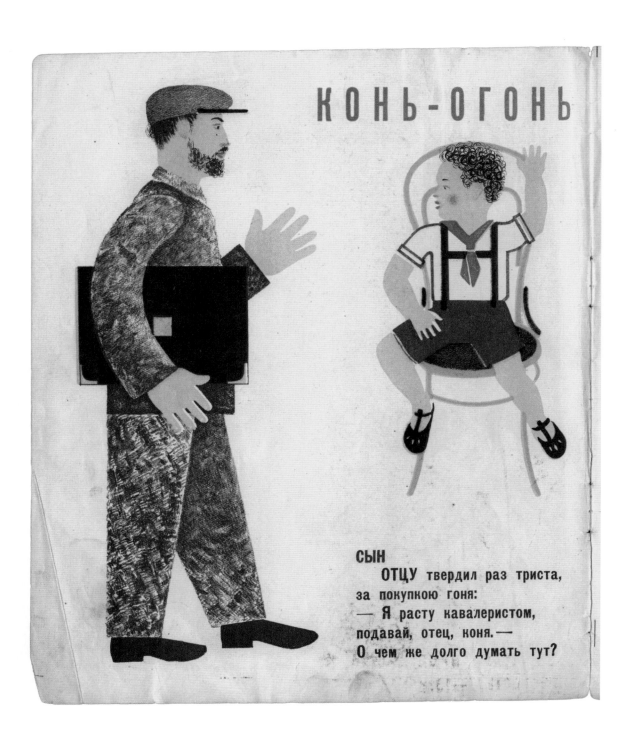

СЫН

ОТЦУ твердил раз триста,
за покупкою гоня:
— Я расту кавалеристом,
подавай, отец, коня. —
О чем же долго думать тут?

Где же конский хвост найти нам?
Там,
 где щетки и щетина!
ЩЕТИНЩИК возражать не стал.
Чтоб лошадь вышла дивной,
дал
 конский волос
 для хвоста

и ГРИВЫ лошадиной.

Прежде чем работать сесть,
осмотрели—

все ли есть?
И в один сказали голос:
— Мало взять картон и волос:
выйдет лошадь бедная,
скучная и бледная.
Взять художника и краски,
чтоб раскрасил

шерсть и глазки. —
К ХУДОЖНИКУ,

удал и быстр,
вбегает наш кавалерист.

— Товарищ,

вы не можете
— покрасить шерсть у лошади?
— Могу!

И вышел лично—
с КРАСКОЮ различной.

Тот, кто ездил,

знает сам —

нет езды без колеса.

Вот они у столяра.
Им СТОЛЯР конечно рад.
Быстро,
 ровно, а не криво
сделал им КОЛЕСИКОВ.
Есть колеса,
 нету гривы,
нет
 на хвост волосиков.

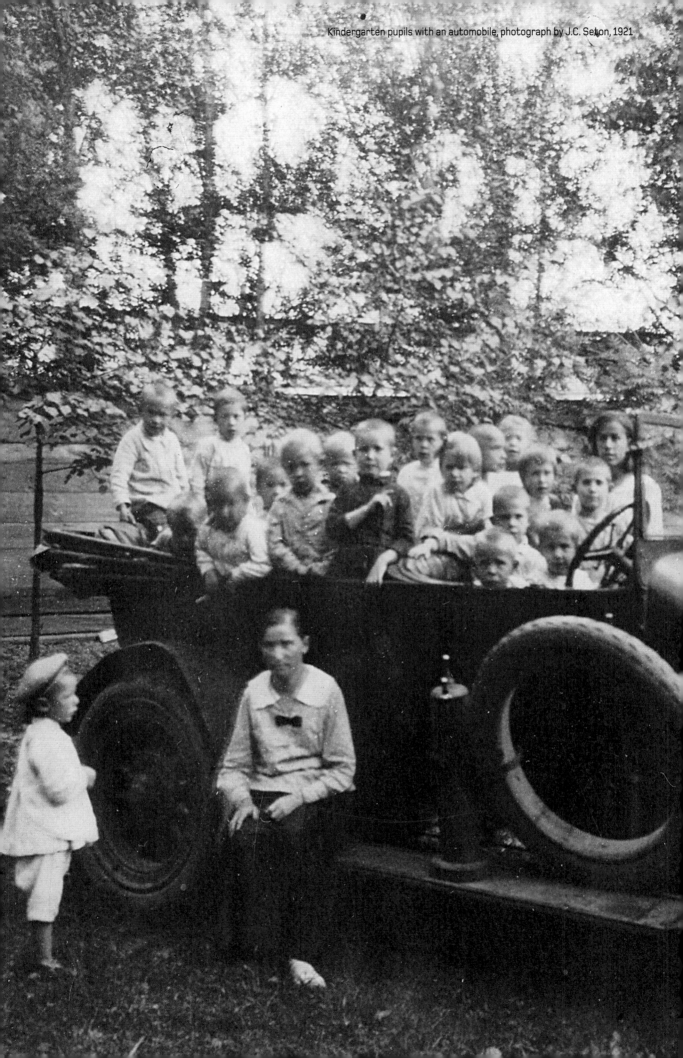

Kindergarten pupils with an automobile, photograph by J.C. Seton, 1921

ON THE MOVE

AND THROUGHOUT THE CITY rushed the muses and furies of the February revolution - trucks and automobiles piled high and spilling over with soldiers, not knowing where they were going or where they would get gasoline, giving the impression of sounding the tocsin throughout the whole city. They rushed around, circling and buzzing like bees.

It was the slaughter of the innocent cars. The countless automobile schools, in order to fill the motorized companies, had been cranking out hordes of drivers with half an hour's training. And now these half-trained characters gleefully fell upon the vehicles.

The city resounded with crashes. I don't know how many collisions I saw during those days... Later on, the city was jammed with automobiles simply left by the wayside.

Viktor Borisovich Shklovsky, *A Sentimental Journey: Memoirs, 1917-1922*

IN THE RED ARMY CLUB AT THE KREMLIN a map of Europe hangs on the wall. Beside it is a handle. When this handle is turned, the following is seen: one after the other, at all the places through which Lenin passed in the course of his life, little electric lights flash. At Simbirsk, where he was born, at Kazan, Petersburg, Geneva, Paris, Krakow, Zurich, Moscow, up to the place of his death, Gorki. Other towns are not marked. The contours of this wooden relief map are rectilinear, angular, schematic. On it Lenin's life resembles a campaign of colonial conquest across Europe. Russia is beginning to take shape for the man of the people. On the street, in the snow, lie maps of the SFSR, piled up by street vendors who offer them for sale . . .

The map is almost as close to becoming the centre of the new Russian iconic cult as Lenin's portrait. Quite certainly the strong national feeling that Bolshevism has given all Russians, regardless of distinction, has conferred a new reality on the map of Europe. They want to measure, compare and perhaps to enjoy that intoxication with grandeur which is induced by the mere sight of Russia; citizens can only be urgently advised to look at their country on the map of neighbouring states, to study Germany on the map of Poland, France or even Denmark; but all Europeans ought to see, on a map of Russia, their little land as a frayed, nervous territory far out to the West.

Walter Benjamin, *Moscow Diary*, 1927

WE SHOULD HAVE BUT ONE SLOGAN – to learn the art of war properly and put the railways in order. To wage a socialist revolutionary war without railways would be rank treachery.

I PARTICULARLY APPROVE of and welcome the arrest of the millionaire saboteurs in the first and second-class railway carriage.

Lenin, *Collected Works,* volume 36, p. 466, and volume 27, p. 108

FIRST IT WAS THE MENSHEVIKS AND THEIR TRUCKS, then the Bolsheviks and their armoured cars. . . The truck: what a terrible symbol it has become for us! How many trucks have been part of our most burdensome and terrible memories! From the very first day, the Revolution has been tied to this roaring and stinking animal, filled to overflowing first with hysterical people and vulgar mobs of military deserters, and then with elitist-type convicts. All the vulgarity of contemporary culture and its "social pathos" are embodied in the truck.

Ivan Bunin, *Cursed Days: Diary of a Revolution,* 1927

Vladimir Tambi, cover for *Ships*, 1929

Eduard Krimmer, cover and illustrations for *Port* by Semyon Polotsky, 1926

ЗЕМЛЕЧЕРПАЛКА

Дело знаю одно:
Залезаю на дно
И руками-черпаками

Вынимаю грязь и камень,
Чтобы с моря сюда
Заходили суда.

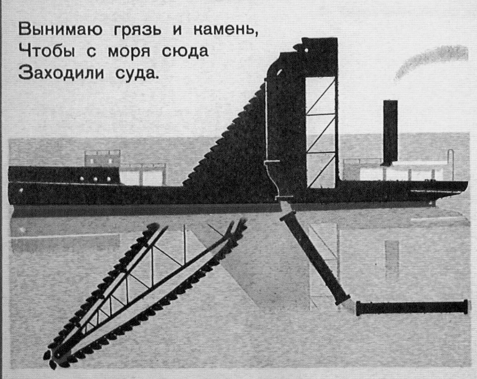

Хрюкаю и чавкаю,
Как свинья за травкою.

ИЗ МЕАНОГО КРАНА БЕЖИТ ВОАА
ПО ТРУБАМ ОНА АОБРАЛАСЬ СЮАА

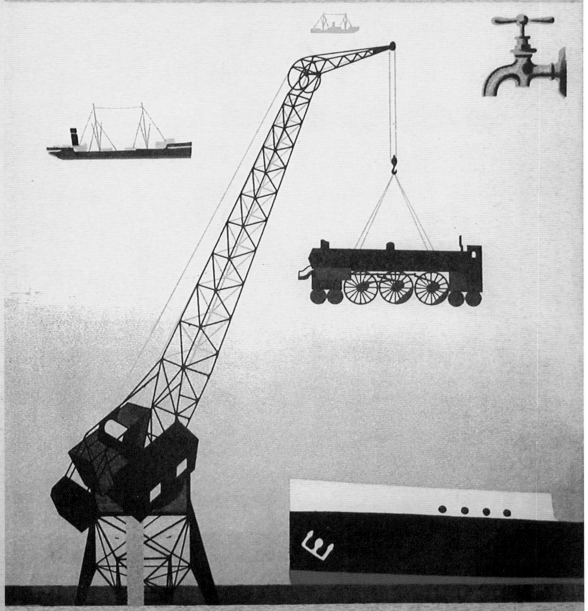

ТЯЖЕЛЫЕ ГРУЗЫ ИЗ ААЛЬНИХ СТРАН
В ПОРТУ ВЫГРУЖАЕТ ПОД'ЕМНЫИ КРАН

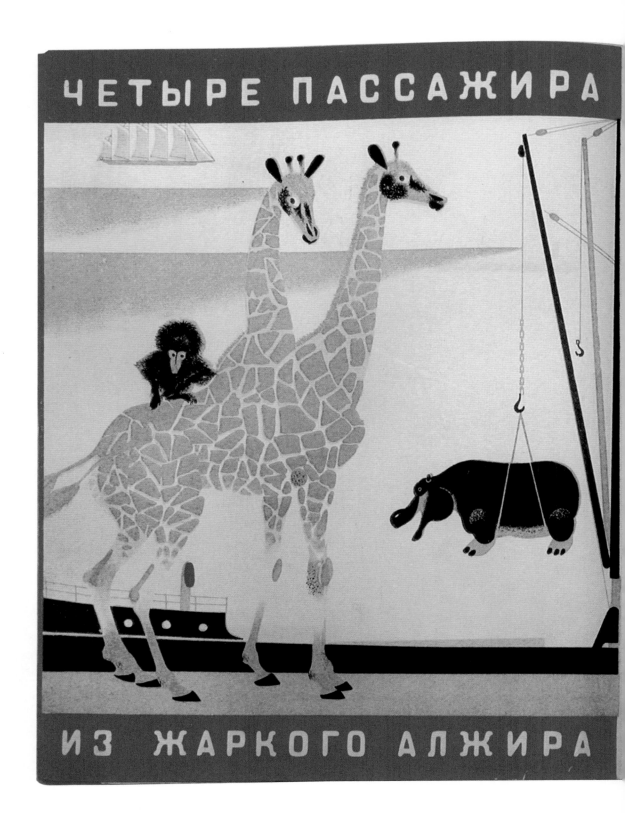

ЧЕТЫРЕ ПАССАЖИРА

ИЗ ЖАРКОГО АЛЖИРА

ПАРОХОДЫ ВЕРЕНИЦЕЙ

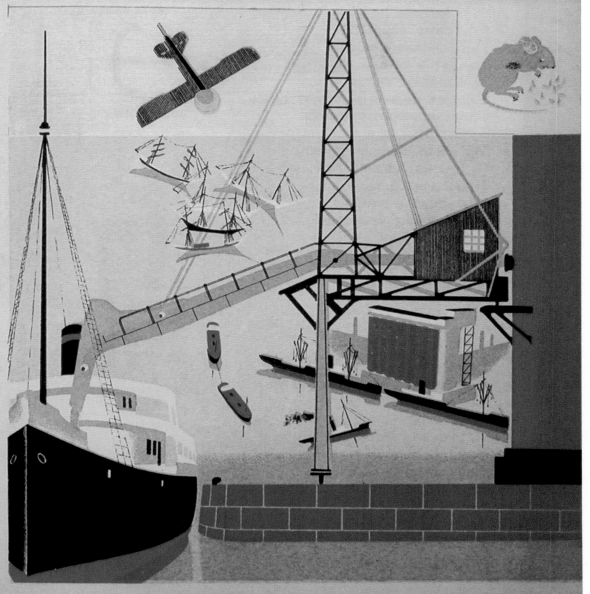

НАЕДАЮТСЯ ПШЕНИЦЕЙ

РАЗГОВОР ФЛАГОВ

1 ЧТО ВЕЗЕТЕ
2 КНИГУ

ПОД КОМАНДОЙ ДЖОНА БУЛЯ ПАРОХОД ИЗ ЛИВЕРПУЛЯ
"КОМСОМОЛЕЦ" ДЕРЖИТ РУЛЬ ИЗ РОССИИ В ЛИВЕРПУЛЬ.

3 КАКУЮ
4 ПОРТ

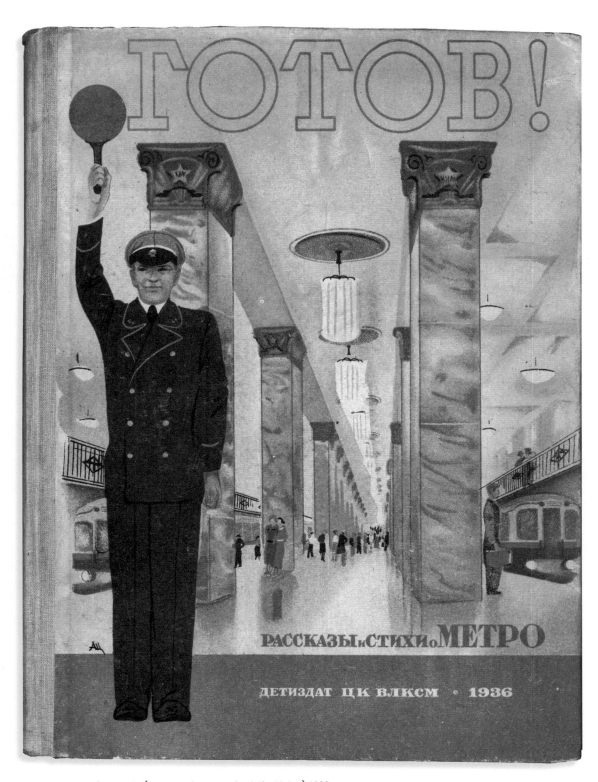

M. Zhukov, cover for *Ready!* (poems and stories about the Metro), 1936

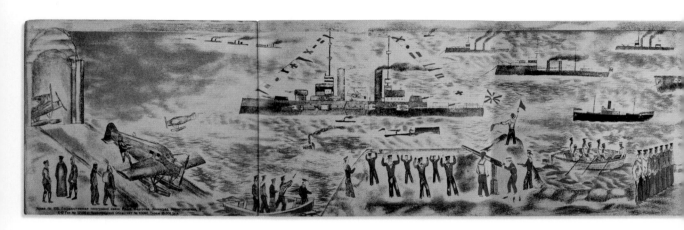

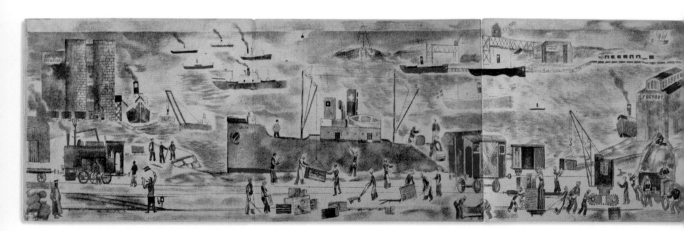

A. Nikolaev, cover and illustrations for *Port,* 1930

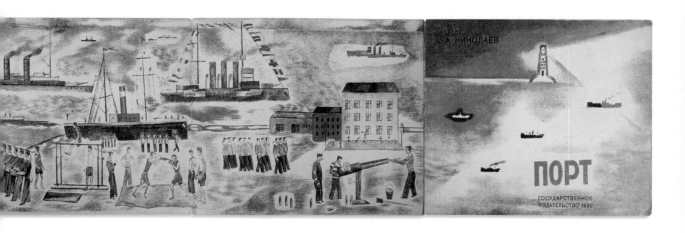

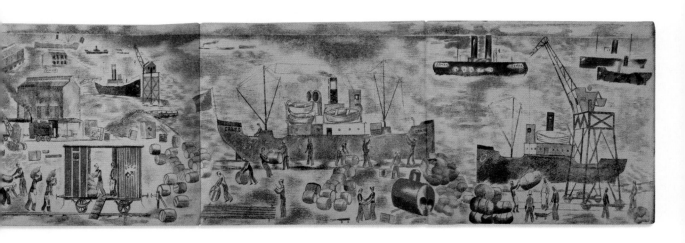

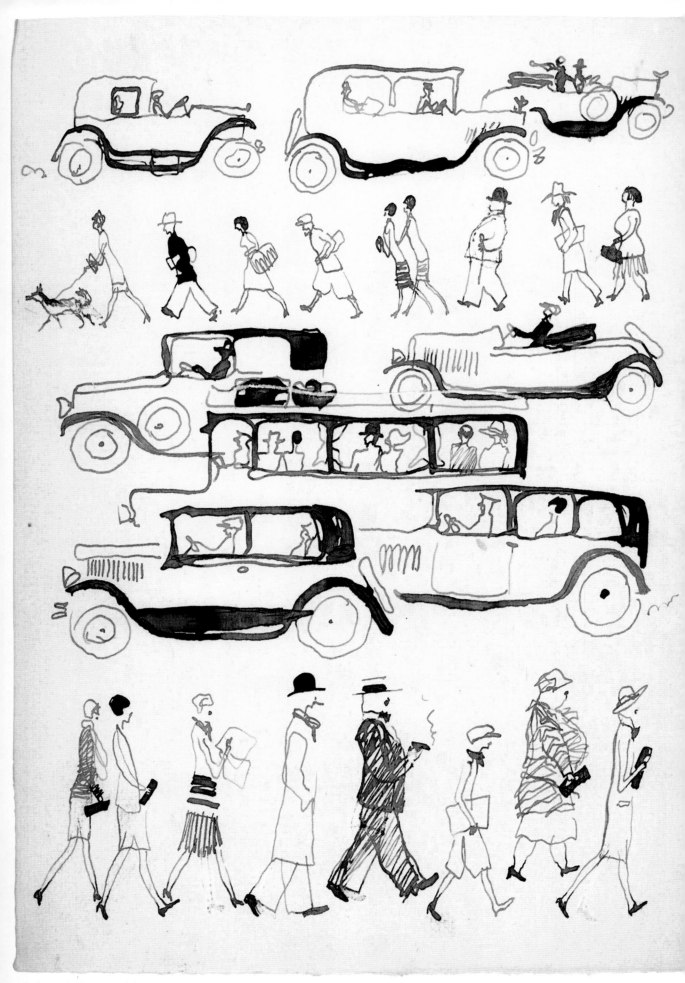

Vladimir Lebedev, original drawing, c. 1932

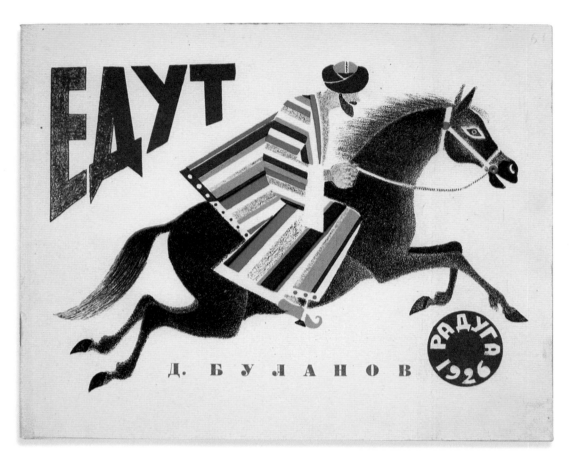

Мулат на страусе. Турок на осле.

Dimitri Bulanov, cover and illustrations for *They Travel,* 1926

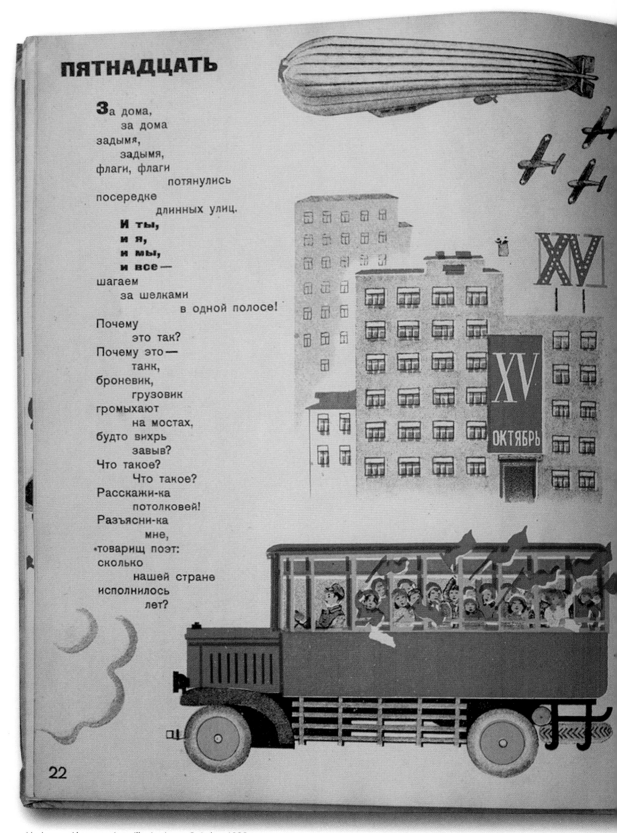

ПЯТНАДЦАТЬ

За дома,
 за дома
задымя,
 задымя,
флаги, флаги
 потянулись
посередке
 длинных улиц.
 И ты,
 и я,
 и мы,
 и все —
шагаем
 за шелками
 в одной полосе!

Почему
 это так?
Почему это —
 танк,
броневик,
 грузовик
громыхают
 на мостах,
будто вихрь
 завыв?
Что такое?
 Что такое?
Расскажи-ка
 потолковей!
Разъясни-ка
 мне,
товарищ поэт:
сколько
 нашей стране
исполнилось
 лет?

22

Various authors, various illustrators, *October*, 1932

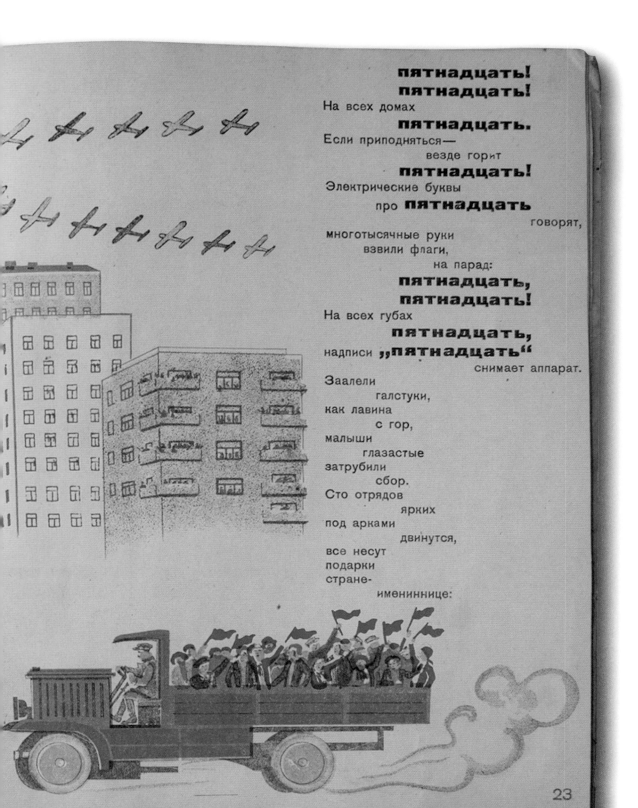

ПЯТНАДЦАТЬ!
ПЯТНАДЦАТЬ!
На всех домах
ПЯТНАДЦАТЬ.
Если приподняться—
 везде горит
 ПЯТНАДЦАТЬ!
Электрические буквы
 про **ПЯТНАДЦАТЬ**
 говорят,
многотысячные руки
 взвили флаги,
 на парад:
 ПЯТНАДЦАТЬ,
 ПЯТНАДЦАТЬ!
На всех губах
 пятнадцать,
надписи „**ПЯТНАДЦАТЬ**"
 снимает аппарат.
Заалели
 галстуки,
как лавина
 с гор,
малыши
 глазастые
затрубили
 сбор.
Сто отрядов
 ярких
под арками
 двинутся,
все несут
подарки
стране-
 имениннице:

23

ЧАРЛИ ЧАПЛИН

ВЕСЕЛЫЙ АМЕРИКАНЕЦ

Его показывают на картинах в кино,
Решил представить путешествие на экране,—
И для этого объехать шар земной,
Везде побывать... на все взглянуть,—
Решил, уложил чемодан—и в путь.

— 4 —

Но поскорее объехать весь свет как?
Чарли Чаплин и тут не сплошал.—
У Чарли Чаплина

МОТОЦИКЛЕТКА

Он ее вывел и оседлал.

Все замелькало, как в кино,
Город остался за спиной.

— 5 —

В час не меньше как верст по сорок
Чаплина вез его мотоцикл.
К ночи домчал

до города НЬЮ-ЙОРКА

И на пристань прямо проник.

— 6 —

ЧАРЛИ СЛЫШИТ-ГУДИТ ПАРОХОД,

ОН - НА НЕГО

И В ЕВРОПУ ПЛЫВЕТ.

— 7 —

Olga and Galina Chichagova, illustrations for *The Travels of Charlie* by Nikolai Smirnov, 1925

Японцы хотели отправить Чарли

НА
ВОЗДУШНОМ
ШАРЕ

ЧЕРЕЗ ОКЕАН,

Но Чарли отказался лететь на шаре,

— 13 —

ЧАПЛИНА В МОСКВЕ
ВСЕГДА ЛЮБИЛИ ,

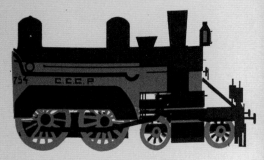

Ему подали курьерский ПАРОВОЗ.
Двадцать дней он ехал по Сибири,
Пил и ел и спал под стук колес.
Но вот раздался последний свисток,
Чарли приехал во Владивосток.

ТАМ, НА _____
ПОДВОДНУЮ ЛОДКУ
ПРОНИКШИ,

Чарли под водою до Японии плыл,

ПО САМОЙ ЯПОНИИ
ПРОЕХАЛ
НА
РИКШЕ

При чем рикша бежал выбиваясь из сил.
Чарли сказал, спрыгнув на берегу:
— Я вижу, здесь людей не берегут.

Японцы хотели отправить Чарли

НА
ВОЗДУШНОМ
ШАРЕ

ЧЕРЕЗ ОКЕАН,

Но Чарли отказался лететь на шаре,

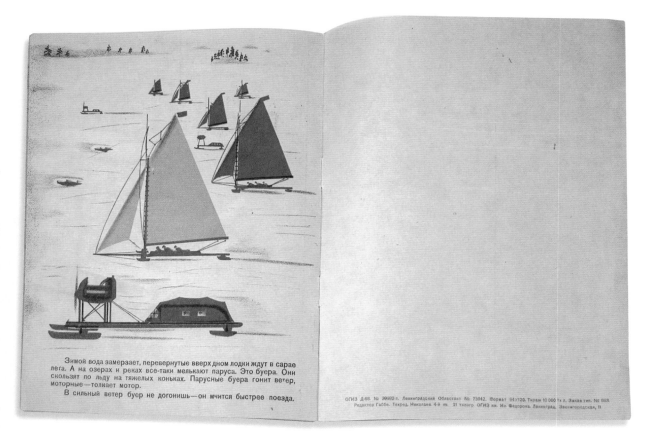

ОГИЗ Д-68. № 39992 г. Ленинградский Областлит № 73042. Формат 94×120. Тираж 10 000 ½ п. л. Заказ тип. № 983.
Редактор Габбе. Техред. Николаев. 4-я кн. 21 типогр. ОГИЗ кн. Им. Федорова. Ленинград, Звенигородская, 11

Зимой вода замерзает, перевернутые вверх дном лодки ждут в сарае лега. А на озерах и реках все-таки мелькают паруса. Это буера. Они скользят по льду на тяжелых коньках. Парусные буера гонит ветер, моторные—толкает мотор.

В сильный ветер буер не догонишь—он мчится быстрее поезда.

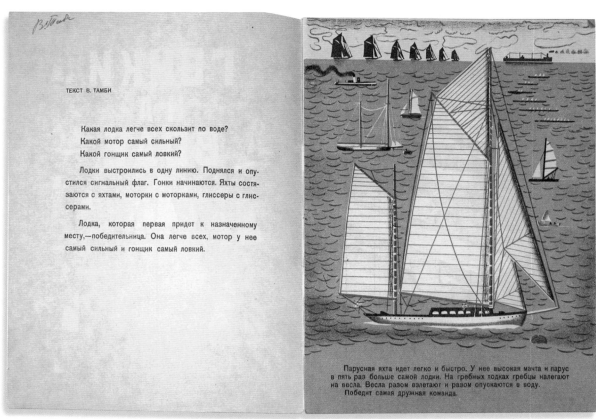

ТЕКСТ В. ТАМБИ

Какая лодка легче всех скользит по воде?
Какой мотор самый сильный?
Какой гонщик самый ловкий?

Лодки выстроились в одну линию. Поднялся и опустился сигнальный флаг. Гонки начинаются. Яхты состязаются с яхтами, моторки с моторками, глиссеры с глиссерами.

Лодка, которая первая придет к назначенному месту,—победительница. Она легче всех, мотор у нее самый сильный и гонщик самый ловкий.

Парусная яхта идет легко и быстро. У нее высокая мачта и парус в пять раз больше самой лодки. На гребных лодках гребцы налегают на весла. Весла разом взлетают и разом опускаются в воду.
Победит самая дружная команда.

Vladimir Tambi, *Book of Shipwrecks*, 1932

Nikolai Denisovsky, front and back cover for *The Machine Got Going*, 1929

По газетах пишуть:

Радянський інженер придумав незвичайного літака—

дужого,

швидкого,

тримоторового.

У ньому дванадцять чоловіка полетить.

Літака збудували в Москві й назвали

„КРИЛА РАД“.

Полетить літак далеко, в чужі країни:
ДО НІМЦІВ, ФРАНЦУЗІВ, АНГЛІЙЦІВ.

Нехай поглянуть там, які літаки вміють будувати в СРСР.

Полетить на „КРИЛАХ РАД“ літун ГРОМОВ, відважний, сміливий, справжній літун радянський.

Полетить ще його помічник. Полетить інженер. Полетять і письменники. Вони будуть про літ листи писати,

А ми прочитаємо й про все дізнаємось.

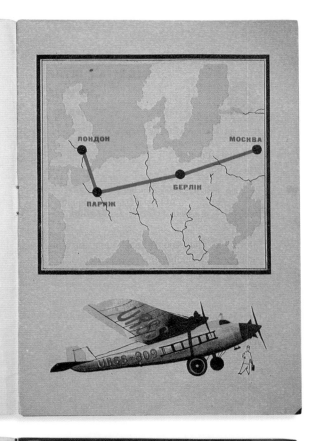

Швидко його зовсім не стало видно.

Люди в літакові писали один одному цидулки:

РОЗМОВЛЯТИ НЕ БУЛО ЗМОГИ
ТАК ГУРКОТІЛИ МОТОРИ—

довелося заткнути уші бавовною.

У літунів навіть кістяні кнопки на цей випадок є.

Геть-геть унизу на землі

БУДИНОЧКИ малесенькі-манюні,

ЛІС _____ немов спориш,

А ОЗЕРО _____ як тарілка.

У шахмати стали гуляти. То одна, то друга фігурка на підлогу котиться:

Boris Kryukov, illustrations for *Biography of Kolkin* by D. Chepurniy, 1930

151

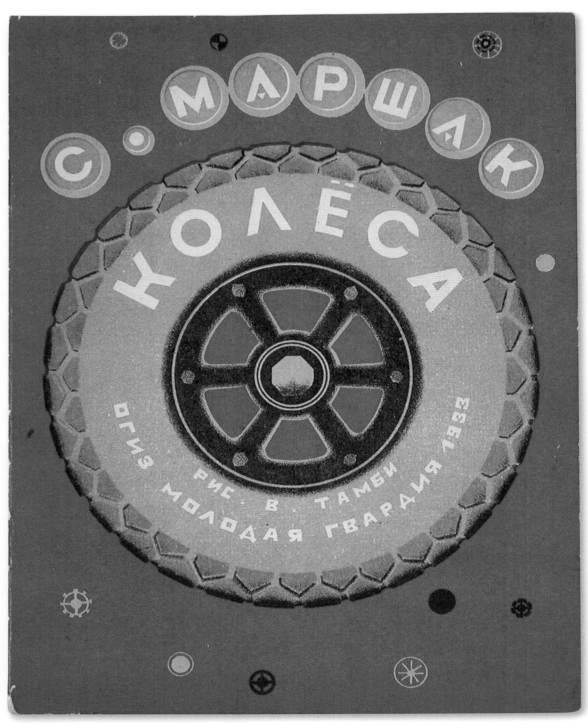

Vladimir Tambi, cover for *Wheels* by Samuil Marshak, 1933

Vladimir Tambi, cover and illustrations for *Aviation*, 1930

СПАЛЬНЫЙ АВТОБУС

ШЕСТИКОЛЕСНЫЙ АВТОБУС

Vladimir Tambi, illustration for *The Automobile*, 1930

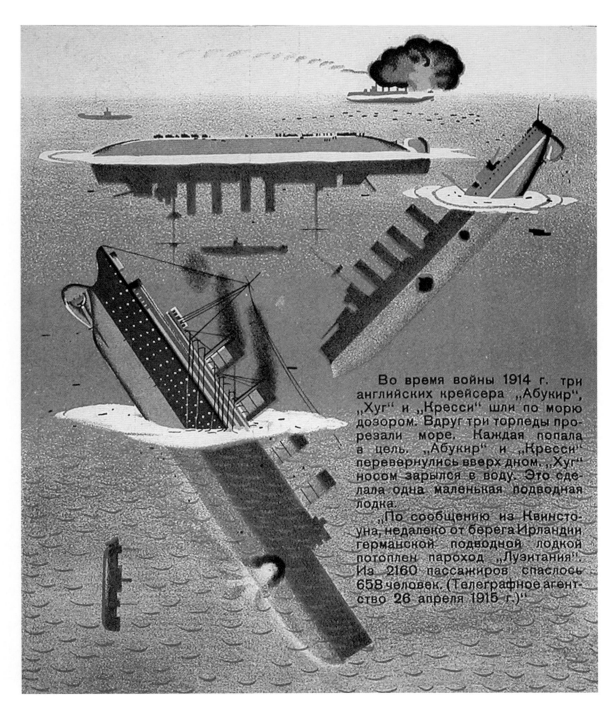

Во время войны 1914 г. три английских крейсера „Абукир", „Хуг" и „Кресси" шли по морю дозором. Вдруг три торпеды прорезали море. Каждая попала в цель. „Абукир" и „Кресси" перевернулись вверх дном. „Хуг" носом зарылся в воду. Это сделала одна маленькая подводная лодка.

„По сообщению из Квинстоуна, недалеко от берега Ирландии германской подводной лодкой потоплен пароход „Лузитания". Из 2160 пассажиров спаслось 658 человек. (Телеграфное агентство 26 апреля 1915 г.)"

Vladimir Tambi, illustration for *The Submarine*, 1930

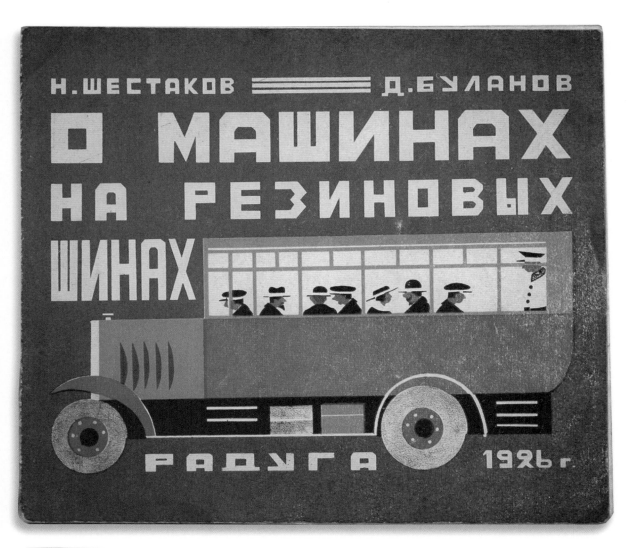

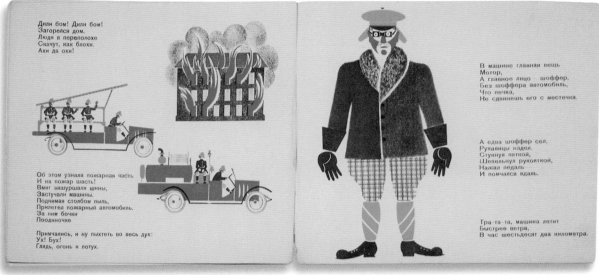

Dmitri Bulanov, cover and illustrations for *About Automobiles with Rubber Tyres* by Nikolai Shestakov, 1926

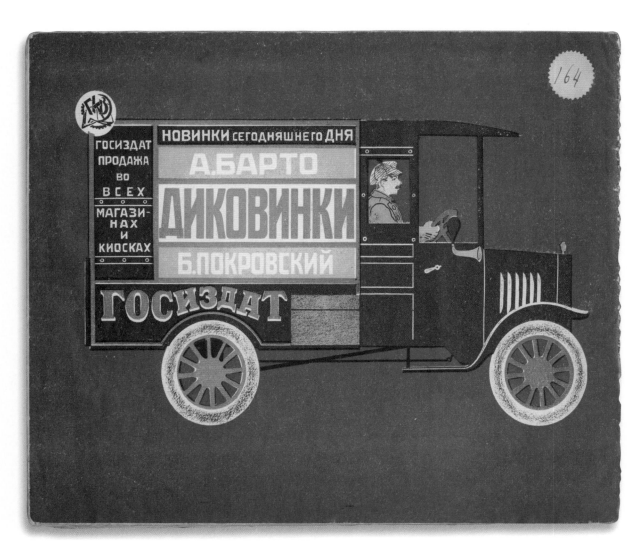

ABOVE: Boris Pokrovsky, back cover for *Wonder Things* by Agnia Barto, 1928

BELOW: Galina and Olga Chichagova, illustrations for *Let's Go*, 1929

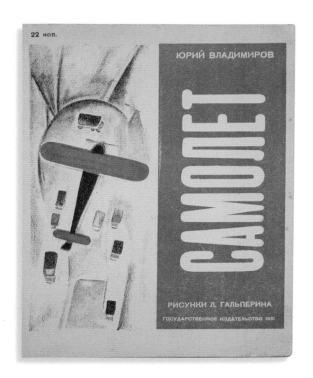

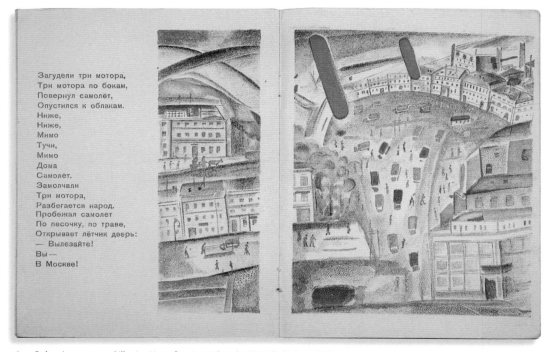

Lev Galperin, cover and illustrations for *Aeroplane*, by Yuri Vladimirov, 1931

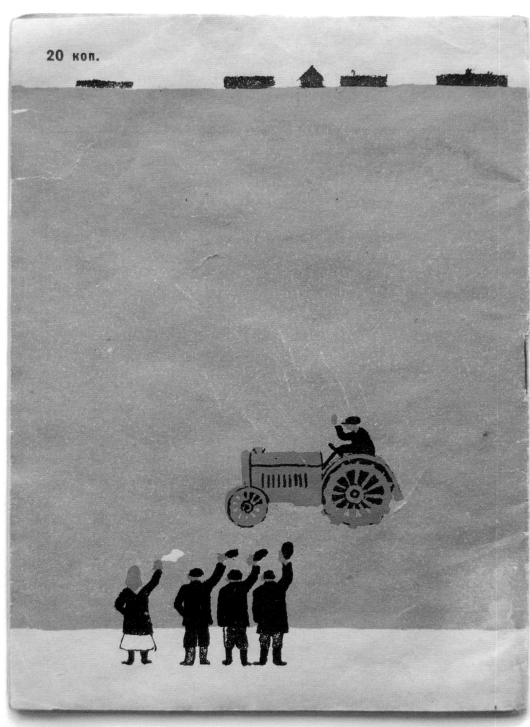

V. Suckau, back cover for *Sowing*, 1931

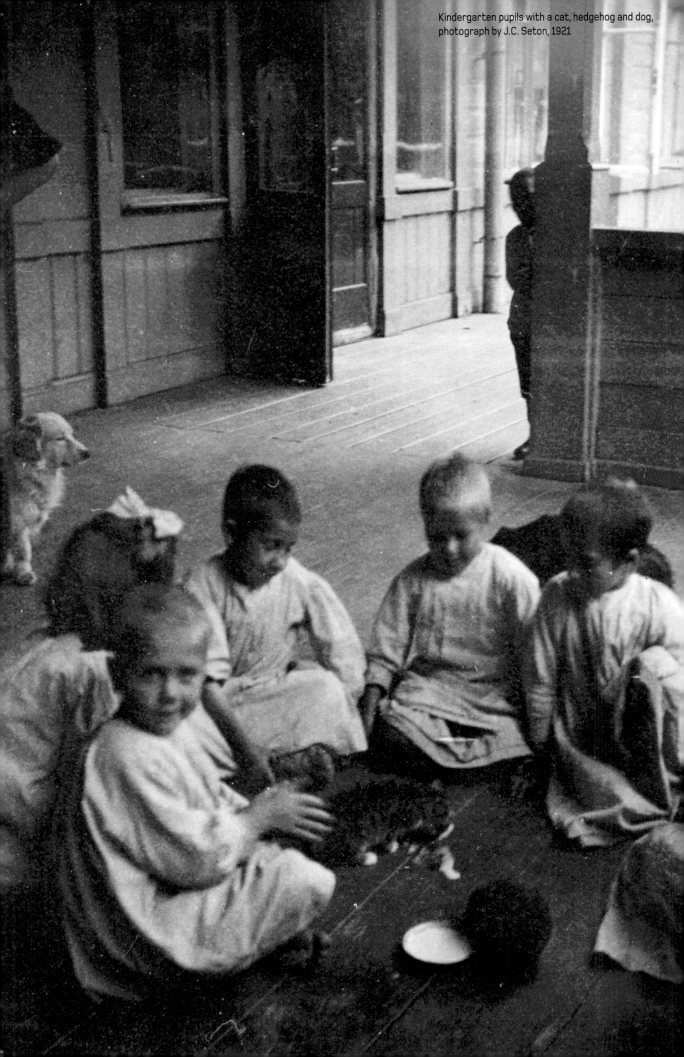

Kindergarten pupils with a cat, hedgehog and dog, photograph by J.C. Seton, 1921

6

MEET THE REMARKABLE ANIMALS

Moscow Zoo, 1920

SO FASHIONABLE and, now, so popular a work as Chukovsky's *Crocodile,* like all of Chukovsky's stories for children, is one of the better examples of (the) perversion of children's poetry with nonsense and gibberish. Chukovsky seems to proceed from the assumption that the sillier something is, the more understandable and the more entertaining it is for the child, and the more likely that it will be within the child's grasp. It is not hard to instill the taste for such dull literature in children, though there can be little doubt that it has a negative impact on the educational process, particularly in those immoderately large doses to which children are now subjected. All thought of style is thrown out, and in his babbling verse Chukovsky piles up nonsense on top of gibberish. Such literature only fosters silliness and foolishness in children.

Lev Vygotsky, *Educational Psychology,* 1926

25 August, 1925

FROM MY TRAVELS this summer I've gathered a general impression of provincial Russia. Most of all from conversations in the country (leaving out the local nuns), about wolves, and in the towns and cities, about mad dogs. Rabies, according to statistical evidence, has reached unprecedented proportions, and moreover occurs throughout Russia. The whole way people complained about the wolves and told of all kinds of terrible things…

Of art – not a word; from no-one, anywhere, it doesn't exist…

Nikolay Punin, *The Diaries 1904-1953*

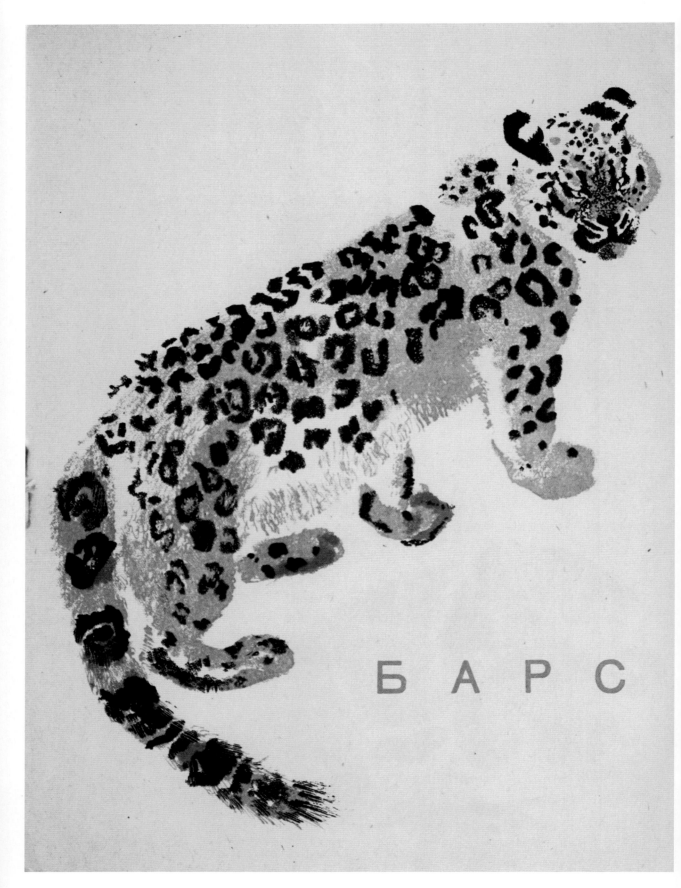

БАРС

Yevgeny Charushin, illustration for *Different Animals*, 1929

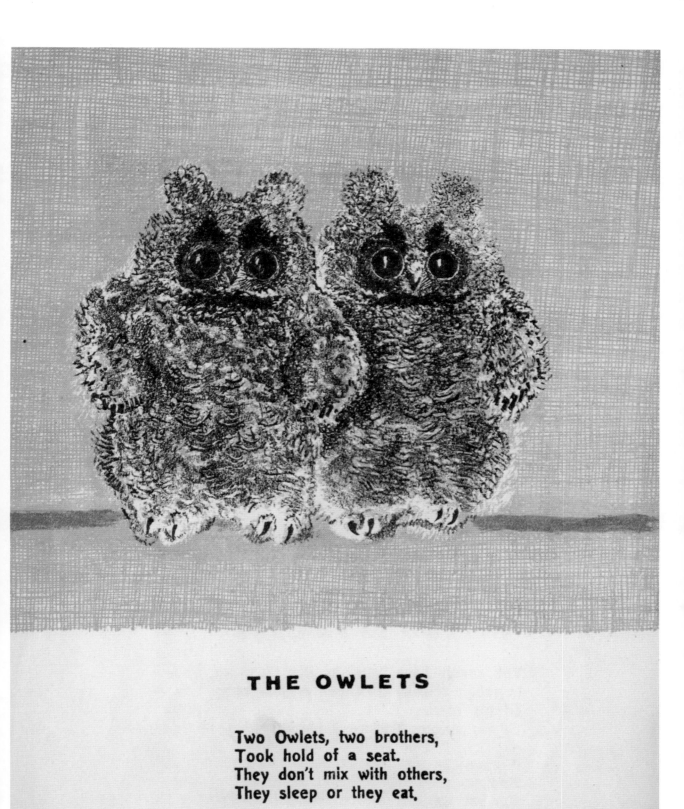

THE OWLETS

Two Owlets, two brothers,
Took hold of a seat.
They don't mix with others,
They sleep or they eat.

Yevgeny Charushin, illustrations for *Babies of the Zoo* by Samuil Marshak, c. 1935

THE TIGER CUB

I'm a Tiger, not a Cat,
I'm too dangerous to pat!

THE CAMEL

This young Camel's mood
Is gloomy and sad:
Two pails full of food
Was all that he had!

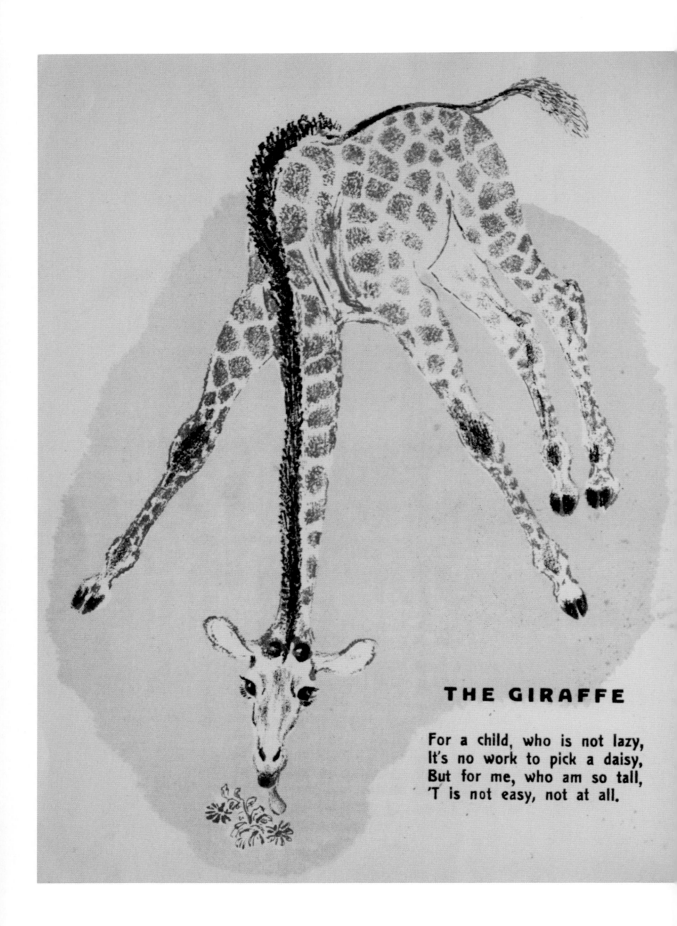

THE GIRAFFE

For a child, who is not lazy,
It's no work to pick a daisy,
But for me, who am so tall,
'T is not easy, not at all.

THE TWO PENGUINS

You see,—my little brother
And I were hatched today.
We don't know who's our mother,
I'ts hard for us to say.

We don't look like a Crow,
Or Ostriches or Geese.
But wait... of course, we know,
Do call us Penguins, please!

THE POLAR BEARS

We swim and dive here gaily
Within this handsome pool.
They change the water daily
And keep it fresh and cool.

From one wall to the other
We paddle to and fro.
Keep to the right, my brother,
Don't shove me with your toe!

KANGAROO

Little long-tailed Kangaroo
Has a baby sister too,
But the mother's keeping her
In a belly-bag of fur.

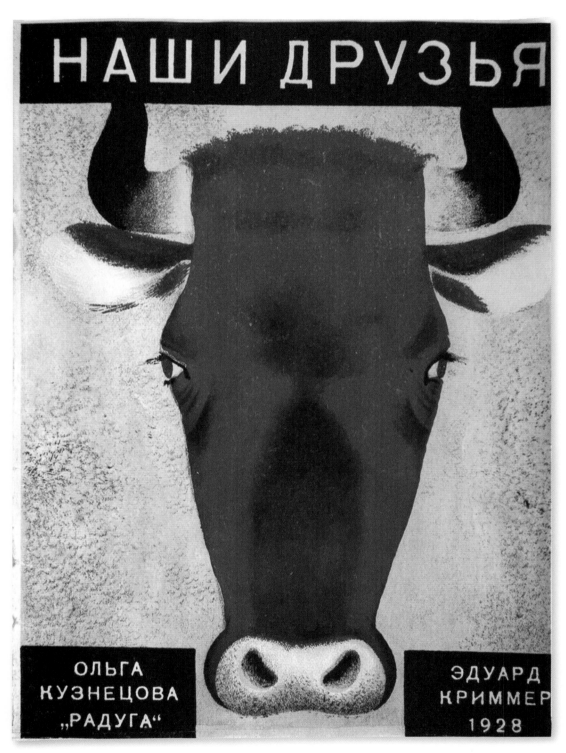

Eduard Krimmer, cover and illustrations for *Our Friends* by Olga Kuznetsova, 1928

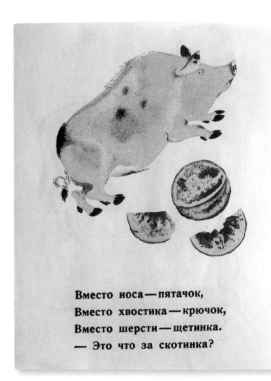

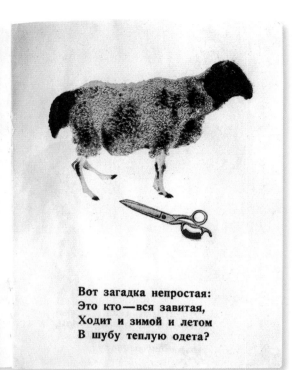

Вместо носа — пятачок,
Вместо хвостика — крючок,
Вместо шерсти — щетинка.
— Это что за скотинка?

Вот загадка непростая:
Это кто — вся завитая,
Ходит и зимой и летом
В шубу теплую одета?

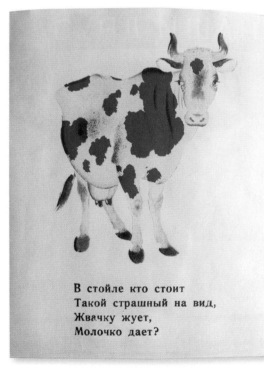

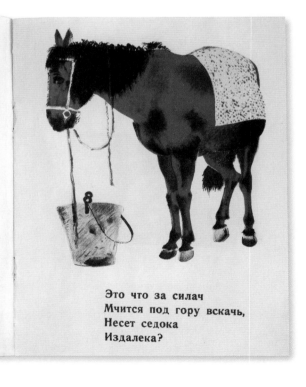

В стойле кто стоит
Такой страшный на вид,
Жвачку жует,
Молочко дает?

Это что за силач
Мчится под гору вскачь,
Несет седока
Издалека?

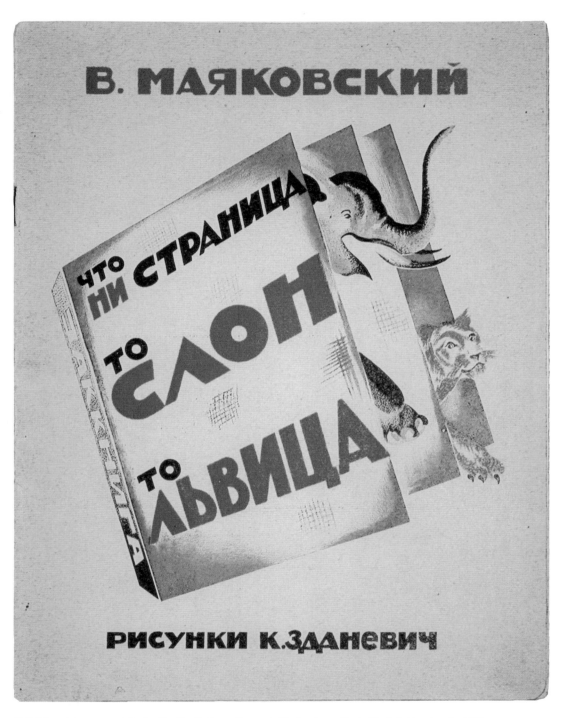

Kirill Zdanevich, cover and illustration for *On Every Page – An Elephant or a Lion* by Vladimir Mayakovsky, 1928

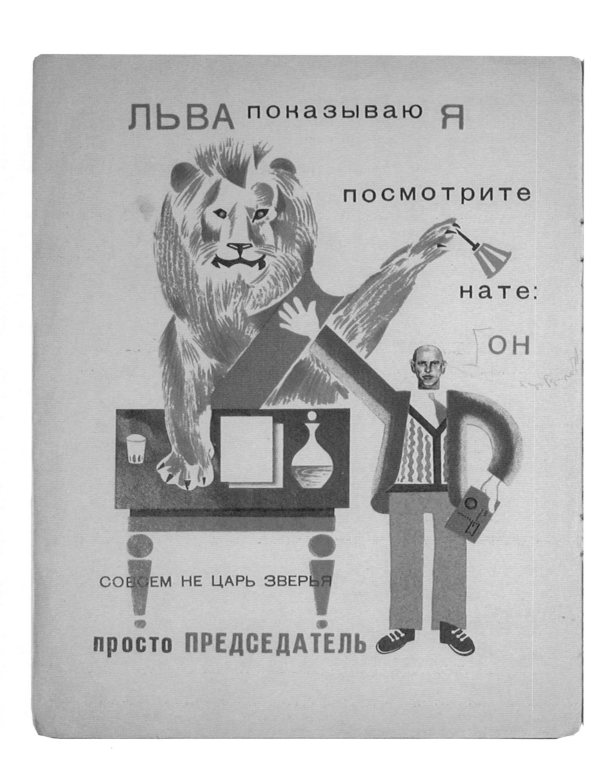

ИЗДАТЕЛЬСТВО „МЫСЛЬ"

ПЕТРОГРАД | **МОСКВА**
Ковенский, 11 | Тверская, 19

ДЕТСКИЕ КНИЖКИ | **РИСУНКИ**

Золотое яичко	В. В. Лебедев
Медведь	В. В. Лебедев
Заяц, петух и лиса	В. В. Лебедев
Три козла	В. В. Лебедев
Серенький козлик	Н. А. Тырса
Коза-дереза	К. С. Петров-Водкин
Снегурочка	К. С. Петров-Водкин

Петрооблит № 11395 Тираж 10000 Петроград, Лит. Л. В. Волка, 9 линия 18.

Vladimir Lebedev, front and back cover for *The Bear*, c. 1923

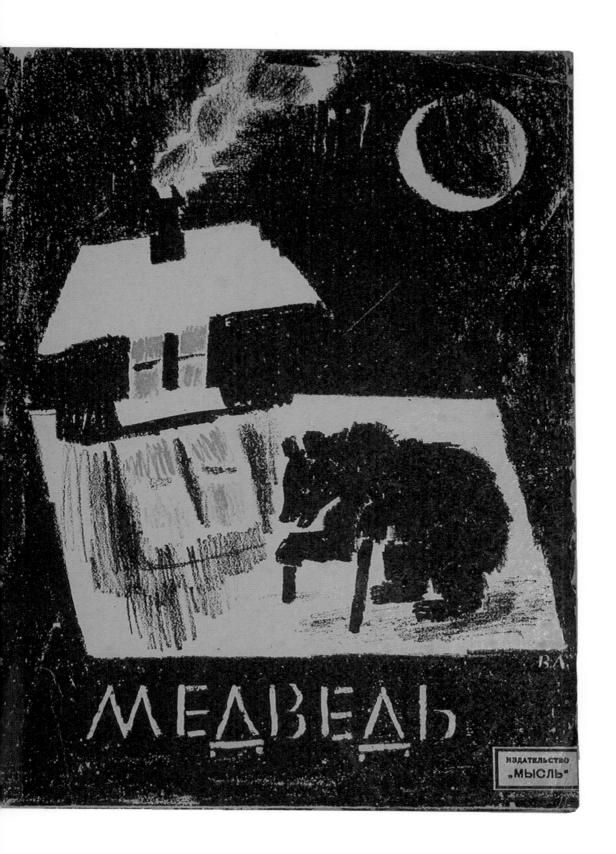

МЕДВЕДЬ

ИЗДАТЕЛЬСТВО
„МЫСЛЬ"

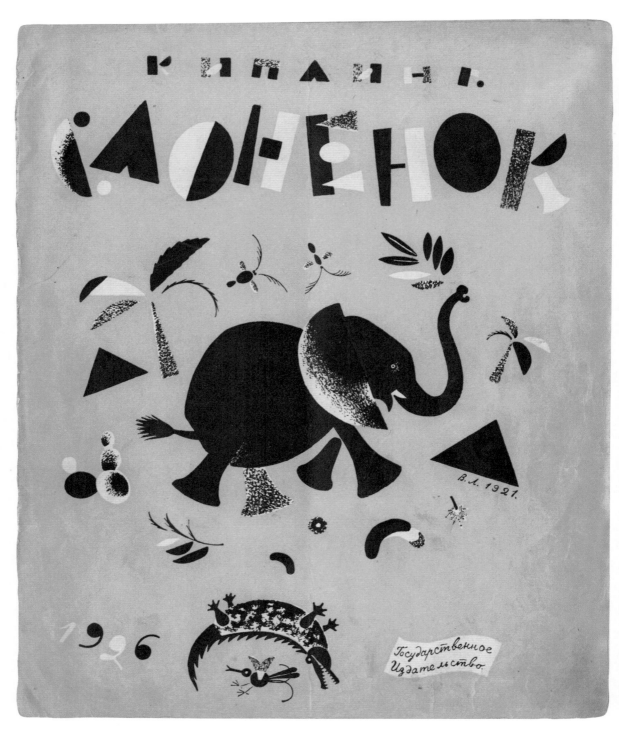

Vladimir Lebedev, cover for *The Elephant's Child* by Rudyard Kipling, 1926

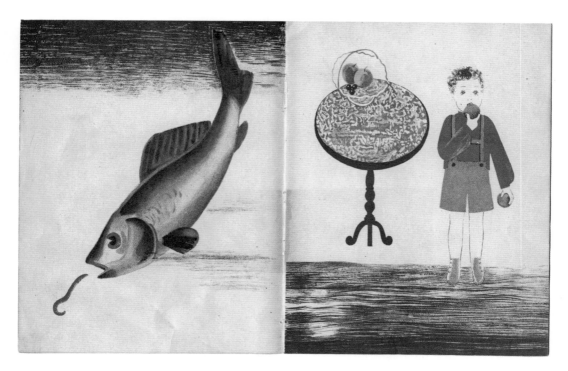

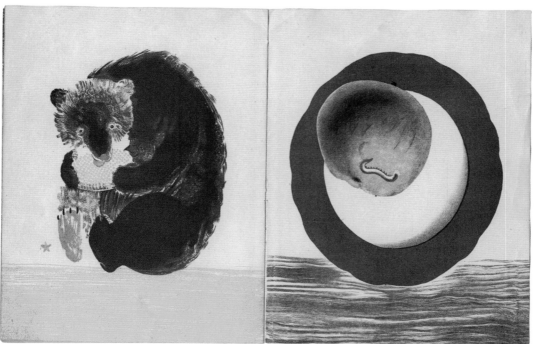

Lidia Popova, illustrations for *Little Foodies*, 1930

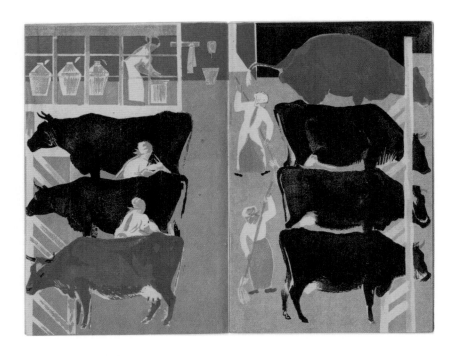

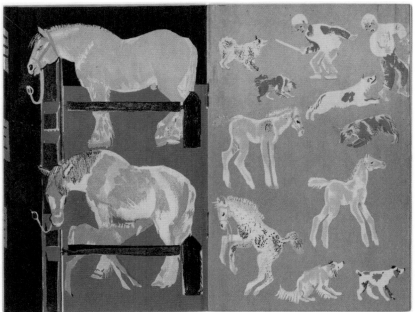

Theodor Pevzner, illustrations for *Animal Farm* by Yevgeny Shvarts, 1931

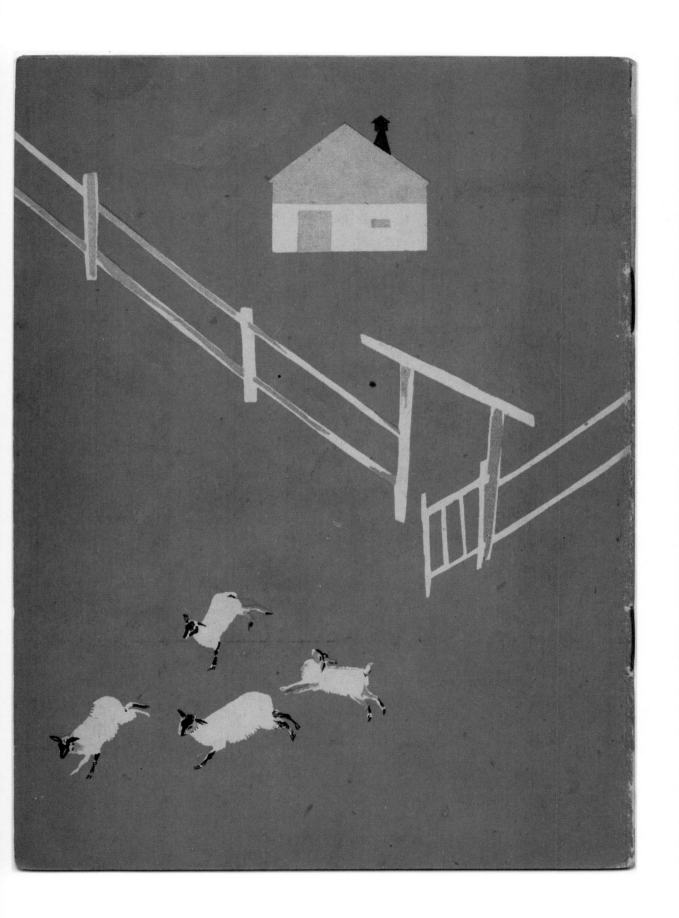

Unknown illustrator, cover for magazine, *Hedgehog,* No.1, 1928

КОШКА

П 30 г.

Yuri Pimenov, illustration for *House Pets*, c.1925

Evgeny Charushin, illustrations for *The Little Chick* by Kornei Chukovsky, 1934

Evgeny Charushin, cover for *Little Beasties*, c. 1925

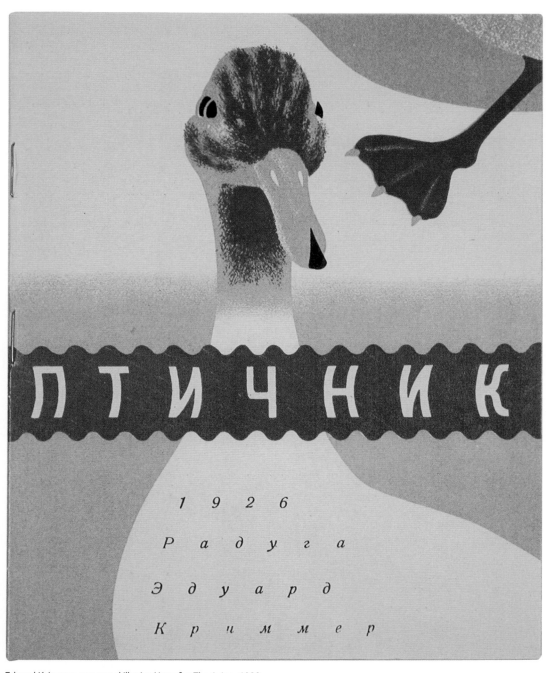

ПТИЧНИК

1 9 2 6

Р а д у г а

Э д у а р д

К р и м м е р

Eduard Krimmer, cover and illustrations for *The Aviary*, 1926

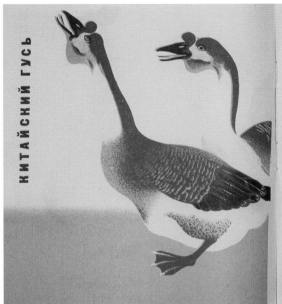

КИТАЙСКИЙ ГУСЬ

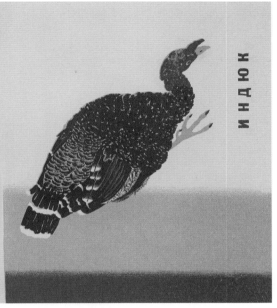

ИНДЮК

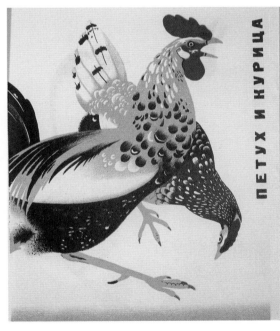

ПЕТУХ И КУРИЦА

ФАЗАН

Vladimir Konashevich, illustration for *The Muddle* by Kornei Chukovsky, 1923

Kornei Chukovsky THE MUDDLE

Once the kittens raised a row:
"Oh, how dull it is to miaow!
Let us better bark like doggies:
Bow-wow-wow!"

After that the ducklings spoke:
"What's the good of quacking, folk?
Let us better croak like froggies:
Croak-croak-croak!"

So the piglets started miaowing:
"Miaow-miaow-miaow!"

And the cats began bow-wowing:
"Bow-wow-wow!"

And the ducklings started croaking:
"Croak-croak-croak!"

And the chicken started quacking:
"Quack-quack-quack!"

Then the sparrow hopped along
And began a milk-cow's song:
"Moo-oo-oo!"

Then came Bruin-Touzled-Fur
And instead of gr-gr-gr
Said "Cockadoodledoo!"

And the cuckoo shouted too:
"Why have I to say cu-ckoo?
Let me grunt like little piggies:
Oink-oink-oink!"

"Those who say miaow
Shouldn't say bow-wow
Those who say bow-wow
Shouldn't say miaow."

Only little Bunny
Didn't think it funny

To say miaow
Or bow-wow-wow.
He lay beneath a cabbage-head
And in bunny-language said
To coax his naughty playmates:
"Toads don't fly and flies don't browse
Nor can crows turn into cows!"

But the merry cubs and chicks
Wouldn't stop their naughty tricks,
But went on to shout and roar,
Even louder than before.

Fishes toddled high and dry,
Toads went flying through the sky.
Mice set traps and caught a cat:
In a mouse-trap Pussy sat,

While the foxes
Took matchboxes,
Walked across the grassy lea
And set fire to the blue sea.

How it burned and how it smoked!
Out a whale's great muzzle poked;
"Fire!" The whale began to shout,
"People, help us put it out!"

Running up, the crocodile
Tried to quench the flames a while
With dry mushrooms, cakes and pies,
Yet the flames still reached the skies.

With a barrel came two hens,
But the flames were too immense.

From the lakes two rufflings swam,
Bringing water in a pan.
With a wooden bucket last
Two young frogs came running fast.
Long they poured and poured and poured,
But the flames just roared and roared.

Then a butterfly flew by,
Flapped and fluttered from the sky;
Quieter, quieter grew the flames
And went out.

Full of joy, the beasts and birds
Danced and sang in flocks and herds,
Stamped their feet and wagged their tails
Over all the woods and dales.
Baby gosling honked once more
As they used to do before:
"Honk-honk-honk!"

Cats and kittens purred and miaowed:
"Miaow-miaow-purr!"

And the birdies sang aloud:
"Tweet-tweet-tweet!"

Foals and colts began to neigh:
"Hee-haw-haw!"

Flies and beetles buzzed away:
"Zzz-zz-zz!"

And the little froggies croaked:
"Croak-croak-croak!"

And the little ducklings quacked:
"Quack-quack-quack!"

Beasts and birds, both tame and wild,
Flocking in from earth and sky,
Sang in chorus to my child:
"Lulla-lulla-by!"

Translated by Dorian Rottenberg

M. A. Purgold, cover and illustration for *Snatcher the Mathematician* by M. Andrievskaya, 1926

Дело было на опушке,
Где жужжала мошкара,
У лягушки, у квакушки
Народилась детвора:

El Lissitzky, cover for *The Elephant's Child* by Rudyard Kipling, 1922

Vladimir Tatlin, cover for *Firstly and Secondly* by Daniil Kharms, 1929

В. МАЗУРКЕВИЧ

УЛИТА
ЕДЕТ

КАР
ТИН
КИ
Э. КРИМ
МЕРА

РАДУГА
1925

Eduard Krimmer, cover for *At a Snail's Pace* by Vladimir Mazurkevich, 1925

ХИЩНЫЕ

Тигр.

(Фотография на 15 стр.).

Тигр распространен очень широко. Настоящее царство тигров—Индия.

В пределах СССР он водится в следующих пунктах: юго-восточная Сибирь до Амурского края; южный берег Каспия (в Закаспийском крае редок), Аральское море, р. Сыр-Дарья, Бухара, Семиречье, южный Алтай.

Естественная обстановка жизни тигра— необозримые пространства, покрытые тростником и мелким кустарником, которые тянутся по берегам озер и рек в средней Азии и которые известны в Индии под названием „джунглей“.

Издали полосатая шкура тигра сливается со стеблями камышей и скрывает зверя.

Леопард.

Распространен по всей Африке и южной части Азии. В пределах СССР заходит в Амурскую область, на Кавказ, в Закаспийскую область.

Живут в обширных высокоствольных лесах.

14

Dmitri Bulanov, illustrations for *The Zoo: A Guide to Leningrad's Zoological Garden* by M. Soloviev, 1928

TALL TALES

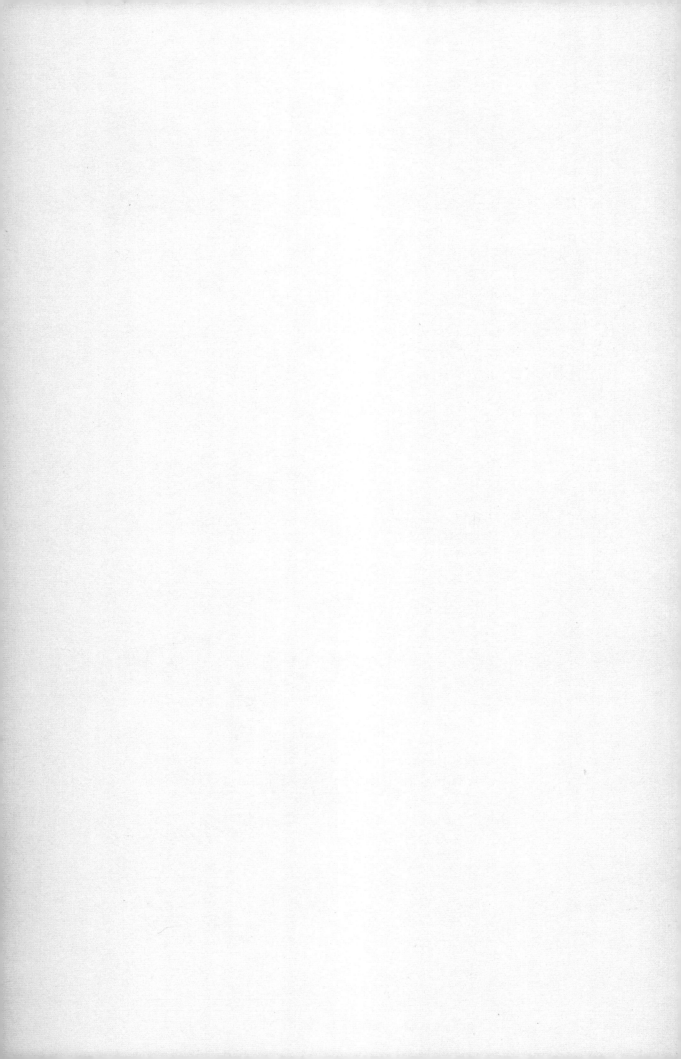

"I'm nobody, said the little girl.

'How can you be nobody? Surely some sort of principle of the female sex must have fixed things so you could get yourself born under Soviet power?'

'But I didn't want to be born – I was frightened my mother would be a bourgeois.'

'How did you get yourself organised, then?'

The girl hung her head in confusion and fear and began to pull at her shirt; she knew she was in the presence of the proletariat and so she was on her guard, remembering what her mother had kept on telling her so long ago.

'But I can tell you who's the boss.'

'Who?' asked Safronov, pricking up his ears.

'Lenin – and after him comes Budyonny. Before they were around, when there was only the bourgeoisie, I wasn't born because I didn't want to be. But as soon as Lenin came along, then so did I.'

'Well, my girl,' Safronov managed to say. 'Your mother must have been a conscientious woman! And if kids can forget their own mothers but still have a sense of comrade Lenin, then Soviet power really is here to stay!'

Andrei Platonov, *The Foundation Pit*, 1930, translated by Robert Chandler and Geoffrey Smith

Vladimir Konashevich, cover for *Barabiek* by Kornei Chukovsky, 1929

Vladimir Lebedev, original, unpublished cover design for *Suspension Points* by Samuil Marshak, 1929

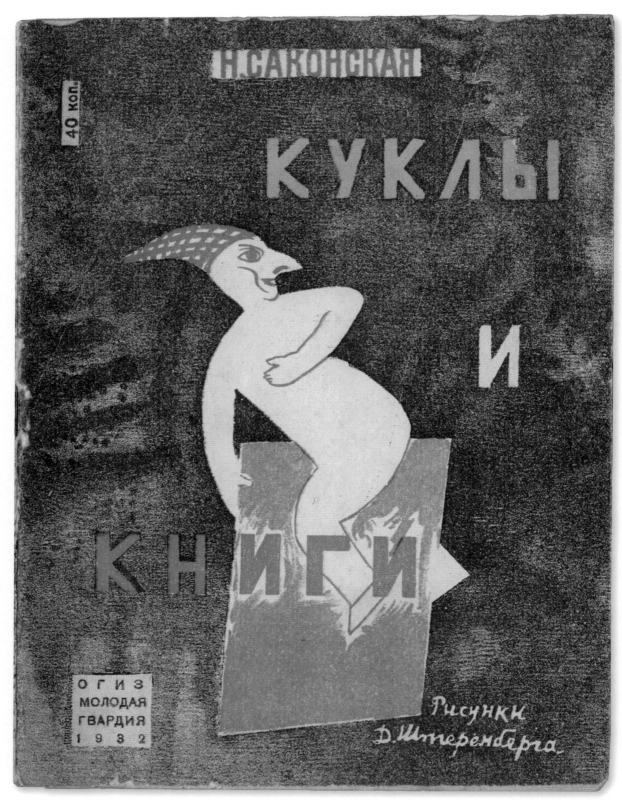

David Shterenberg, cover and illustration for *Dolls and Books* by Nina Sakonskaya, 1932

Петрушка едет с Гансом в Германию.

В Германии еще водятся и буржуи, и попы, и городовые. Приходится вспомнить старое время: пустить в ход тумаки.

Путешествует Петрушка всегда налегке:

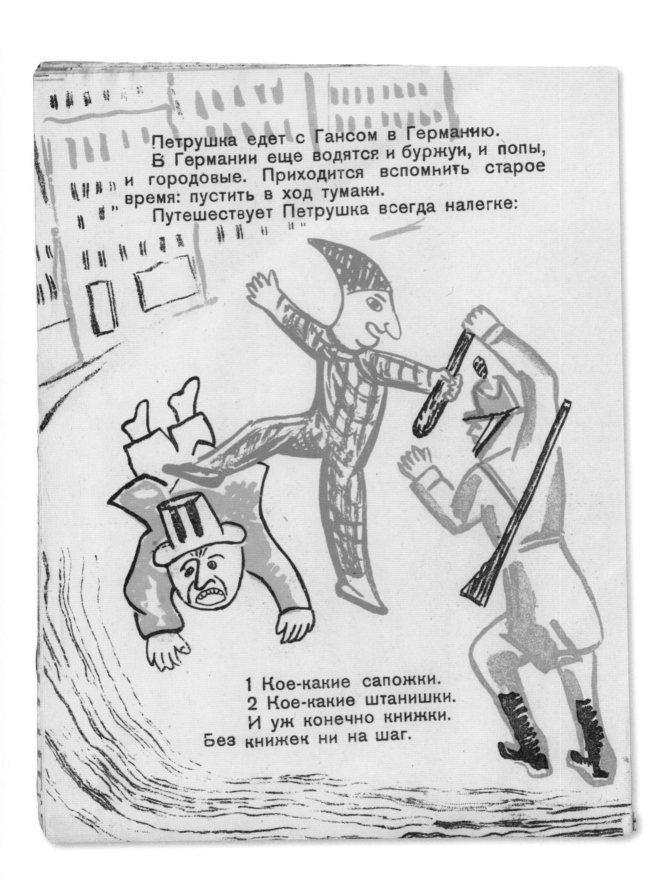

1 Кое-какие сапожки.
2 Кое-какие штанишки.
И уж конечно книжки.
Без книжек ни на шаг.

Kornei Chukovsky THE STOLEN SUN

The sun went strolling in the sky
When suddenly a cloud came by.
Bunny took a look outside.
"Oh, how dark it is!" he cried.

And the magpies on the farm
Chattered loudly in alarm.
They hopped about the hills and plains
And shouted to the storks and cranes:
"Listen, listen, everyone,
The crocodile devoured the sun!"

It got dark as dark can be,
Not a thing could people see.
He who ventured in the lane
Was never, never seen again.

So the timid little sparrow
Kept on sobbing in his sorrow:
"Please, dear sun, come out again!
We can't see to peck our grain!"

And the rabbits wept
As they jumped and leapt:
Home was still so far away
And they couldn't see their way.

Only in the murky swamp
The pop-eyed lobsters dared to romp
And the wolves beyond the hill
Howled and growled around their kill.
Early, early in the morning
While the land was wrapped in mourning
Loud and sharp came "Rat-tat-tat!"
Goodness gracious, what was that?
Two black sheep were at the gate:
"Come out, folks, before it's too late!
Come and fight in heroes' style
And save the sun from the crocodile!"

But the shaggy folk were mute,
Afraid to tackle such a brute.
"Such great teeth! And he weighs a ton!
He'll never give us back our sun!"

So they ran to the bear in his lair.
"Now, Bruin, there's no time to spare.
Come, Lazy-Bones, leave off sucking your paw,
Help us rescue the sun, let it shine as before."

But, although he was big and mighty,
The bear didn't feel like fighting.
He roared and sobbed and he sobbed and roared
As he called his cubs from the grassy sward:

"Oh, children, come back to your poor old father!"
He wept and he wept, searching farther and farther.
And his wife, Mrs Bear,
Looked around everywhere,
Under roots, under stumps, under stairs, in despair:

"Oh, my Eddy, Teddy and Pronto!
Where, O where have you gone to!
Have you fallen into a ditch and drowned,
Or been torn to bits by a mad stray hound?"

She wandered all day over marsh and scrub,
But there wasn't a trace of a single cub.
Only the black owls stared from the copse
Sitting high up on the fir-tree tops.

But then Mrs Bunny popped out
And began to scold him and shout:
"Now, please, stop whimpering there!
Behave like a grown-up bear!
"Go on, Bandy-Legs, and grab him,
By the scaly collar nab him,
Bash him up and underneath,
Tear the sun from his ugly teeth.

As soon as it returns
To the sky and brightly burns.
All your little ones,
All your pretty ones
Will come running from afar:
'Hullo, Daddy, here we are!' "

And the bear he reared
And the bear he roared
And the bear he ran
To the river ford,
Where the crocodile lay
With the sun, of course,
Shining away
In his dreadful jaws–
The golden sun,
The stolen sun.

Bruin crept up to the beast,
Never frightened in the least:
"Listen here, you ugly crook,
Give us back that sun you took,
Or I'll take you by the scruff
And I'll pound you into snuff!
Yes, I'll teach you how to steal,
You cross between a toad and eel!
All the world's gone dark as ink.
What the dickens do you think?"

All the rascal did was laugh
Till he was almost split in half.
"Get away, you big baboon,
Or I'll gobble up the moon!"

"That's too much to bear!"
Roared the angry bear,
And his fangs went bare
At the enemy.

He hauled him up
And he mauled him up:
"Now, out with the sun, by golly!"

And the crocodile
Soon forgot his smile
And he yelled in fright
With all his might.

From his jaw
From his maw
The sun flew high
Till it reached the sky,
And its bright light fell
Over hill and dell.

"Welcome, welcome, golden sun!"
Gladly shouted everyone.

All the birds took wing
And began to sing
And the rabbits started dancing,
Turning somersaults and prancing
On the meadow by the spring.

Then the bear-cubs came along
And like jolly kittens
Tugged and pulled at their shaggy dad
With their soft brown mittens,
Shouting, calling Dad and Mum,
"Hullo, parents, here we come!"
Every little girl and boy,
Every beast just beamed with joy,
They thanked old Bruin for the rescued sun
And they all had lots and lots of fun.

Translated by Dorian Rottenberg

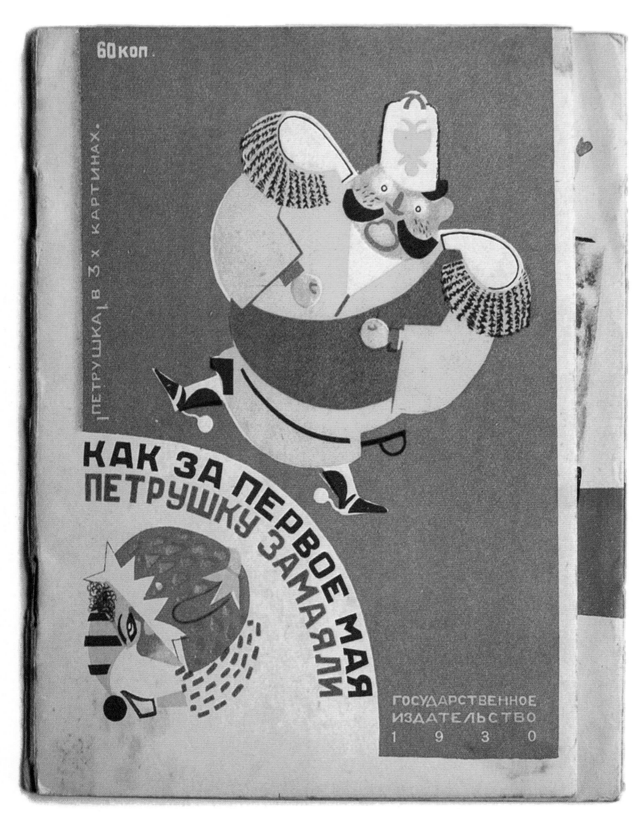

Fedor Kondratov, cover and illustrations for *How the First of May Was Celebrated by Petrushka* by Sofia Fedorchenko, 1930

Идут мама с Юрой.

ПЕТРУШКА (раскланивается).

До чего ж публика чистая,
наше вам с кисточкой!

МАМА (отворачивает Юру от Петрушки).

Душечка Юра,
не смотри на подобную фигуру!

ЮРА (вырывается).

Хочу смотреть!

МАМА (тащит Юру).

Не сметь!

Идут два важных господина. Петрушка раскланивается.

ПЕТРУШКА.

С первым мая, ваши сиятельства,
особое обстоятельство!

1-й БАРИН (возмущенно).

За чем смотрит полиция!

2-й БАРИН (печально).

Да... Не то за границею!

КТО
ПРЕДСТАВЛЯЕТ:

Петрушечник
Петрушка
Мама с Юрой
Две дамы
Два господина
Два солдата
Генерал
Городовой
Околоточный
Три городовых

На ширме появляется Петрушка, в руках у него на палке плакат, на плакате написано: „С первым мая, иди не зевай!" Навстречу Петрушке две барыни.

ПЕТРУШКА (раскланивается).

С первым маем
вас поздравляем!

1-я БАРЫНЯ.

Фи, какой грязный! (Подбирает платье.)

2-я БАРЫНЯ.

Фи, какой безобразный! (Затыкает нос платочком.)

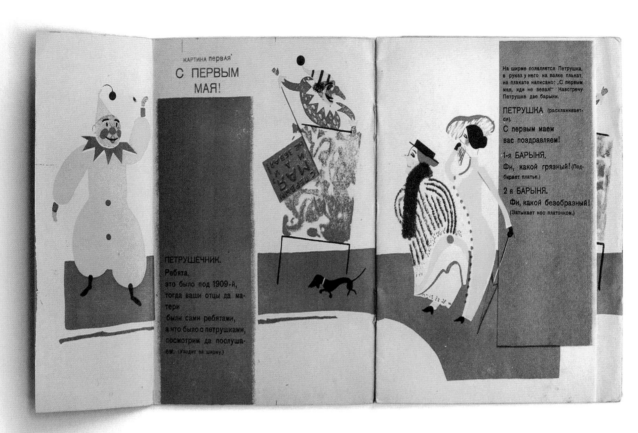

КАРТИНА ПЕРВАЯ

С ПЕРВЫМ МАЯ!

ПЕТРУШЕЧНИК.

Ребята,

это было под 1909-й,

тогда ваши отцы да матери

были сами ребятами,

а что было с петрушками,

посмотрим да послушаем. (Уходит за ширму.)

На ширме появляется Петрушка, в руках у него на палке плакат, на плакате написано: „С первым мая, иди не зевай!" Навстречу Петрушке две барыни.

ПЕТРУШКА (раскланивается).

С первым маем

вас поздравляем!

1-я БАРЫНЯ.

Фи, какой грязный! (Подбирает платье.)

2-я БАРЫНЯ.

Фи, какой безобразный! (Затыкает нос платочком.)

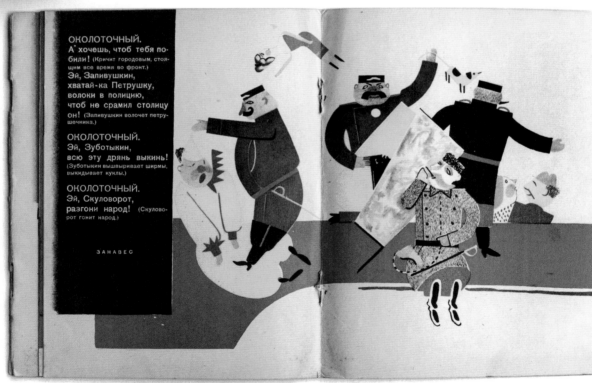

ОКОЛОТОЧНЫЙ.

А' хочешь, чтоб тебя побили! (Кричит городовым, стоящим все время во фронт.)

Эй, Запивушкин,

хватай-ка Петрушку,

волоки в полицию,

чтоб не срамил столицу

он! (Запивушкин волочет петрушечника.)

ОКОЛОТОЧНЫЙ.

Эй, Зуботыкин,

всю эту дрянь выкинь! (Зуботыкин вышвыривает ширмы, выкидывает куклы.)

ОКОЛОТОЧНЫЙ.

Эй, Скуловорот,

разгони народ! (Скуловорот гонит народ.)

З А Н А В Е С

Samuil Marshak

THE TRUMPET AND THE DRUM

Once there was a kettle-drum,
Rumble-bumble, rum-tum-tum
One day he shook his empty head
And to his friend the trumpet said:

"Dear trumpet, you're a lucky soul,
Your life is full of bliss:
Whoever wants to play on you
Must start off with a kiss.

"And me, you can't imagine, dear
The sorry plight I'm in.
My drummer beats me with his sticks,
My skin is worn all thin."

"Yes," said the trumpet to the drum,
"My life is bright, and yours is glum
Although we're carried side-by-side
When down the street the bandsmen stride.

"And yet it's you that got yourself
In such a dreadful fix:
I've never seen you set to work
Until you're thrashed with sticks!"

Eduard Krimmer, illustrations from *The Miracle*, 1928

ПЕРВАЯ
Типография Огиза РСФСР
"ОБРАЗЦОВАЯ"
Москва, Валовая, 28.

Главлит № Б - 1276.
Заказ № 3469. Тир. 50000.

РИСУНКИ

Т. Лебедевой

T. Lebedeva, back cover for *Shadow Story* by Victor Shklovsky, 1931

Osip Mandelstam

To read only children's books, treasure

Only childish thoughts, throw

Grown-up things away

And rise from deep sorrows.

I'm tired to death of life,

I accept nothing it can give me,

But I love my poor earth

Because it's the only one I've seen.

In a far-off garden I swung

On a simple wooden swing,

And I remember dark tall firs

In a hazy fever.

1908, translated by James Greene

Boris Ender, cover and illustrations for *Two Trams* by Osip Mandelstam, 1925

КЛИК и ТРАМ

Жили в парке два трамвая:
Клик и Трам.
Выходили они вместе
По утрам.

От стука и авона у каждого стыка
На рельсах болела площадка у Клика.

Под вечер слипались его фонари:
Забыл он свой номер; не пятый, не третий...

Смеются над Кликом извозчик и дети:
— Вот сонный трамвай, посмотри!

Улица-красавица, всем трамваям мать,
Любит электричеством весело моргать.
Улица-красавица, всем трамваям мать,
Выслала метельщиков рельсы подметать.

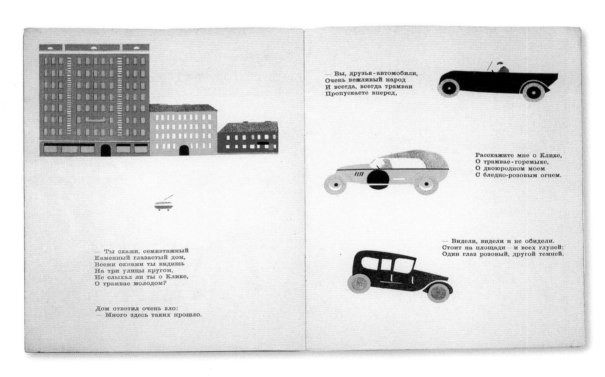

— Ты скажи, семиэтажный
Каменный глазастый дом,
Всеми окнами ты видишь
На три улицы кругом,
Не слыхал ли ты о Клике,
О трамвае молодом?

Дом ответил очень зло:
— Много здесь таких прошло.

— Вы, друзья-автомобили,
Очень вежливый народ
И всегда, всегда трамваи
Пропускаете вперед,

Расскажите мне о Клике,
О трамвае-горемыке,
О двоюродном моем
С бледно-розовым огнем.

— Видели, видели и не обидели.
Стоит на площади — и всех глупей;
Один глаз розовый, другой темней.

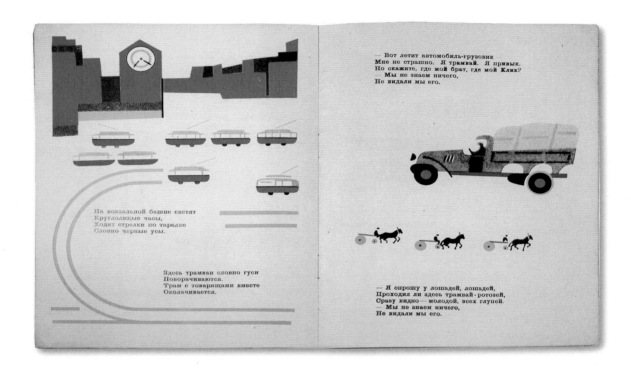

На вокзальной башне светят
Круглолицые часы,
Ходят стрелки по тарелке
Словно черные усы.

Здесь трамваи словно гуси
Поворачиваются.
Трам с товарищами вместе
Околачивается.

— Вот летит автомобиль-грузовик
Мне не страшно. Я трамвай. Я привык.
Но скажите, где мой брат, где мой Клик?
— Мы не знаем ничего,
Не видали мы его.

— Я спрошу у лошадей, лошадей,
Проходил ли здесь трамвай-ротозей,
Сразу видно — молодой, всех глупей.
— Мы не знаем ничего,
Не видали мы его.

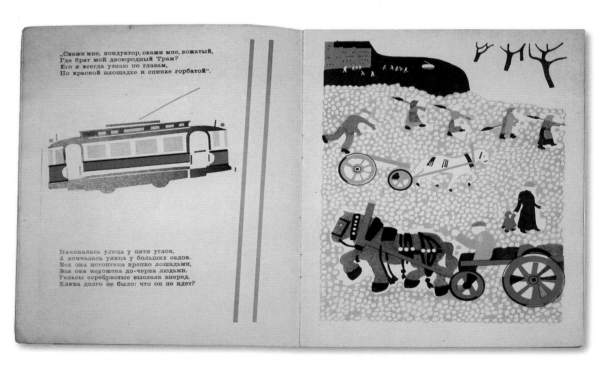

„Скажи мне, кондуктор, скажи мне, вожатый,
Где брат мой двоюродный Трам?
Его я всегда узнаю по глазам,
По красной площадке и спинке горбатой".

Начиналась улица у пяти углов,
А кончалась улица у больших садов.
Вся она истоптана крепко лошадьми,
Вся она исхожена до-черна людьми.
Рельсы серебристые выслала вперед.
Клика долго не было: что он не идет?

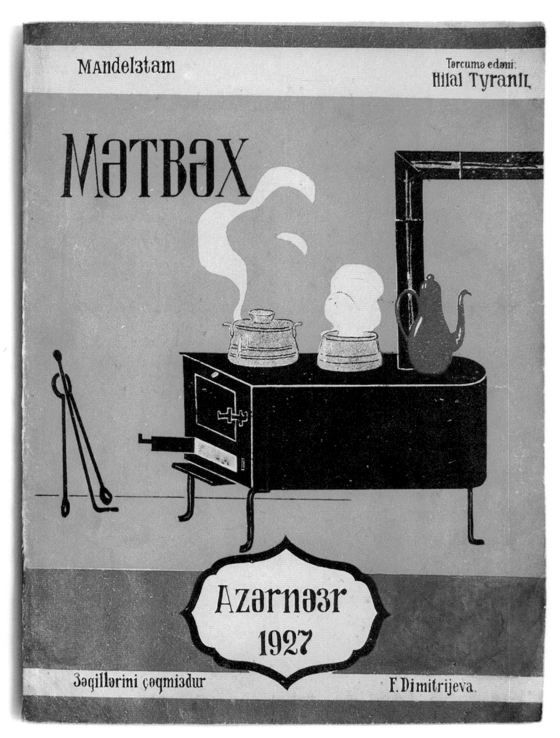

F. Dmitriyeva, cover and illustrations for *The Kitchen* (in Axerbaijaini) by Osip Mandelstam, 1927

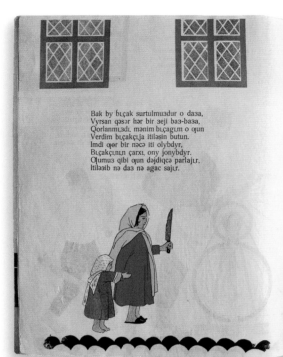

Bak by bıçak surtulmuzdur o daza,
Vyrsan qəsər hər bir zeji baz-baza,
Qorlanmızadı. mənim bıçagım o qun
Verdim bıçakçıja itiləsin butun.
Imdi qer bir nəcə iti olybdyr,
Bıçakçının çarxı, ony jonybdyr.
Ojumuz qibi qun dəjdiqcə parlajır,
İtiləzib nə daz nə agac sajır.

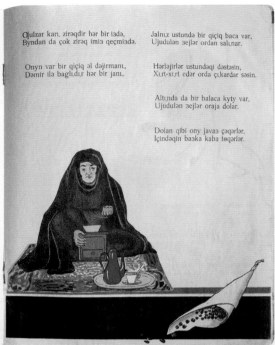

Ojulzar karı, zirəqdir hər bir izdə,
Byndan da çok zirəq imiz qeçmizdə.

Onyn var bir qiçiq əl dəjirmanı,
Dəmir ilə baglıdır hər bir janı.

Jalnız ustundə bir qiçiq baca var,
Ujudulən zejlər ordan salınar.

Hərləjirlər ustundəqi dəstəsin,
Xırt-xırt edər orda çıkardar səsin.

Altında da bir balaca kyty var,
Ujudulən zejlər oraja dolar.

Dolan qibi ony javaz çaqərlər,
İçindəqin bazka kaba təqərlər.

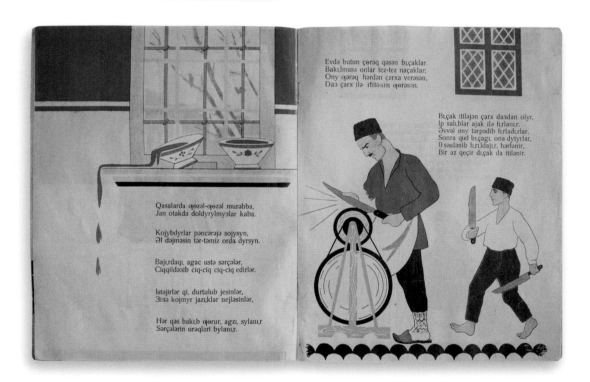

Qasalarda qəzəl-qəzəl murəbba,
Jan otakda doldyrylmyzlar kaba.

Kojybdyrlar pəncərəjə sojysyn,
Əl dəjməsin tər-təmiz orda dyrsyn.

Bajırdaqı agac ustə sərçələr,
Ciqqildəzib ciq-ciq ciq-ciq edirlər.

İstəjirlər qi, durtulub jesinlər,
Zizə kojmyr jazıklar nejləsinlər,

Hər qəs bakıb qerur, agzı, sylanır,
Sərçələrin urəqləri bylanır.

Evdə butun çərəq qəsən bıçaklar
Bakılmasa onlar tez-tez naçaklar;
Ony qərəq hərdən çarxa verəsən,
Daz çarx ilə itiləsin qərəsən.

Bıçak itiləjən çarx dazdan olyr,
İp salıblar ajak ilə fırlanır.
Əvvəl ony tərpədib fırladırlar,
Sonra qud bıçagı ona dytyrlar,
O səslənib fırıldajır, hərlənir,
Bir az qeçir dıçak da itilənir.

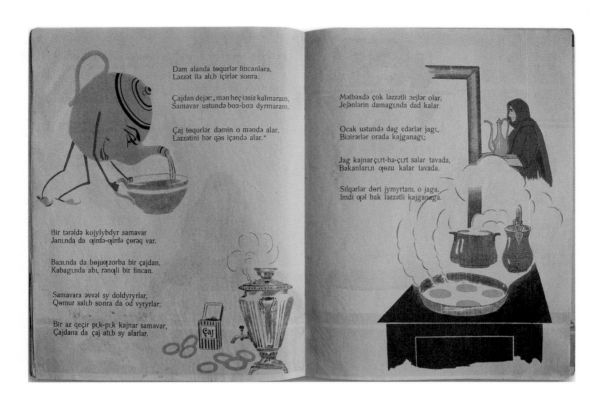

Dəm alanda təqurlər fincanlara,
Ləzzət ilə alıb içirlər sonra.

Çajdan dejər: „mən heç ıəsiz kalmaram,
Samavar ustundə boз-boз dyrmaram.

Çaj təqurlər dəmin o məndə alar,
Ləzzətini hər qəs içəndə alar."

Bir tərəfdə kojylybdyr samavar
Janында da qırdə-qırdə çərəq var.

Baзında da bəjuqzorba bir çajdan,
Kabagında abı, rənqli bir fincan.

Samavara əvvəl sy doldyryrlar,
Qəmur salıb sonra da od vyryrlar;

Bir az qeçir pık-pık kajnar samavar,
Çajdana da çaj atıb sy alarlar.

Mətbəxdə çok ləzzətli зejlər olar,
Jeʃənlərin damagında dad kalar.

Ocak ustundə dag edərlər jagı,
Biзirərlər orada kajganagı;

Jag kajnar çırt-ha-çırt salar tavada,
Bakanların qeзu kalar tavada.

Silqərlər dərt jymyrtanı, o jaga,
Imdi qəl bak ləzzətli kajganaga.

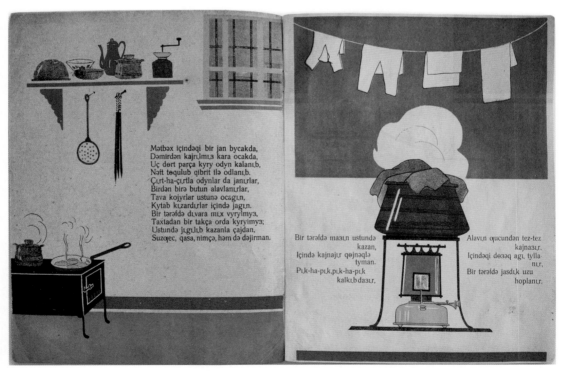

Mətbəx içindəqi bir jan bycakda,
Dəmirdən kajrılmıз kara ocakda,
Uç dərt parça kyry odyn kalanıb,
Nəit təqulub qibrit ilə odlanıb.
Çırt-ha-çırtla odynlar da janırlar,
Birdən birə butun alavlanırlar,
Tava kojyrlar ustunə ocagın,
Kytab kızardırlar içində jagın.
Bir tərəfdə dıvara mıx vyrylmyз;
Taxtadan bir takça orda kyryımyз;
Ustundə jıgılıb kazanla çajdan,
Suzqec, qasa, nimçə, həm də dəjirman.

Bir tərəfdə maзın ustundə
kazan,
Içində kajnajır qəjnəqlə
tyman.
Pık-ha-pık,pık-ha-pık
kalkıb daзır,

Alavın qucundən tez-tez
kajnaзır,
Içindəqi dəзəq agı, tylla
nır,
Bir tərəfdə jasdık uzu
hoplanır.

219

Bir də evdə daha baʒka bir ʒej var,
Jorylmak bilməz hər zaman çʟkkʟldar,
Iqi dənə kytasʟ var sallanʟr,
Qəfqiri var hər tərəfə jellənir.
Altʟndan sallananı yzyn zəncir var,
Iʒlətməqçin dytyb ony dartarlar,
By saatdʟr iʒlər həmiʒə çʟk-çʟk,
Tənbəllərə dejər „tez kalk iʒə çʟk!"

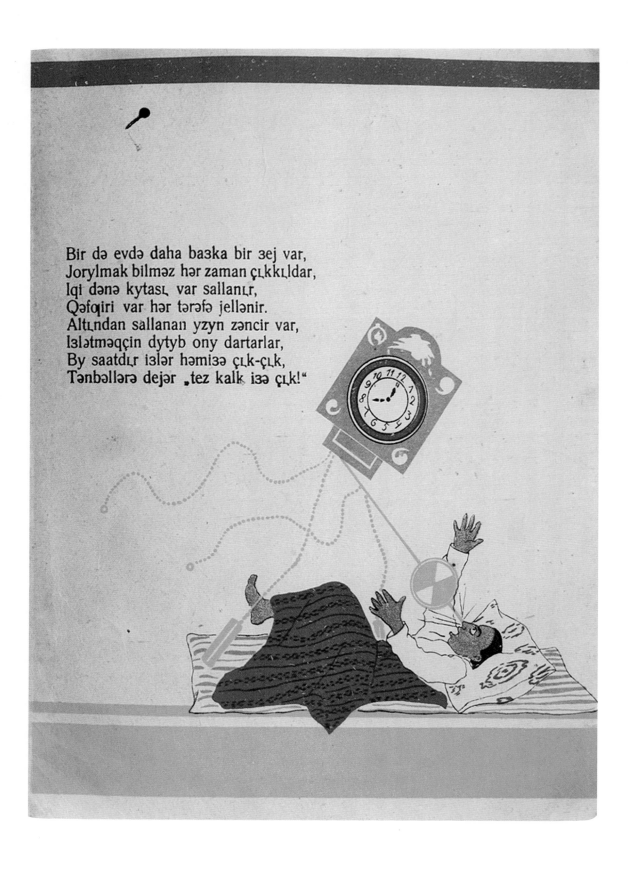

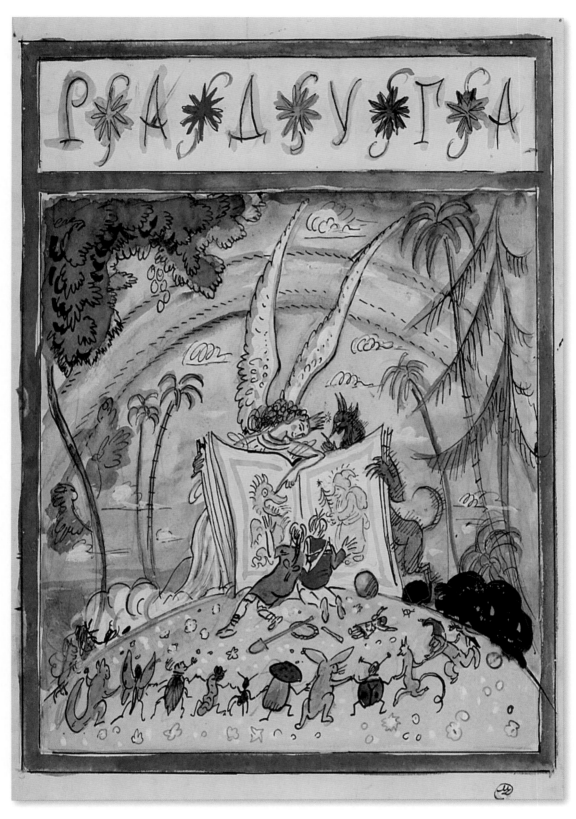

Mstislav Dobuzhinsky, sketch for the cover of *Rainbow*, 1924

Daniil Kharms A FAIRY TALE

"So, Lyonochka," said the aunt, "I'm leaving. You stay home and be good. Don't pull the cat's tail, don't pour semolina in the clock on the table, don't swing on the lamp, and don't drink the ink. All right?"

"All right, " said Lyonotchka, and she picked up a big pair of scissors.

"So," the aunt said, "I'll be gone two hours, and I'll bring you mint candies. Do you want some mint candies?"

"I want some," said Lyonochka. She held the big scissors in one hand and with the other hand she took the napkin off the table.

"So long, Lyonochka," said the aunt, and left.

"So long, so long!" Lyonochka started to sing, looking over the napkin. The aunt had already gone, but Lyonochka went on singing: "So long, aunt! The napkin is square! So long! So long! So long, square napkin!"

As she was singing these words, Lyonochka started to work with the scissors.

"And now, and now," Lyonochka was singing, "the napkin has become round! And now it is half round! And now it has become tiny! There used to be one napkin and now there are many tiny napkins!"

Lyonochka looked at the tablecloth.

"There's one tablecloth, too! Lyonochka sang. "And soon there are going to be two! And now there are two tablecloths! And now three! One big one and two small ones! And there's just one table!"

Lyonochka ran to the kitchen and brought out a hatchet.

"And now out of one table we'll make two tables!" Lyonochka sang, and she hit the table with the hatchet. But no matter how hard Lyonochka worked, she was only able to chip a few chips off the table.

Translated by George Gibian

Lidia Zholtkevich, back cover for *The Bird Cherry Tree* by Leo Tolstoy, 1928

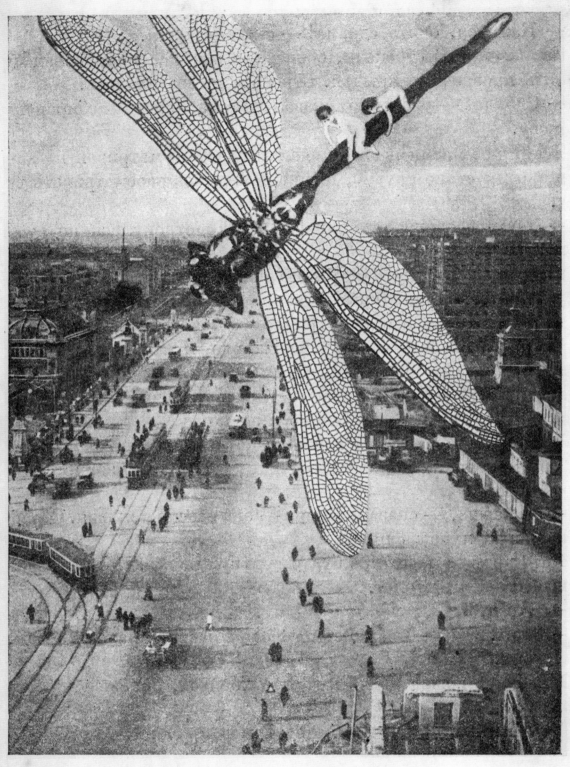

S. Petrovich, photo illustration for *The Remarkable Adventures of Karik and Valya* by Jan Larry, 1937

Daniil Kharms THE FOUR-LEGGED CROW

There once lived a four-legged crow. Properly speaking, it had five legs, but this isn't worth talking about.

So once this four-legged crow bought itself some coffee and thought, "Okay, so I bought coffee, what I am supposed to do with it now?"

Just then, unfortunately, a fox was running by. The fox saw the crow and shouted, "Hey," it shouted, "you crow!"

And the crow shouted back:

"Crow yourself!"

And the fox shouted to the crow:

"You're a pig, crow, that's what you are!"

The crow was so insulted it scattered the coffee. And the fox ran off. And the crow climbed down and went on its four, or to be more precise, five legs to its lousy house.

Translated by Eugene Ostashevsky

David Shterenberg, illustrations and cover for *To Children* by Vladimir Mayakovsky, 1931

В. МАЯКОВСКИЙ

ДЕТЯМ

1931 ОГИЗ МОЛОДАЯ ГВАРДИЯ

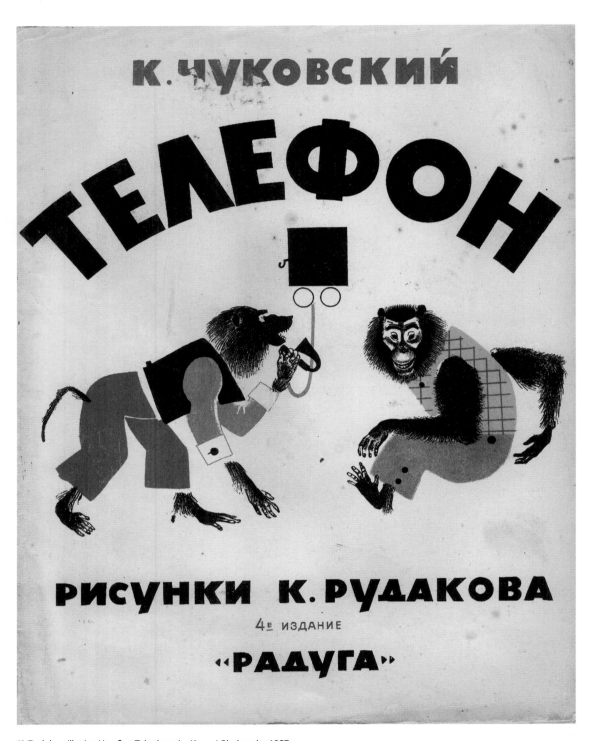

K. Rudakov, illustration for *Telephone* by Kornei Chukovsky, 1927

Kornei Chukovsky THE TELEPHONE

Ting-a-ling-a-ling…
A telephone ring!
"Hallo! Hallo!"
"Who are you?"
"Jumbo Joe,
"I live at the zoo!"
"What can I do?"
"Send me some jam
For my little Sam."
"Do you want a lot?"
"A five-ton pot,
And send me some cake-
The poor little boy
Has swallowed a toy
And his tummy will ache
If he gets no cake."

"How many tons of cake will you take?"
"Only a score.
He won't be able to eat any more-
My little Sam is only four!"

And after a while
A crocodile rang from the Nile:
"I will be ever so jolly
If you send us a pile
Of rubber galoshes -
The kind that one washes -
For me and my wife and for Molly!"

"You're talking too fast!
Why, the week before last
I posted ten pair
Of galoshes by air."

"Now, doctor, be steady!
We've eaten already
The pile that you posted!
We ate them all roasted,
And the dish it was simply delicious,
So everyone wishes
You would send to the Nile
A still bigger pile
That would do for a dozen more dishes."

The next was a ring from the hares;
"Our fingers are bitten,
We badly need mittens,
Please send about five or six pairs!"

Said the monkeys who live in the trees:
"Will you send us some books, if you please."

Now, the next to ring was a bear.
Well, he roared and he raised such a scare!
"Do not yell, Mr Bear, do not yell,
I can tell you are feeling unwell;
Are you sure that you haven't a fever?
Will you kindly hang up the receiver!"
But the bear - silly fellow -
Did nothing but bellow.

Then a heron called up on the 'phone,
And started to whimper and moan:
"We've feasted on frogs and we're ill!
Please, Doctor, please send us a pill."

Ding-dong-dell,
Rang the telephone bell.
Ding-ding-dong
The whole day long.

A ring from an ox.
A ring from a fox,
And a ring from a couple of cocks!

Let me tell or a ring-
'Twas the funniest thing!
Said a graceful gazelle
In a voice like a bell:

"Is it true that you found
That the merry-go-round
Which stands on the mound
Has stopped going round
And the swings have been burnt to the ground?"

"You silly gazelle!
Are you mad or unwell?
Now run off to the mound.
For the merry-go-round
Is still going round
And the swings are not burnt to the ground!"
I grew angry and frowned –
It was only too plain
That my words were in vain.
"We were told to beware
And keep away from the fair

So we'll bet you a pound
That the merry-go-round
Has stopped going round,
And the swings have been burnt to the ground!"

Ah well! Ah well!
What a silly gazelle!

As I was yawning
At two in the morning,
A kangaroo rang up from the zoo:
"I should like to speak to Billy Bubbles!"

My anger grew
At the kangaroo.
"Will there never be an end to troubles?
I'm the doctor. I live alone.
This is not time to ring on the 'phone.
A hundred and twenty five is the number.
But don't ring now! It's time for slumber!"

Three nights I was kept out of bed-
My eyes were swollen and red.
I had just gone to bed
And laid down my poor head
When the telephone rang,
So up I sprang.

"I'm the rhinoceros
Please run across to us!
Our hippopotamus strayed in a fog
And then the poor fellow fell in a bog.
The bog it is bottomless-
Poor Hippopotamus!
We want you to help us
To pull our dear Hippo
From out of the bog,
Poor old Hippo, mild as a dove!
The dear old chap is sure to die
Poor old Hippo, whom all of us love!
If you don't put on your coat and fly."

"All right! All right!
It's late at night,
And though I really ought to rest!
I promise I shall do my best"

With the help of the Rhino, a bird and a dog,
I pulled poor Hippo from out of the bog;
We lassoed his legs and lassoed his snout,
And pulled and pulled till we pulled him out.

Translated by Dorian Rottenberg

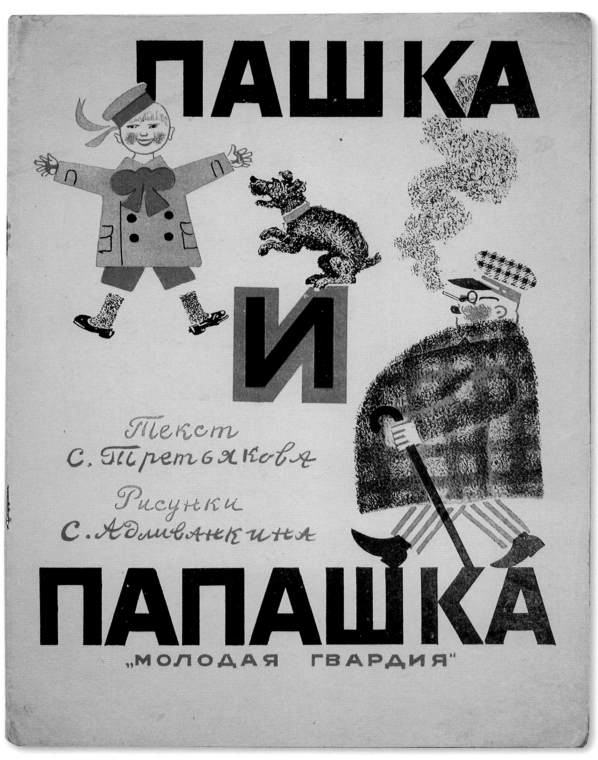

Samuil Adlivankin, cover for *Pashka and Papashka* by Sergei Tretyakov, 1926

Два пристальных глаза
Глядят на отца.
Затем — у рассказа
Четыре конца.

Сначала расскажем
Весёлый конец:
Доехали вместе
Блинов и отец.

Mikhail Tsekhanovsky and S. Petrovich, illustration for *The 4 Endings* by Samuil Marshak, 1938

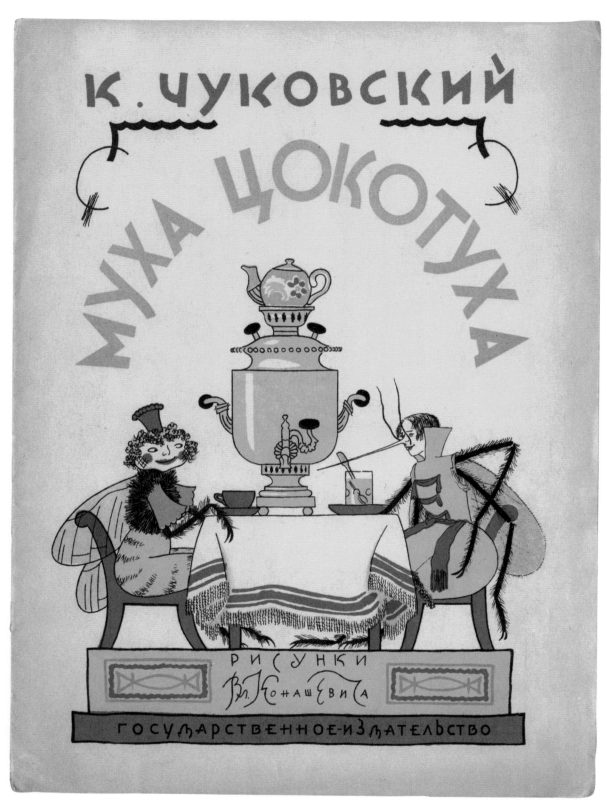

Vladimir Konashevich, cover for *Mukha Tsokotukha* by Kornei Chukovsky, 1930

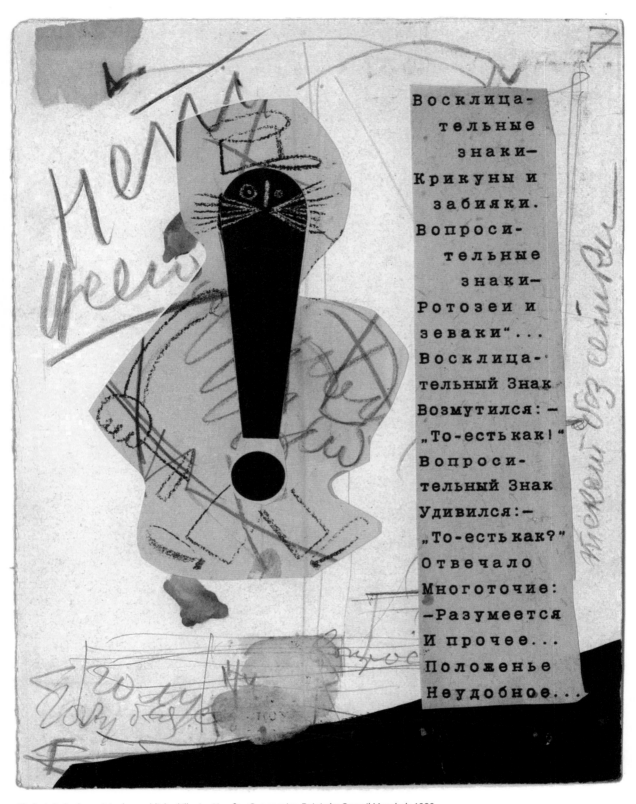

Vladimir Lebedev, original, unpublished illustration for *Suspension Points* by Samuil Marshak, 1929

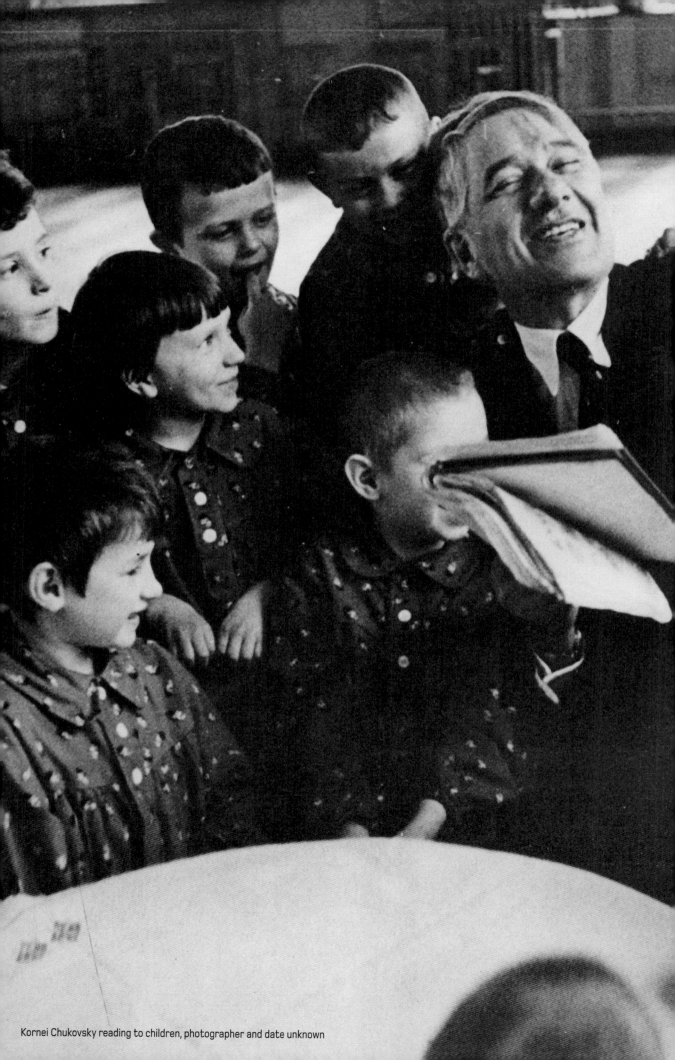

Kornei Chukovsky reading to children, photographer and date unknown

L ET'S PLAY!

TWO WEEKS BEFORE 7 NOVEMBER 1920 there appeared over the gates of the Winter Palace a sign "Headquarters Organizer of October Celebrations"... Dozens of producers, writers, stage designers and technicians worked out an overall scenario for the production, splitting it into five parts: "White", "Red", "Bridge", "Square" and "Palace"... The masses were treated as masses. The sole exception was the small figure of Kerensky, which served to emphasize his insignificant role in the events as they unfolded...

The searchlights installed on the roofs of the buildings surrounding the square lit up the area of action... Right up to the moment when the troops at the front rebelled and when the masses on the Red platform invaded the White, the action developed just as it might have done in the theatre. But the moment when the signal rocket sped up from the square and exploded in the night sky, spectators and participants alike witnessed one of the most astonishing sights imaginable... which rose above those earthbound blanks, boldly mixing recent reality with a vivid, audacious, theatricalised interpretation of that reality on a scale hitherto undreamt of.

K. Derzhavin, *The Capture of the Winter Palace*, 1925

[ART] WAS TOTALLY REPLACED by the games of a single Magician, who for a lengthy period was able to lend history itself the power and appearance of fairy-tale fantasy. Art vanished and rotted away so that, for a while, life (if one looks at it from a standpoint that is detached and tolerant of evil) might acquire the aesthetic savour of nightmarish and bloody farce played out according to theatrical and literary rules.

One only has to consider the detective-novel conception of history, that the leader managed to inculcate into the minds of millions of people, and his love of realizing metaphors...when the whole country was suddenly crawling with all kinds of invisible (and therefore especially dangerous) reptiles, snakes and scorpions with such terrible names as "Trotskyite" or "wrecker".

Abram Terz, *The Literary Process in Russia*, translated by Michael Glenny, Kontinent, 1976

LECTURES TO PARENTS: PLAY

Play has the same significance for the child that activity, work and service have for the adult. . . As children are in play, so by and large, will they be in work when they grow up. . .

There is really no great difference between work and play. Good play is like good work, bad play is like bad work. . . All good play requires physical and intellectual effort. If you buy the child a mechanical mouse, you may wind it up all day and the child may watch – there is nothing good about this sort of play! The child is passive. If your child is occupied only with such games, he will grow up without initiative, unaccustomed to undertaking new tasks or work, or to overcome difficulties. Play without effort, play without activity, is bad play. In this respect, play is very like work.

Play brings the child happiness. This will be creative happiness, or joy in achievement or aesthetic pleasure. . .and here is a resemblance to good work. . .

Parents often make mistakes in how they guide play. Some are simply not interested or think that children know best how to play. Other parents pay too much attention to their children's play! They interfere, point out, discuss, set problems in games and resolve them before the child has a chance to - they have taken over the enjoyment! If the child builds something and has difficulty, father or mother sit down beside him and say, "Don't do it that way. Look, this is how you should do it. . . " The child can only listen and imitate. He gets used to the idea very early that only grown-ups know how to do everything well. Such children grow up with a lack of confidence in their own strength and a fear of failure. . .

Children's play passes through several stages of development and each demands a special kind of guidance. The first phase is indoor play with toys. This continues until about the age of about five or six when the second stage begins. This first period is characterized by the fact that the child prefers to play alone or, rarely, with one or two friends. He loves to play with his own toys rather than with strange ones. This is the very time when the individual capacities of the child are developing. There is no need to fear that because he plays alone the child will grow egotistical. He must be given the chance to play alone! The child is not yet able to play in a group, often quarrels with comrades, does not know how to find collective interests. Give him freedom for this individual play; there is no need to force companions on him. This only destroys his play mood, makes him nervous. . . The better the child plays alone when he is young, the better he will be later with companions. At this age the child is aggressive and in a certain sense is a "property-owner". Playing alone the child develops his own abilities, his imagination: skill in building, organizing, and this is useful.

Sooner or later all children will show an interest in friends, in group play. . .One must help the child to make this rather difficult transition. . . it is good if an older child in the vicinity helps to organize the little ones....This second stage is harder to guide, for the child is now in a broader social arena. This stage continues to the age of eleven or twelve. School brings a wider circle of friends and interests. . . the child is already a member of society but a child society of social control and discipline.

School helps them to reach the third stage. . . at this stage they are members of the collective, not only for play but for study and work. Now play becomes sport. . . collective discipline appears.

At all three stages the parent's influence is of great importance. . .

In guiding children's play it is important: (1) to see that the child is really playing, creating, building, combining; (2) to see that the child does not go from one thing to another without carrying through his activities to completion; (3) to see that each plaything has value and is cherished. There should always be order, cleanliness, in playland. The child should not break toys, should love them. . .(But he should also not suffer too much if they are spoiled or broken.) If the

child is in difficulties or if the play is uninteresting, give him help; set up some interesting problem, bring new material or play with him. . .When the child goes outdoors and meets groups of youngsters, parents should know what kind of children these are and how they play. . .The care and initiative of one of the mothers or fathers will often help to change the life of a whole group of children for the better.

At this second stage, the relationships among parents of the children are important. . Every parent may at some time be dissatisfied with what the children are doing outdoors yet fail to discuss it or consider how they may improve matters. . .and this is not at all hard to do. At this stage the children are already organized in something like a collective; it is very helpful if parents can give them some guidance.

At this stage children often quarrel and complain about each other. It is a great mistake for parents to take sides with their children quickly and get into quarrels themselves with the parents of the offender. Even if your child comes to you in tears, hurt and angry, do not rush to attack the offender and his parents. Quietly question your son or daughter and try to get a clear picture of what happened. Guilt is seldom all on one side. Your child probably lost his temper, too. Explain that it is always both necessary and possible to find a peaceful solution to conflicts. Try to reconcile your child with his "enemy" – invite him to your home as a guest, talk with him, get acquainted with his parents, clear up the affair.

The most important thing is that you see not only your own child but the whole group of youngsters and that you and other parents co-operate in bringing them all up. . .Let the child see that you are not carried away by family loyalties, but activated by social motives; then he will see in your behaviour an example for his own.

Later, at the third stage, play leadership is in the hands of the school or sports organization. Parents, however, can still exert a good influence on the child's character. . .They must see that sport does not become an all-absorbing concern for the child and they should develop other types of activity. . .They must stimulate pride not only in personal success but in the success of the team or group.

Boastfulness must be checked. Educate the child to respect his antagonist's strength, to pay attention to training, organization and discipline in his team. Teach him to be calm in victory or defeat. At this period of the child's development it is a good thing for parents to be intimately acquainted with his comrades on the team or in the sports club. Parents must see that play does not absorb the child's whole spiritual life, but that, at the same time, his work habits are developing correctly.

To sum up:

Play has great significance in human life, it is a preparation for work and must gradually change to work.

Many parents do not give enough attention to guiding play and either leave the child entirely to himself or surround his play with too much care and too many toys.

Parents should apply different methods at different stages of play but always give the child the chance for independence and correct development of his capabilities, while never refusing to help in difficult situations.

In the second and third stages, it is not so much play as relations among children that need to be guided as well as their relationship to their collective.

Anton Makarenko, Lectures to Parents, given on radio in 1937 from the *Collected Works of Makarenko*, Vol. 4, 1951, translated by Elizabeth Moos

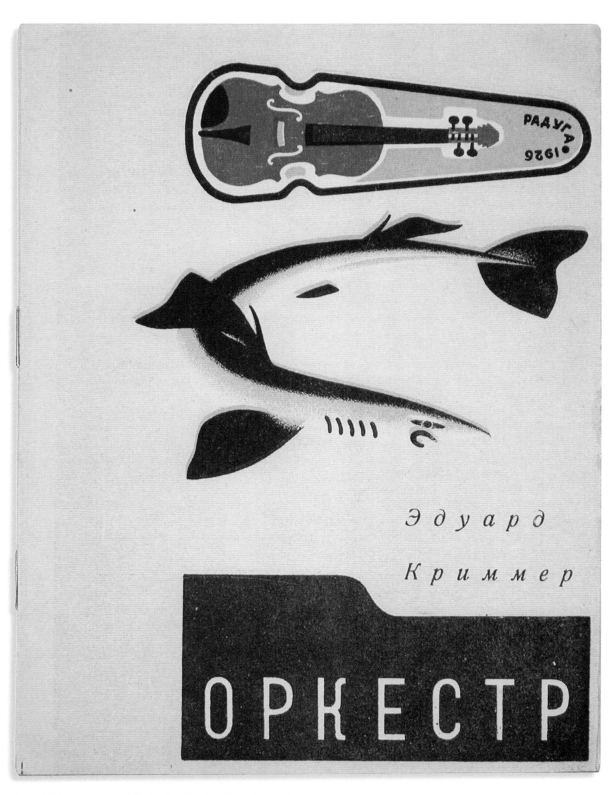

Eduard Krimmer, cover and illustrations for *The Orchestra*, 1926

Белка и
цимбалы

Медведь и
контрабас

Лев и барабан

Обезьяна
и скрипка

Unknown illustrator, original artworks, c. 1930

БУДЬ ГОТОВ

Olga Deineko and Nikolai Troshin, illustration for *A Thousand Dresses a Day* by L. Kassil, 1931

Lidia Popova, cover for *Riddles* by S. Fedorchenko, 1928

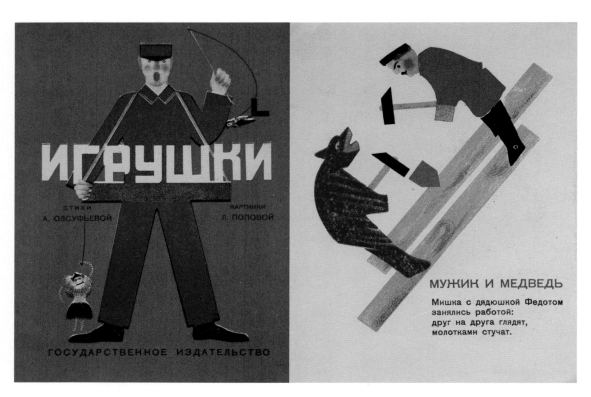

МУЖИК И МЕДВЕДЬ

Мишка с дядюшкой **Федотом**
занялись работой:
друг на друга глядят,
молотками стучат.

КУРЫ

Не боятся мороза
куры из Совхоза —
и летом и зимой
клюют наперебой.

ОБЕЗЬЯНА

Обезьяна Фока
танцует без отдыха и срока,
вышла погулять,
учит дочку танцовать.

Lidia Popova, illustrations for *Toys* by A. Olsufieva, 1928

ИГРУШКИ

А вот игрушки отличные,
прочные, симпатичные!
Самые новые,
кустарные, дешевые!
Про эти игрушки детские
знает вся страна советская!
А ну-ка, ребята, малые и большие,
посмотрим, что это за игрушки такие.

Рыба-селедка —
настоящая красотка.
Шевелится, как червяк,
хвостом машет так и сяк.

ПТИЦА

Птица-синица
на палочке вертится,
жужжит, летает,
хвостом мотает.

МАТРЕШКИ

Матрешки-подружки
спрятались друг в дружке,
каждая раскрывается,
каждая вынимается.

Вот они стоят
все двенадцать в ряд.

ДРАКОН

Дракон из Китая
штука не простая —
во все стороны вертится,
очень любит веселиться.

ЗМЕЯ

Змея-забияка,
ужасная ломака:
бьет сама себя хвостом,
извивается кольцом.

Вот они, эти краски трех основных цветов

желтая красная синяя

Теперь смешай их по две и получишь еще три

оранжевый зеленый фиолетовый

А если смешаешь все три краски сразу, то получишь темный, почти черный цвет. Вот ты из трех красок уже получил семь цветов.

черный

Nikolai Troshin, original artwork and printed illustrations for *Colouring Book*, c. 1927

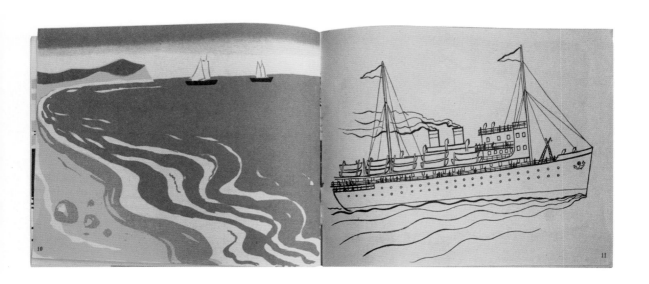

Konstantin Kuznetsov, cover and illustrations for *I Am a Printer* by Ekaterina Zonnenshtral, 1932

ТЕКСТ И РИСУНКИ

Е. ЗОННЕНШТРАЛЬ
К. КУЗНЕЦОВ

Сдано в производство 1/XII 1931 г.
Подписано к печати 25/II 1932 г.
Редактор Е. Шабад.
Техн. редактор О. Соловьев.

Уполномоченный Главлита № Б-17055. Издат. № 2828
Д. 52. Заказ № 286. Тир. 50 000.

1-я типо-литография Огиз РСФСР „Образцовая".
Москва, Валовая, 28.

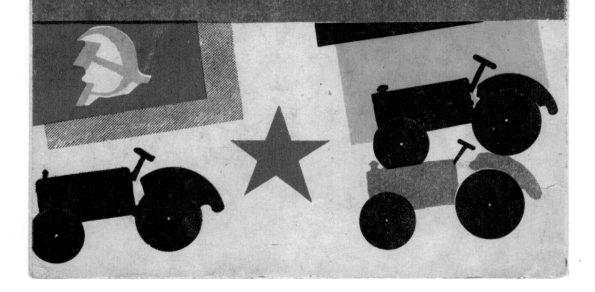

Я Вы все читали, вероят-
ЦК ВКП(б) о начальной
Вы, вероятно, уже обсу-
бою, как вам, пионерам,
изнь постановление ЦК
тся поговорить с вами по
т стоят ряд вопросов.
— как наладить аккурат-
школы. Вы постановля-
ться с опозданиями и с
т». Это правильно. Раз
обязаны это делать.
о — убедить всех реб

сказать ребятам, как
он всегда, как-бы он
обрание, шел выступа-
у Ленин был ранен, он
, что он пропускает за-
ома, а там стоят важные
ько он стал поправлять-
ить врачей, чтобы скорее
стать и пойти на заседа
у позволили. Он встал,
а у него к сердцу, и он
едный. Когда он пришел
товарищи были очень
стойчив прин лись за
— не зап дывал на засе-
а. За

уже пришел кто-нибудь?
лько придут двое, сейчас
» И как только Фотиева
пришло два или три че-
заторопится, возьмет бу-
шагами идет в Совнар-
ется, пока все соберутся.
месте. Скоро все стали
нарком без всяк

это всем школьникам, и
ым ленинцам, но и всем
гупать так, как Ленин. Во

бумажку, бездушное, формальное отно-
шение к делу и называется бюрократиз-
мом. Положим, надо быстро послать к
больному врача. Посы ают б ажку в ка-
кое нибудь учрежден от орого это
зависит, а там выходн ден На другой
день посмотрит кто у ажку, ска-
жет, что надо враче утвердил
мажка путешес уч-
реждение, а больной лежит без помощи,
ог но было бы ему помочь.
может быть, удивит, к чему это я
оворю и чему рассказываю вам о
рократизме. Я об этом говорю потому,
то и среди пионеров иногда бывает по-
дочно бюрократизма, а это никуда не
одится. Вглядитесь в свою работу, и вы
идите, что лу тоже отно-
есь фор но бюро ически.
не один что его зачи-
прогульщики и поэтому даже одеж-
когда другим выдавали. А
ж от школы в пяти километрах, и
река. Река разлилась весной,
из попасть в школу, а его за-
м в прогульщики.
же но бюрократически подойти к
опаздывании и пропусках?
о ясить каждый раз причину за-
здыва я или пропуска. Может быть,
ть считает, что девочке, ее дочери, со-
ем не к чему ходить в колу, пусть она
чше сидит дома и выш ает душечки.
кая-нибудь дома яя хоз ка най-
ет себе девчонку няньку, в школу ее не
устит. «Все не для того важно, чтобы
а в школу бегала для того, чтобы
ие ребят ньчила». На таких об и ов
домашних хозяек надо раву.
при но всеобщее обязательное
ние, и ех, кто пускает ребят в
колу, полагается трофовать. Пионеры
олжны этого добиваться.
Может не ходить в школу ученик и по
нужде. Мать уходит на работу, а малые
ребята остаются без всякого призора, ко-

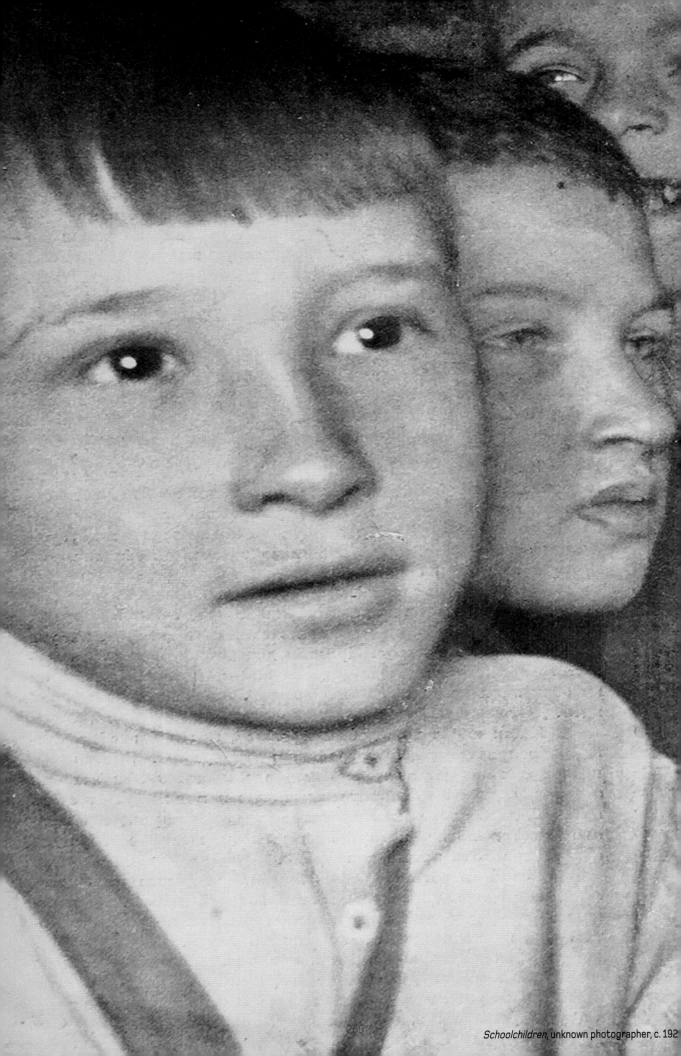

Schoolchildren, unknown photographer, c. 192

LET'S STUDY, STUDY AND STUDY

I ASKED KAMENEV ABOUT THE SCHOOLS and he explained that one of their difficulties was due to the militarism forced upon them by external attacks. He explained that the new Red Army soldiers, being mostly workmen, are accustomed to a higher standard of comfort than the old army soldiers, who were mostly peasants. They objected to the planks which served as beds in the old, abominably over-crowded and unhealthy barracks. Trotsky, looking everywhere for places to put his darlings, found nothing more suitable than the school buildings; and, in Kamenev's words, "We have to fight hard to get every school." Another difficulty, he said, was the lack of school books. Histories, for example, written under censorship and in accordance with the principles of the old regime, were now useless, and new ones were not yet ready, apart from the difficulty of getting paper and of printing...

Among the other experts I consulted on the subject of Soviet educational work were two friends, a little boy, Glyeb, who sturdily calls himself a Cadet though three of his sisters work in Soviet institutions, and an old and very wise porter. Glyeb says that during the winter they had no heating, so they sat in school in their coats, and only sat for a very short time, because of the great cold. He told me, however, he was given a good dinner there every day, and that lessons would be all right as soon as the weather got warmer. He showed me a pair of felt boots which had been given to him at the school. The old porter summed up the similar experience of his sons. "Yes," he said, "they go there, sing the Marseillaise twice through, have dinner and come home." I then took these expert criticisms to Pokrovsky who said, "It is perfectly true. We don't have enough transport to get food to our soldiers, let alone to provide food and warmth for ourselves.

And if, under these conditions, we forced children to go through all their lessons we should have corpses to teach, not children. But by making them turn up for their meals we do two things, keep them alive, and get them into the habit of coming, so that when the warm weather comes we can do better."

Arthur Ransome, *Russia in 1919*.

PORNOGRAPHY AND RELIGIOUS BOOKS shall not be released for free sale, and shall be turned over to the Paper Industry Board as waste paper.

Vladimir Lenin, *Collected Works,* vol. 42, p. 343.

WE CAN ONLY ENTRUST the teaching of our children to those who share the ideals to which we aspire.

Anatoly Lunacharsky, interview with Lincoln Eyre in *New York World*, March 1920

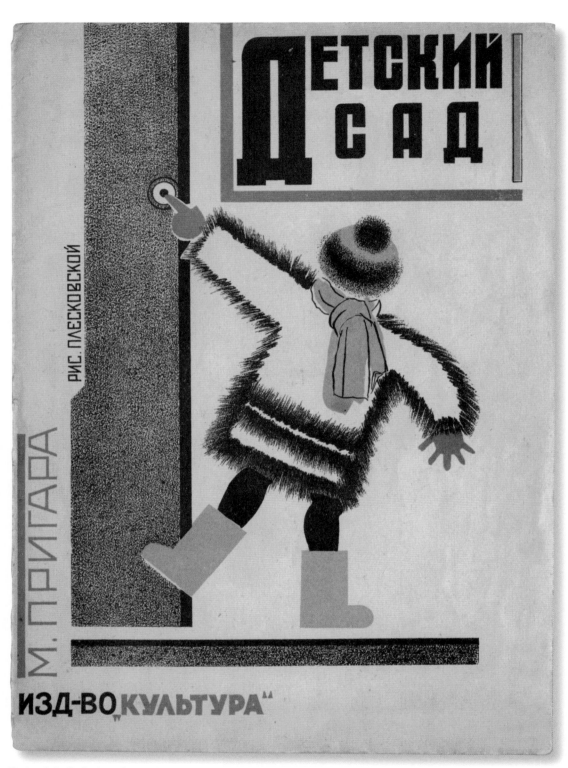

Pleskovskaia, illustrations for *KIndergarten* by M. Prigara, 1930

На стене часы звонят:
В детский сад!

 В детский сад!
Быстро дети собираются,
собираются, раздеваются.

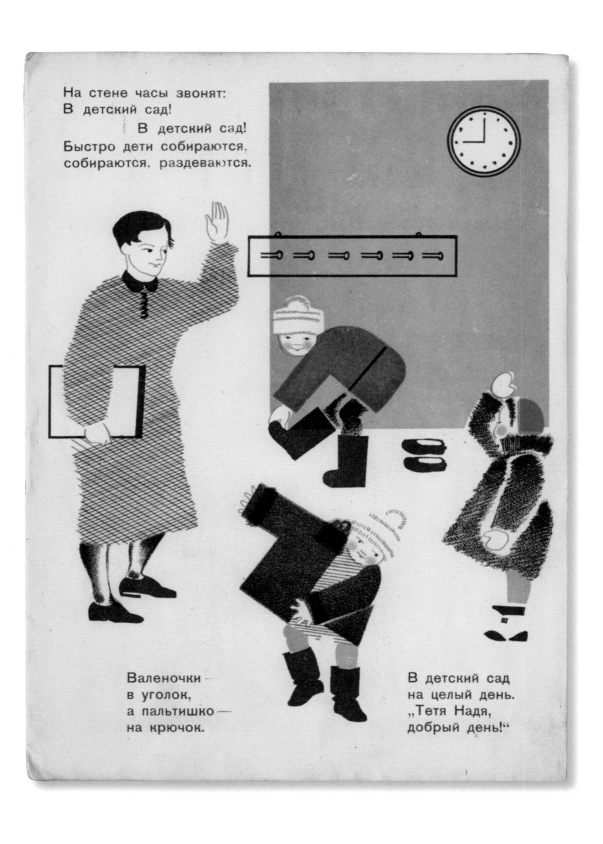

Валеночки —
в уголок,
а пальтишко —
на крючок.

В детский сад
на целый день.
„Тетя Надя,
добрый день!"

Unknown illustrator, *The Tiny ABC Book*, 1928

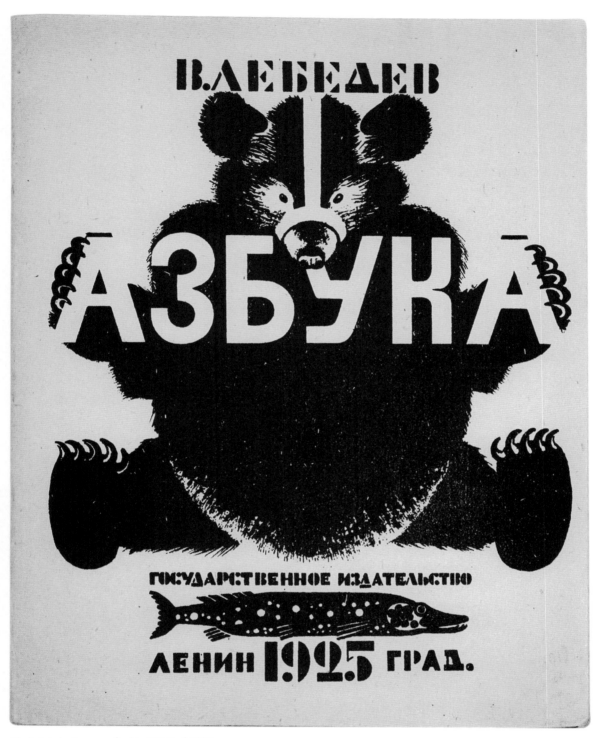

Vladimir Lebedev, cover for his *ABC Book*, 1925

90 коп.

Alexander Deineka, cover and illustrations for *A Sparkle, An Easy ABC* by M. Teryaeva, 1930

М. П. ТЕРЯЕВА

ИСКОРКА

ЛЁГКИЙ БУКВАРЬ

1930

ГОСУДАРСТВЕННОЕ ИЗДАТЕЛЬСТВО

24

Дом
и
домик.

Ну и
дым!

ку ку

ку ку

ко ко

ко ко

га га

га га

Большой и маленький.

Где больше
шариков?

Где больше
пуговиц?

4 5

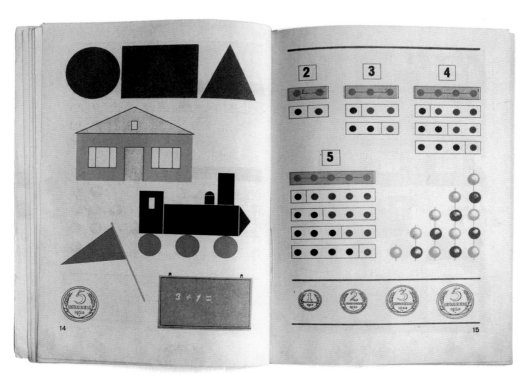

| 2 | 3 | 4 |

| 5 |

$3 + 1 =$

14 15

Ф. Н. БЛЕХЕР

Первая книжка
для обучения счёту

для приготовительного класса
и детского сада

Государственное учебно-педагогическое издательство
Москва — 1934

Unknown illustrator, cover and illustrations for *The First Counting Book* by F. N. Blekher, 1934

ЯНВАРЬ
21
ДЕНЬ
СМЕРТИ
ЛЕНИНА

26

$3 + 3$

$4 + 3$

$5 + 3$

$6 + 3$

$7 + 3$

$1 + 3$	$5 + 3$	$6 + 2$
$3 + 3$	$4 + 3$	$7 + 1$
$2 + 3$	$6 + 3$	$1 + 4$
$4 + 3$	$7 + 3$	$6 + 3$

Сколько копеек?

$3 + 3 =$ $5 + 3 =$

E. Shestopalova, illustrations for *Counting Book* by E. Fortunatova and L. Shleger, 1930

276

A. Gromov, illustrations for *Stencils*, 1931

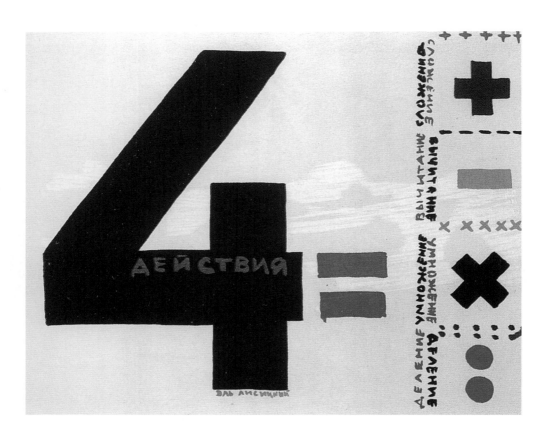

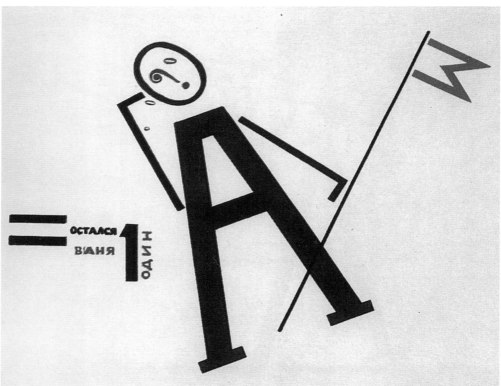

El Lissitzky, unpublished illustrations for *Adding, Subtracting, Multiplying and Dividing*, 1928

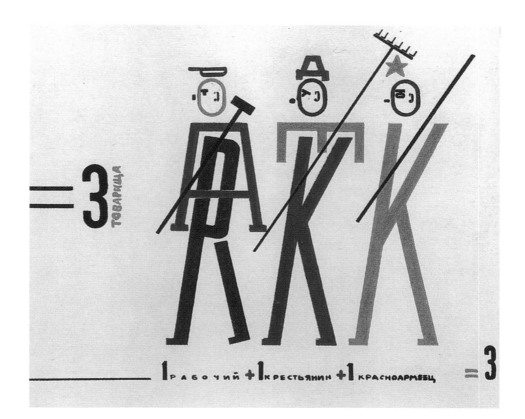

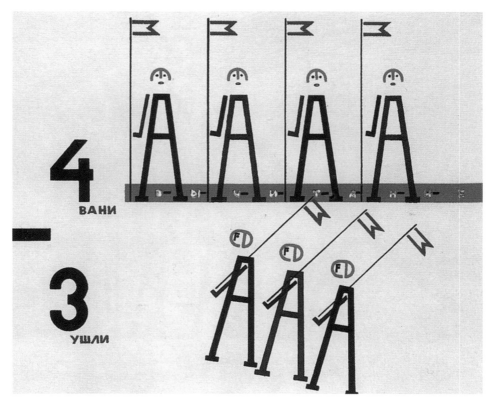

Nisson Shifrin, cover and illustrations for *What Will You Be When You Grow Up?* by Vladimir Mayakovsky, 1929

В.МАЯКОВСКИЙ

РИС. Н.ШИФРИН

КЕМ БЫТЬ?

ГОСУДАРСТВЕННОЕ ИЗДАТЕЛЬСТВО

1929

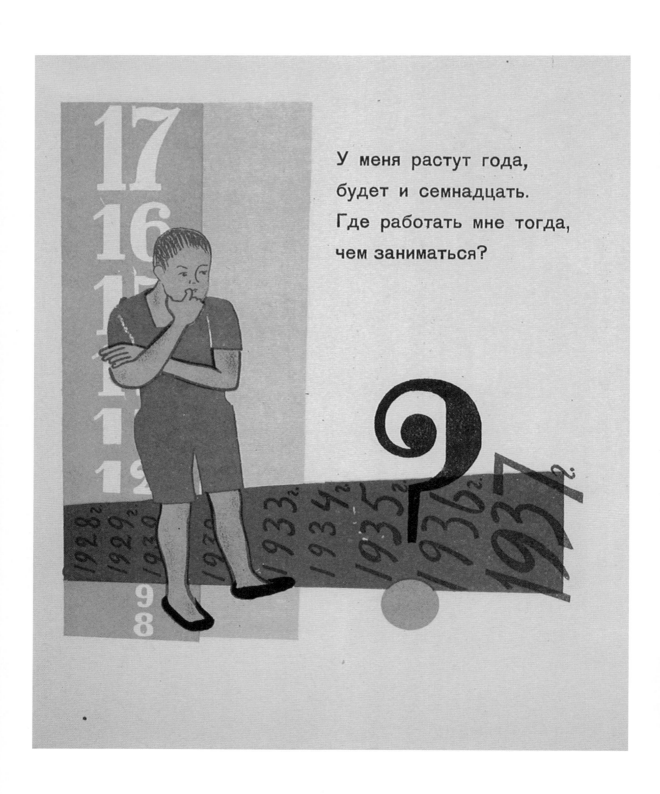

У меня растут года,
будет и семнадцать.
Где работать мне тогда,
чем заниматься?

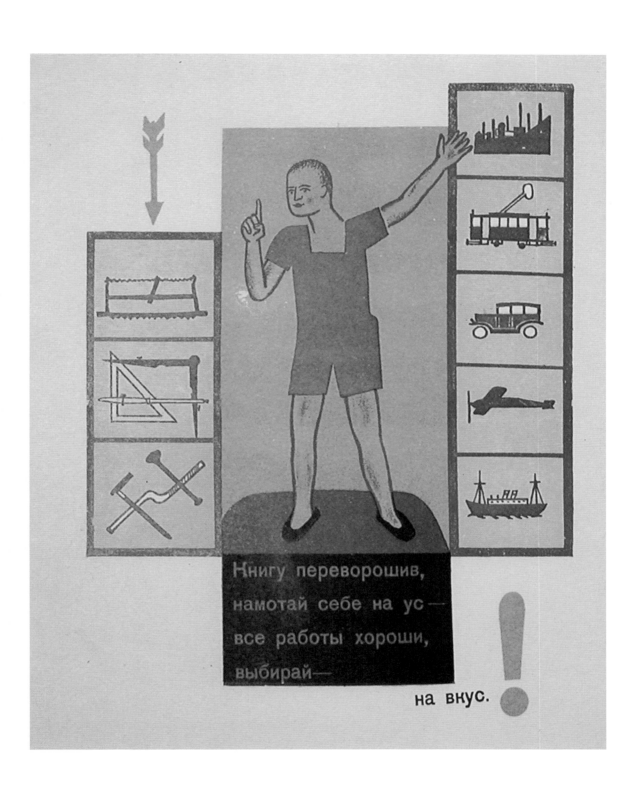

Книгу переворошив,
намотай себе на ус —
все работы хороши,
выбирай —

на вкус.

S. Petrovich photo illustration for
The Remarkable Adventures of Karik and Valya by Jan Larry, 1937

10

HIDE AND SEEK

IN THE MIDDLE OF THE 'TWENTIES, when the atmospheric pressure began to weigh more heavily on us – at critical periods it was heavier than lead – people all at once started to avoid each other. This could not be explained only by fear of informers and denunciation – we had not yet had time to get really scared of these. It was rather the onset of a kind of numbness, the first symptoms of lethargy. What was there to talk about when everything had already been said, explained, signed and sealed?

Only children continued to babble their completely human nonsense, and the grown-ups – everybody from book-keepers to writers – preferred their company to that of their peers. But mothers prepared their children for life by teaching them the sacred language of the seniors. "My children love Stalin most of all, and me only second", Pasternak's wife, Zinaida Nikolaevna, used to say. Others didn't go so far, but nobody confided their doubts to their children: why condemn them to death? And then suppose the child talked in school and brought disaster to the whole family? And why tell it things it didn't need to know? Better it should live like everybody else. . . So the children grew, swelling the ranks of the hypnotized.

Nadezhda Mandelstam, *Hope Against Hope,* 1970

. . . REGRET AS THEY MIGHT the flatness of the scene, the prospect of a new "revolutionary situation", however stimulating to art, could scarcely be welcome to human beings who have lived through more than even the normal Russian share of moral and physical suffering. Consequently there is a kind of placid and somewhat defeatist acceptance of the present situation among most of the intellectuals. There is little fight left even in the most rebellious and individualistic; Soviet reality is too recalcitrant, political obligation too oppressive, moral issues too uncertain, and the compensations, material and moral, for conformity too irresistible.

Isaiah Berlin, *A Note on Literature and the Arts in the Russian Soviet Federated Socialist Republic in the Closing Months of 1945*, report to the British Foreign Office

THE REAL DANGER FOR A WRITER is not so much the possibility (and often the certainty) of persecution on the part of the state, it is the possibility of finding oneself mesmerized by the state's features, which, whether monstrous or undergoing changes for the better, are always temporary.

The philosophy of the state, its ethics – not to mention its aesthetics – are always "yesterday". Language and literature are always "today," and often – particularly in the case where a political system is orthodox – they may even constitute "tomorrow".

Possessing its own genealogy, dynamics, logic and future, art is not synonymous with, but at best parallel to history; and the manner by which it exists is by continually creating a new aesthetic reality. That is why it is often found "ahead of progress", ahead of history, whose main instrument is - should we not, once more, improve upon Marx – precisely the cliché.

Joseph Brodsky, Nobel Lecture, 8 December, 1987

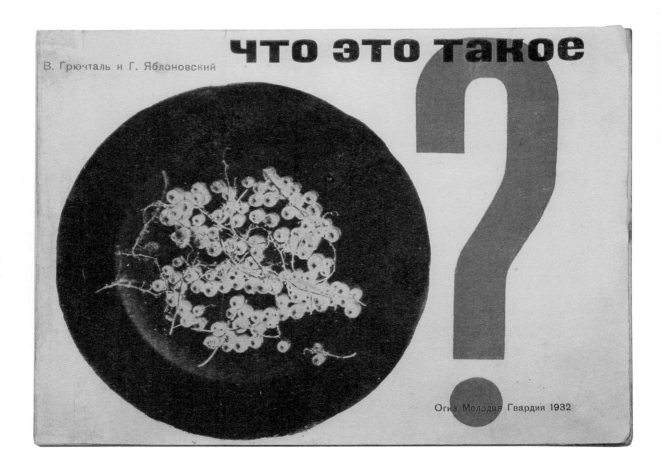

Vladimir Gryuntal and G. Yablonsky, cover and illustrations for *What is This?* by Mikhail Gershenzon, 1932

хорошая вещь арифметика **!**

37+19=

69+28=

54:9=

=15

=97

=21

61-18=

В этой книжке восемь кар-
тинок-загадок.

Каждая картинка с фокусом.
Посмотришь картинку — ничего
не понять.

Чтобы картинки были по-
нятны, здесь приложены две
прозрачные бумажки.

Сперва накрой картинку с и-
ней бумажкой. Тогда увидишь
загадку.

Для того чтобы увидеть раз-
гадку, надо накрыть картинку
красной бумажкой.

B. Tatarinov and E. Dorfman, illustrations for *Magical Pictures,* 1929

Leonid Gamburger, illustration for *The Funny Booklet*, 1930

Д—20. Гиз № 36806/л. Ленинградский Областлит № 55025. Тираж 25.000—³/₄ л. (Л.2). Заказ № 826.
Государственная типография имени Евг. Соколовой, Ленинград, проспект Красных Командиров, 29.

Vladimir Tambi, back cover and illustrations for *Camouflage*, 1932

Красноармейцы разожгли дымовые шашки. Дым валит клубами. Ветер гонит его на неприятеля. Танки выползли из засады. Они прячутся в дымовое облако и идут на врага.

Дымовая завеса загораживает танки от пушек. В небе летит неприятельский самолёт. Наблюдатель высматривает, где стоят наши батареи, чтобы сбросить на них бомбу. Но пушек не видно.

Разноцветные пятна камуфляжа и пучки веток защищают пушки от бомб вернее, чем стальная броня. А возле фальшивых деревянных пушек нарочно жгут порох, как будто они стреляют.

Красноармейцы не боятся выстрелов врага. Они наступают врассыпную, ползут по земле, перебегают и прячутся за каждый бугорок. Враг их не видит. Они в закамуфлированных халатах.

От страшных бомб, от тяжелых снарядов и разрывных пуль красноармейцев защищают зеленые ветки, раскрашенные тряпки да мочалки.

Д—20. Гиз № 3980бл. Ленинградский Облавлит № 65025. Тираж 25 000—½, л. Заказ № 628.
Государственная типография имени Евг. Соколовой, Ленинград, пр. Красных Командиров, 29.

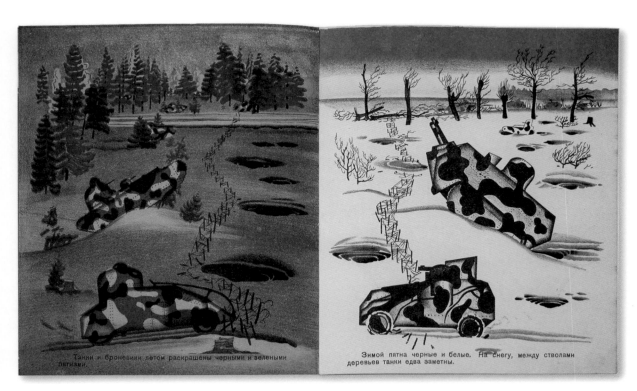

Танки и броневики летом раскрашены черными и зелеными пятнами.

Зимой пятна черные и белые. На снегу, между стволами деревьев танки едва заметны.

Daniil Kharms

A MAN ONCE WALKED OUT OF HIS HOUSE

A man once walked out of his house
with a bag and a walking stick,
and off he went,
and off he went
and he never did turn back.

He walked on straight and forward
and only looked ahead,
he never slept,
nor drank nor slept,
nor slept nor drank nor ate.

Then once upon a morning
he entered a dark wood
and on that day,
and on that day
he disappeared for good.

If anywhere at all you meet
with him by any chance,
then run and tell,
then run and tell,
then run and tell us, please.

Translated by Matvei Yankelevich and Eugene Ostashevsky

Where is the boy?

Tatiana Glebova, illustrations for *Where Am I?* (an unpublished book of hidden images), 1928

Where is the barrel?

Where is the chimney sweep?

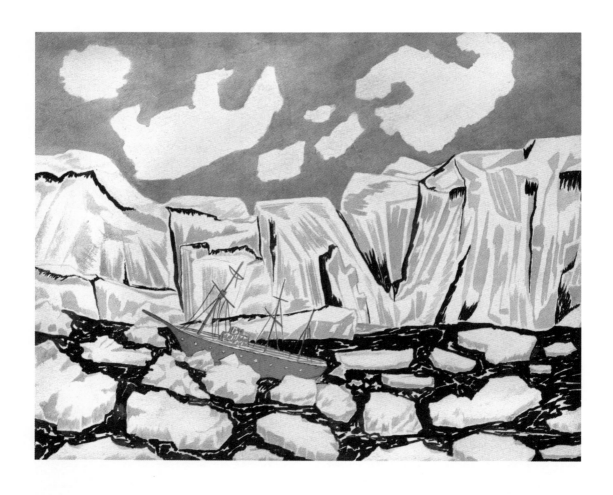

Where is the bear?

Where is the fish?

Where is the fireman?

Where is the driver?

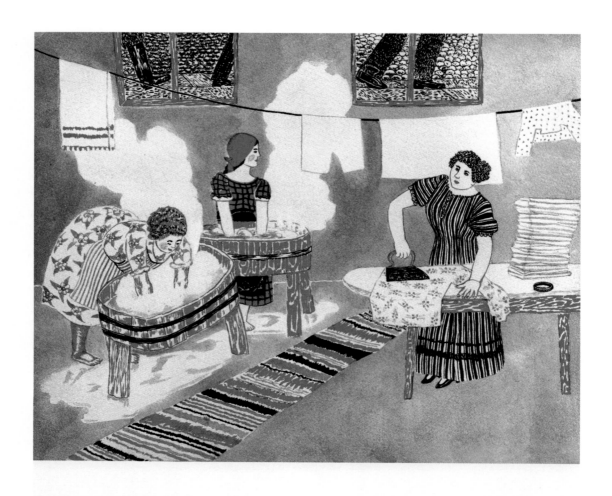

Where is the iron?

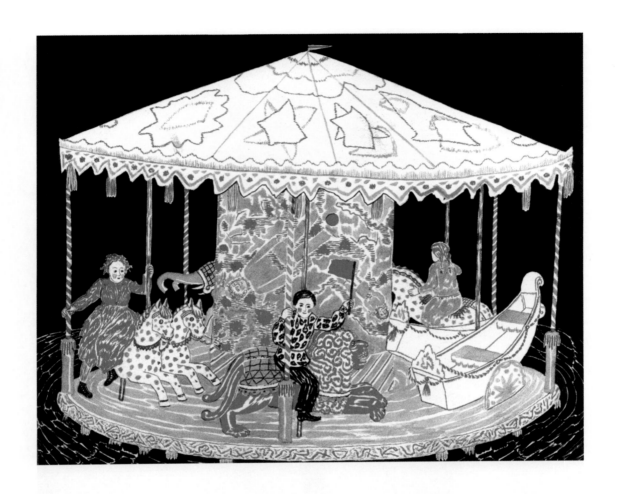

Where is the boy?

Цена 35 коп.

294

Мама, мама,
кончилась вся

ПРОГРАММА

Если публика не заскучала,
можно опять начинать сначала.

Главлит № А-40081. Д. 10. Гиз № 31164. Зак. № 834. Тираж 10 000.
1-я Образцовая типо-литография Госиздата. Москва. Валовая, 28.

Boris Pokrovsky, back cover for *Wonder Things* by Agnia Barto, 1928

COMRADES! the discussion at this congress has revealed

the complete unity of the views of our Party leaders on, one can say, all questions

of Party policy. As you know, no objections whatever have been raised against

the report. Hence, it has been revealed that there is extraordinary ideological,

political and organizational solidarity in the ranks of our Party. (Applause.)

The question arises: Is there any need, after this, for a reply to the discussion?

I do not think there is. Permit me therefore to refrain from making any concluding

remarks. (A stormy ovation. All the delegates rise to their feet. Thunderous shouts

of "Hurrah!" A chorus of shouts: "Long live Stalin!" The delegates, all standing, sing

the "International", after which the ovation is resumed.)

Joseph Stalin, speech at XVII Congress of All-Union Communist Party (so-called Congress of Victors), reprinted in *Pravda,* No. 31, 1 February, 1934

FURTHER READING

Ball, Alan, *And Now My Soul is Hardened: Abandoned Children in Soviet Russia, 1918-1930*, University of California Press, USA, 1994

Chukovsky, Korney, *Diary, 1901-1969*, Yale University Press, USA, 2005

Figes, Orlando and Kolonitsky, Boris, *Interpreting the Russian Revolution. The Language and Symbols of 1917*,
Yale University Press, USA, 1999

Fraser, James and Shima, Tayo, *Russian Children's Picture Books in the 1920's and 30's*, Tankosha Publishing Co. Ltd., Japan, 2004

Hearn, Michael Patrick, *From the Silver Age to Stalin: Russian Children's Book Illustration in the Sasha Lurye Collection*,
The Eric Carle Museum of Picture Book Art, USA, 2004

Janecek, Gerald , *The Look of Russian Literature. Avant-garde visual Experiments 1900-1930*, Princeton University Press, USA, 1984

Kelly, Catriona, *Children's World: Growing up in Russia, 1890-1991*, Yale University Press, USA, 2007

Kuznetsov, Ernst, *L'Illustrazione del Libro per Bambini e l'Avanguardia Russa*, Cantini, Italy, 1991

Lemmens, Albert and Stommels, Serge, *Russian Artists and the Children's Book 1890-1992*, Nimega, LS, Holland, 2009

Lévèque, Françoise and Plantureux, Serge, *Dictionnaire des Illustrateurs de Livres d'Enfants Russes, 1917-1945*,
Agence Culturelle de Paris, France, 1997

Lévèque, Françoise with Michielsen, Béatrice and Noret, Michèle, *Promesas de Futuro, Blaise Cendrars y el Libro Para Niños
en la URSS / 1926-1929*, Fundación Museo Picasso, Spain, 2010

Milner, John, *A Dictionary of Russian and Soviet Artists 1420-1970*, Antique Collector's club, UK, 1993

Pérez, Carlos, *Infancia y Arte Moderno*, IVAM, Instituto Valenciano de Arte Moderno, Spain, 1998

Rowell, Margaret and Wye, Deborah, *The Russian Avant-Garde Book 1910-1934*, The Museum of Modern Art, USA, 2002

Semenikhin, Vladimir, *Children's Picture Books in the History of Russia, 1881-1939*, Samolet, Russia, 2009

Steiner, Evgeny, *Stories for Little Comrades: Revolutionary Artists and the Making of Early Soviet Children's Books*,
University of Washington Press, USA, 1999

Zenzinov, Vladimir, *Deserted: The Story of the Children Abandoned in Soviet Russia*, H. Joseph, UK, 1931

INDEX OF ILLUSTRATORS